HOW TO READ

European Decorative Arts

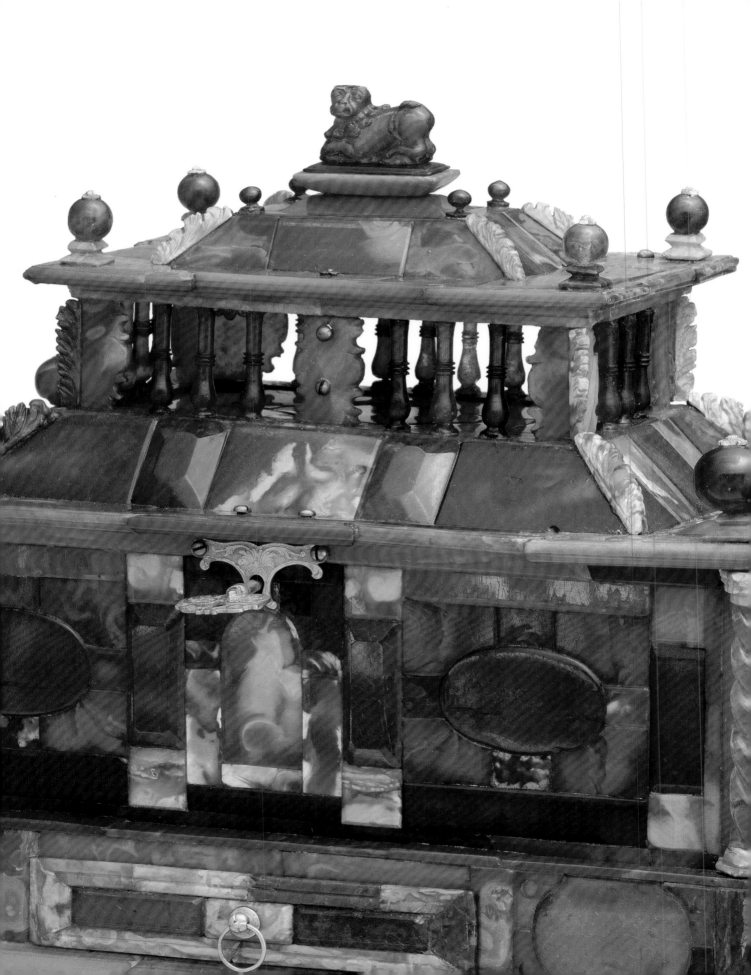

HOW TO READ
European Decorative Arts

Daniëlle Kisluk-Grosheide

The Metropolitan Museum of Art, New York
Distributed by Yale University Press, New Haven and London

This publication is made possible by The James Parker Charitable Foundation.

Published by The Metropolitan Museum of Art, New York
Mark Polizzotti, Publisher and Editor in Chief
Peter Antony, Associate Publisher for Production
Michael Sittenfeld, Associate Publisher for Editorial

Edited by Margaret Donovan
Designed by Rita Jules, Miko McGinty Inc.
Production by Christina Grillo
Image acquisitions and permissions by Elizabeth De Mase

Unless otherwise noted, all works are in the collection of The Metropolitan Museum of Art, New York. Photographs of works in the collection are by Richard Lee, © The Metropolitan Museum of Art, except when credited differently.

Additional photography credits: fig. 1: Royal Collection Trust / © Her Majesty Queen Elizabeth II 2023; figs. 2, 4–15, 18, 22, 27, 28, 30, 31, nos. 1 (pp. 30–31), 2–8, 11–13, 16, 19, 21–25, 30, 31, 33, 34, 38: Image © The Metropolitan Museum of Art; fig. 16: Rijksmuseum, Amsterdam; figs. 19, 20: © The Trustees of the British Museum; figs. 21, 26: Image © The Metropolitan Museum of Art, photo by Mark Morosse; fig. 23: Photo: © MAK; fig. 24: Photo © Christie's Images / Bridgeman Images; fig. 25: photo by Studio Tromp; no. 26 (p. 114): Image © The Metropolitan Museum of Art, Photomicrograph 10x by Cristina Balloffet Carr; fig. 32: © Photographic Archive Museo Nacional del Prado; fig. 33: © Veneranda Biblioteca Ambrosiana / Mondadori Portfolio; no. 35 (p. 145): photo by Bryan Whitney; fig. 34: Image courtesy Sotheby's, London; no. 37: Image © The Metropolitan Museum of Art, photo by Janis Mandrus; fig. 35: Image © The Metropolitan Museum of Art, photo by Hyla Skopitz; fig. 36: Image © The Metropolitan Museum of Art, photo by Oi-Cheong Lee.

Typeset in Documenta and Edita by Tina Henderson
Printed on 150 gsm Arctic Silk Plus
Color separations by Pro Graphics, Rockford, Illinois
Printed and bound by Ofset Yapımevi A.Ş., Istanbul

Cover illustration: Folding Fan (reverse). French (Paris), ca. 1783 (no. 26)

Additional illustrations: pp. 2–3, Casket (no. 12, detail); p. 6, *Pietre Dure* Tabletop (no. 1, detail); pp. 8, 9, Flowers (no. 40); p. 12, Decorative Ewer (fig. 3, detail); pp. 28–29, Secretary Cabinet (no. 3, detail); pp. 54–55, Casket with Scenes from the Story of Esther (no. 11, detail); pp. 78–79, Inkstand (no. 18, detail); pp. 96–97, *Nécessaire* (no. 25, detail); pp. 118–19, Book Cover (no. 28, detail); pp. 130–31, *The Kiss* (no. 39, detail); p. 158, Commode (no. 5, detail)

The Metropolitan Museum of Art endeavors to respect copyright in a manner consistent with its nonprofit educational mission. If you believe any material has been included in this publication improperly, please contact the Publications and Editorial Department.

The Metropolitan Museum of Art
1000 Fifth Avenue
New York, New York 10028
metmuseum.org

Distributed by
Yale University Press, New Haven and London
yalebooks.com/art
yalebooks.co.uk

Cataloguing-in-Publication Data is available from the Library of Congress.
ISBN 978-1-58839-751-5

Contents

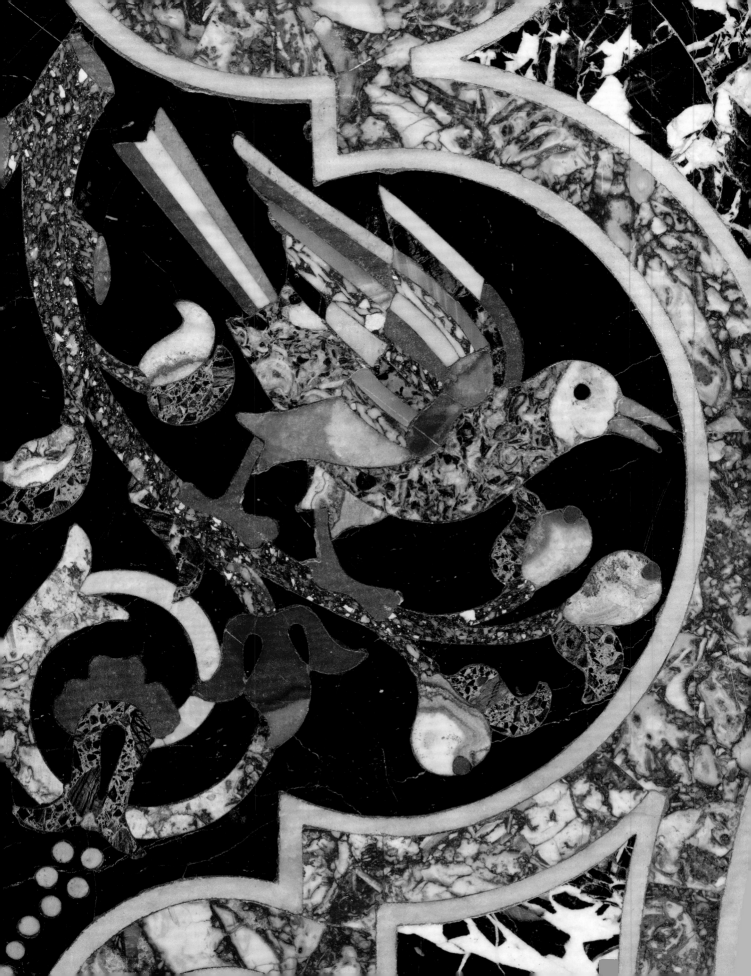

Director's Foreword

Ever since its founding in 1870, The Metropolitan Museum of Art has amassed outstanding examples of European decorative arts, and as a result today's visitors to The Met enjoy one of the finest collections of such objects in the world. The holdings include artworks with a wide variety of uses in a myriad of media and techniques, ranging from teapots to watches, from gilded bronze to porcelain, and from ivory turning to furniture making. Largely formed through gifts and bequests from legendary donors, among them J. Pierpont Morgan, Charles and Jayne Wrightsman, Irwin Untermyer, Jack and Belle Linsky, The Samuel H. Kress Foundation, Lesley and Emma Sheafer, and R. Thornton Wilson, the holdings show great strength in French, English, German, and Italian works, reflecting the prevalent taste in New York. Over the years, strides have been made to add greater breadth to the collection by acquiring works from other European countries as well.

The most iconic decorative art pieces at The Met have long enjoyed their place in the spotlight and have been published frequently, but Daniëlle Kisluk-Grosheide, Henry R. Kravis Curator in the Department of European Sculpture and Decorative Arts, has selected less familiar objects as well as more recent acquisitions as the focus of this book. Examining technique, style, and history, she shares illuminating stories about each of these artworks with the aim of encouraging a broader understanding and appreciation of the decorative arts.

We gratefully acknowledge the generous support of The James Parker Charitable Foundation for making possible the publication of this richly illustrated volume, the eleventh in the Museum's How to Read series. I hope that, like the others in the series, it will captivate the imaginations of its readers and inspire them to explore the pieces featured here and those presented in the period rooms and the galleries devoted to the European decorative arts, located on the main floor of The Met Fifth Avenue.

Max Hollein
Marina Kellen French Director
The Metropolitan Museum of Art

Acknowledgments

First and foremost, I am deeply grateful to Sarah E. Lawrence, Iris and B. Gerald Cantor Curator in Charge of the Department of European Sculpture and Decorative Arts, for initially suggesting me as the author of this book and for contributing her text on the recent scholarly reexamination of the decorative arts. From the inception of the project, Mark Polizzotti, Publisher and Editor in Chief, Michael Sittenfeld, Associate Publisher for Editorial, and Peter Antony, Associate Publisher for Production, enthusiastically embraced the idea of adding a volume on the subject to the How to Read series. My gratitude also extends to Daniel H. Weiss, President and CEO, and to Max Hollein, Marina Kellen French Director, for their approval of the project.

Accomplishing the necessary research would have been impossible without the excellent staff of the Thomas J. Watson Library, who delivered books, scanned articles, and accommodated countless requests for interlibrary loans. An art book relies on beautiful illustrations, and this one has the very best. Its high-quality images, which truly capture the essence of the three-dimensional objects, were taken in the Museum's Imaging Department, for which I thank Scott Geffert and his stellar team, especially Richard Lee.

I owe much to Margaret Donovan, my meticulous and invaluable editor, who made the editing process seamless and enjoyable. Also indispensable to the project have been Elizabeth De Mase, for brilliantly sourcing the many images, and Christina Grillo, for her outstanding work on the production. The designers Rita Jules and Miko McGinty are to be commended for the elegant design of the volume.

An institution with a long history, The Met has benefited greatly over the years from a series of gifted curators who have expanded the departmental collections and contributed to the study of individual artworks. For the

text of this publication, I stand on the shoulders of former colleagues to whom I am most grateful, especially Ellenor M. Alcorn, James David Draper, Clare Le Corbeiller, James Parker, Olga Raggio, Luke Syson, Clare Vincent, Ian Wardropper, and Melinda Watt. I owe them an immense debt and feel very fortunate to have worked with them.

Special thanks are also due to my current colleagues: Sarah E. Lawrence; Denise Allen; Wolf Burchard; Elizabeth Cleland; Wolfram Koeppe, Marina Kellen French Senior Curator; Iris Moon; and Elyse Nelson. I have profited enormously from their expertise, connoisseurship, and helpful suggestions and have been inspired by their enthusiasm and encouragement.

I also express my deep appreciation to Janice Barnard, Pilar Ferrer, Kristen Hudson, Abigail Meyer, Juan Stacey, Denny Stone, and Sam Winks, who have offered assistance in myriad ways. I have learned much from members of the Sherman Fairchild Department of Objects Conservation, particularly from Mechthild Baumeister, Linda Borsch, Anne Grady, Pascale Patris, Jennifer Schnitker, and Wendy Walker, as well as from Cristina Balloffet Carr in the Department of Textile Conservation, to whom I am profoundly grateful.

For his indispensable advice and patience reading through more versions of the text than he might have cared to, I am forever beholden to Anthony M. Benjamin.

My sincere gratitude goes to The James Parker Charitable Foundation and to its trustees, Nancy Parker Wilson and Brian Potts, for their generous support of the book. It was James Parker who took a big gamble on me, engaging as a volunteer a young, inexperienced art historian; it is to him that I owe my career at The Met.

Daniëlle Kisluk-Grosheide
Henry R. Kravis Curator
Department of European Sculpture and Decorative Arts

The Decorative Arts Reexamined

In the early sixteenth century, Leonardo da Vinci sketched a fantastic downpour of household wares falling from the clouds (fig. 1). Underneath this stormy landscape, he added the inscription, "Oh human misery, how many things you must serve for money." The precise meaning of this allegory remains enigmatic, but the artist clearly expresses a certain wariness of the sudden abundance of domestic goods and the unprecedented demand on artists for their production.

The history of European decorative arts starts at just this moment and was made possible by a particular concurrence of cultural, economic, and social conditions. Previously, sumptuary laws had restricted the production of domestic luxury goods—embellished furnishings and sumptuous apparel—in an effort to regulate consumption. Ornately fabricated items in precious metals were limited for the most part to the production of ritual objects used in liturgical practice, a context in which lavish expenditure was justified as an expression of devotion. Beginning in the late fifteenth century, there was a shift in values and an emergence of a new market for beautifully crafted furniture, utensils, and decoration, acquired for the home by an increasingly affluent merchant class in a moment of self-defining consumerism. Magnificent residences were richly outfitted with furnishings and with elaborate displays of collections that were intentional demonstrations of social standing and civic virtue. Interior spaces differentiated the public and private functions of rooms for reception, dining, sleeping, prayer, and study. Each space had distinct needs for furniture, utensils, and ornament. The result was a new proliferation of domestic goods and furnishings, in which decoration and function were inextricable.

The term "decorative arts" is commonly used to designate a category of objects differentiated from the "fine arts" of painting, sculpture, and architecture. The decorative arts are both decorative and functional—in contrast to the fine arts, which have traditionally been regarded as aesthetically significant and intellectually resonant, without any utilitarian function per se, without an external purpose. But while the ostensible function of the decorative arts is immediately apparent—a bowl, a box, a table—many of these objects were in fact used predominantly for display. A more precise definition for this category might be that these are functional objects valued as much, and sometimes more, for their ornamental qualities as for their practical uses.

The term "decorative" has been employed to marginalize the importance of these objects: they are *merely* decorative, in contrast to the allegedly more substantive content of the fine arts, which elicit and sustain deep interpretation. The scholarly emphasis on connoisseurship and technique has misconstrued the full significance of the decorative arts as being contained within the beautiful object and suggested that the object itself should be the single focus of research. More recently, however, the values embedded in a traditional hierarchy of the arts have come into question, and new modes of inquiry have recognized the decorative arts as fertile ground for innovative forms of research. Invigorating the critical consideration of the decorative arts, current scholarship has recognized their unique capacity to narrate more diverse stories of everyday life across social strata, to manifest global colonial economies of material and labor, and to demonstrate scientific and technological innovations. In

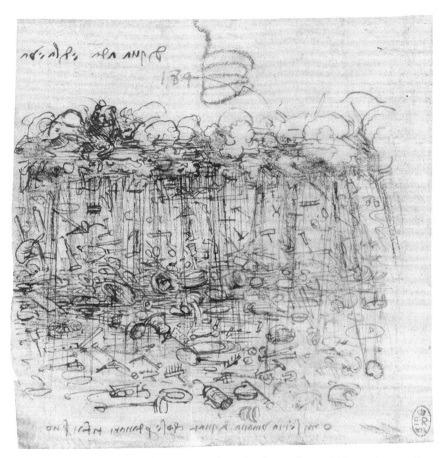

Fig. 1. Leonardo da Vinci (Italian, 1452–1519). *A Cloudburst of Material Possessions*, 1506–12. Black chalk, pen, and ink, 4⅝ × 4⅜ in. (11.7 × 11.1 cm). Royal Collection Trust (RCIN 912698)

combination, these new approaches enrich and transform our understanding of European decorative arts and their resonance in the present day.

*How to Read European Decorative Art*s is more than simply a primer to instruct the reader how to "read" the decorative arts: it is an inquiry into the manifold and richly rewarding ways to do so. There are multiple opportunities to interpret, appreciate, and above all enjoy a wide variety of decorative arts objects. Daniëlle Kisluk-

Grosheide's selection of forty works from The Met collection were chosen to reflect the chronological and geographic range of the collection as well as its diversity of materials and techniques, but above all to share the compelling stories to which these objects give voice.

Sarah E. Lawrence
Iris and B. Gerald Cantor Curator in Charge
Department of European Sculpture and Decorative Arts

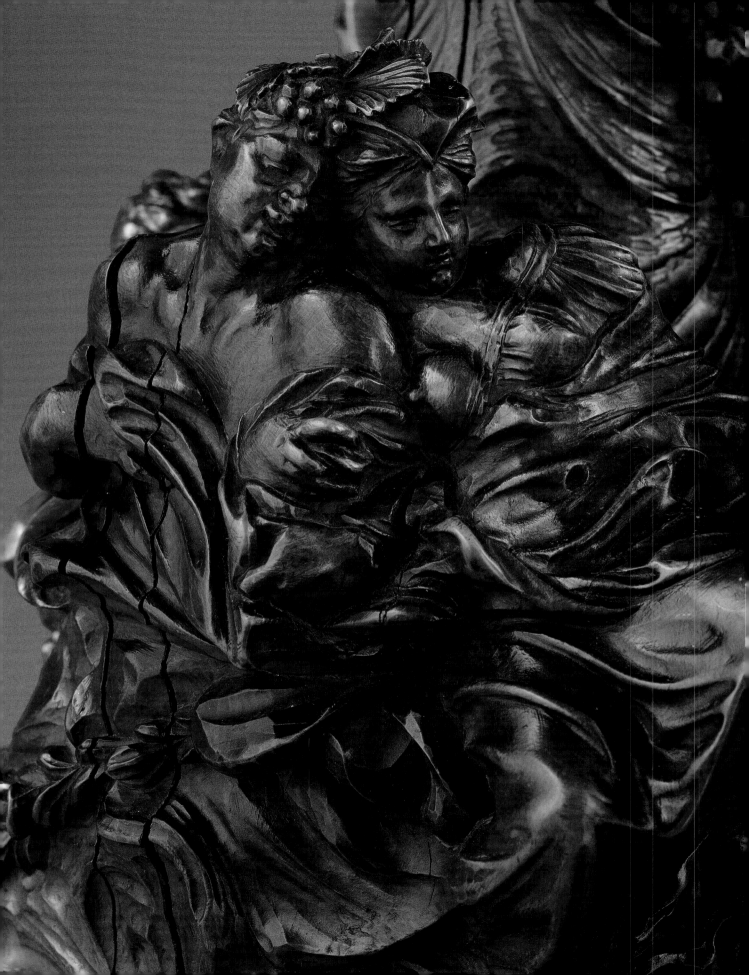

Introduction

Whether used on a regular basis, intended for learning, devotion, or amusement, acquired for display, or desired as symbols of prestige, the decorative arts have historically played an important role in daily life. Their shapes and ornamentation reveal much about changing tastes, styles, and fashions. Often the result of intercontinental commercial and cross-cultural exchange, the production of these objects echoes contemporary developments in science and technology. While affected by, if not subject to, political and economic circumstances, the decorative arts manifest the unique skills and creativity of their individual makers. Above all, they have influenced modern design and continue to please and fascinate us today. Pertaining to every aspect of our existence, the decorative arts portray, recount, and embellish the human story.

DISTINCTION BETWEEN "FINE" AND "DECORATIVE" ARTS

Any consideration of the decorative arts, also known as the applied or industrial arts, must begin by recognizing the traditional hierarchy that has profoundly shaped the practice and reception of artistic creativity in Western European culture. All three designations have their origin in the medieval category of the mechanical arts (*artes mechanicae*), a classification of knowledge that originally designated physical labors ranging from weaving, tailoring, wood carving, and pottery to tanning, shoemaking, and blacksmithing. Painting, sculpture, and architecture were later added to this group. The mechanical arts stood in contrast to the conceptual liberal arts (*artes liberales*), which encompassed intellectual pursuits such as grammar, logic, rhetoric, arithmetic, geometry, music, and astronomy. These were deemed "liberal" because they were areas of knowledge that were necessary for a free person to participate effectively in civic life. The "arts of the mind" were elevated above the skilled manual labor of the mechanical arts, which were seen as devoid of theoretical knowledge owing to their seemingly mindless, often repetitive methods of production.

Beginning in the Middle Ages, the mechanical arts were regulated by a strict guild system that laid out the rules for the education and training of artisans, who were obligated by law to belong to a particular guild in order to practice their craft. The guilds were organized by the materials their members used rather than by the techniques they employed or the kinds of objects they produced. Painters, for example, belonged to the guild of doctors and apothecaries because they used pigments made from substances that also had medicinal applications. Sculptors belonged to the guild of stonemasons if they carved from marble and to the goldsmiths' guild if they worked in bronze or silver.

Guild rules specified that a young boy would start as an unpaid apprentice, learning a trade in a master's workshop. After studying there for a number of years, the apprentice could become a journeyman, which required traveling to different workshops to gain experience; this of necessity stimulated the dissemination of styles and ideas. Once the journeyman had successfully completed a test of competence by producing a so-called masterpiece according to prescribed requirements and had paid his dues to the guild, he could join as a master craftsman and start his own business. Although it was not forbidden to be a member of more than one guild, this rarely happened because of the high level of specialization. Women, who made up about half the workforce, were generally excluded

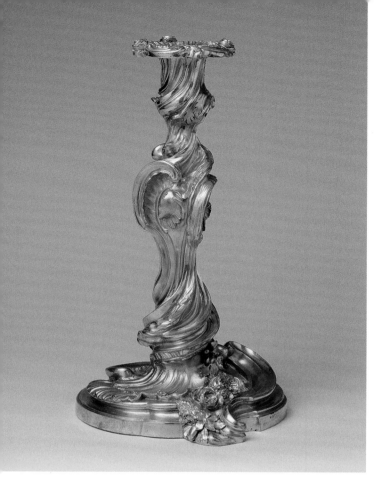

Fig. 2. Juste Aurèle Meissonnier (French, 1695–1750), designer. Candlestick. French (Paris), 1735–50. Gilded bronze, H. 12⅛ in. (30.8 cm), Diam. (base) 7⅜ in. (18.7 cm). Gift of Mrs. Charles Wrightsman, 1999 (1999.370.1a, b)

de' più eccellenti pittori, scultori, et architettori (The Lives of the Most Excellent Painters, Sculptors, and Architects), first published in 1550, Vasari justified the elevation of painting, sculpture, and architecture above the other mechanical arts for the reason that they derive primarily from the creative process, or disegno (literally, design or drawing). As an alternative to the traditional craft guilds, special academies were established in the second half of the sixteenth century for the study of the visual arts.

The category of "fine" arts was thus devised for intellectual purposes—and its creations judged for their beauty, artistic merit, meaning, and ability to engage the viewer—while the decorative arts continued to be appreciated both for their utility and ornamental qualities. Yet the two categories of art frequently intermingled as painters, sculptors, and draftsmen were often responsible for the overall design of decorative objects or for the compositions on which their embellishments were based. For an exuberantly asymmetrical gilded-bronze candlestick, made in France in 1735–50, for example, the artist Juste Aurèle Meissonnier rendered three drawings to show the spiraling design from all sides (fig. 2). Certain pieces of decorative art are exquisitely painted, on glass or porcelain, for instance, rather than on canvas, while other ostensibly "functional" objects, such as an eighteenth-century Flemish ewer, encroach upon the province of sculpture through their masterful carving (fig. 3). Many similarities are also seen in the techniques that were employed; molds, for instance, were instrumental in the production of not only bronze sculpture but also ceramics, silver, and glass.

Unlike painting or sculpture, a work of decorative art was often the result of a collaborative effort owing to the high level of specialization of the artisans involved. The fabrication of an eighteenth-century French chair, for example, required the participation of a series of trained craftsmen (fig. 4). First, a design or drawing was made by a draftsman; in the case of a special commission, a sculptor might produce a small model of wax or wood for the benefit of the client. Once approval was obtained, the menuisier (joiner) would start cutting the basic form

from the guild system. Instead, they were involved as wives and daughters assisting in the workshop but usually without recognition. The guild regulated the size of the atelier and exercised quality control, confiscating pieces that were mediocre or defective, while at the same time offering welfare provisions to its members.

It was not until the Renaissance that the arts we now term "fine"—painting, sculpture, and architecture—were awarded the same intellectual status as poetry and music, distinct from and elevated above the mechanical arts. This was because theorists of the period, among them the Italian artist and writer Giorgio Vasari, privileged intellect, conception, and artistic imagination over manual skills. In the introduction to his influential book Le vite

Fig. 3. Decorative Ewer. Probably Flemish, first half of the 18th century. Carved alder, H. 33½ in. (85.1 cm).
Purchase, Friends of European Sculpture and Decorative Arts Gifts, 2000 (2000.492)

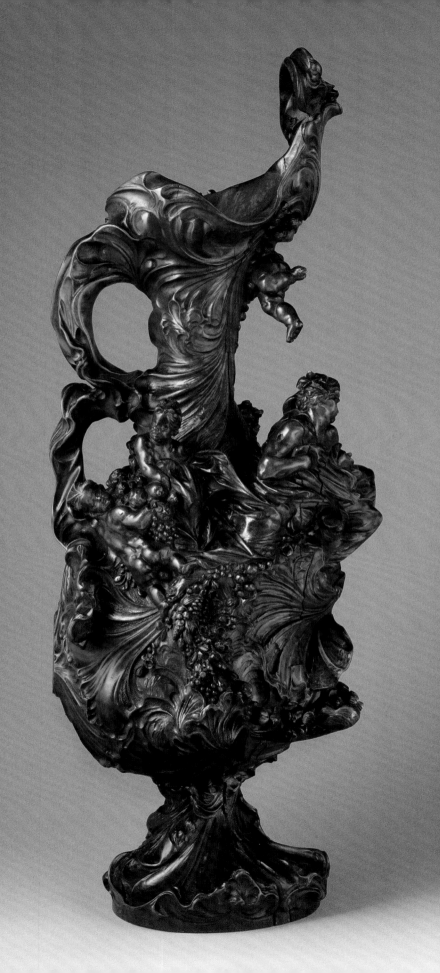

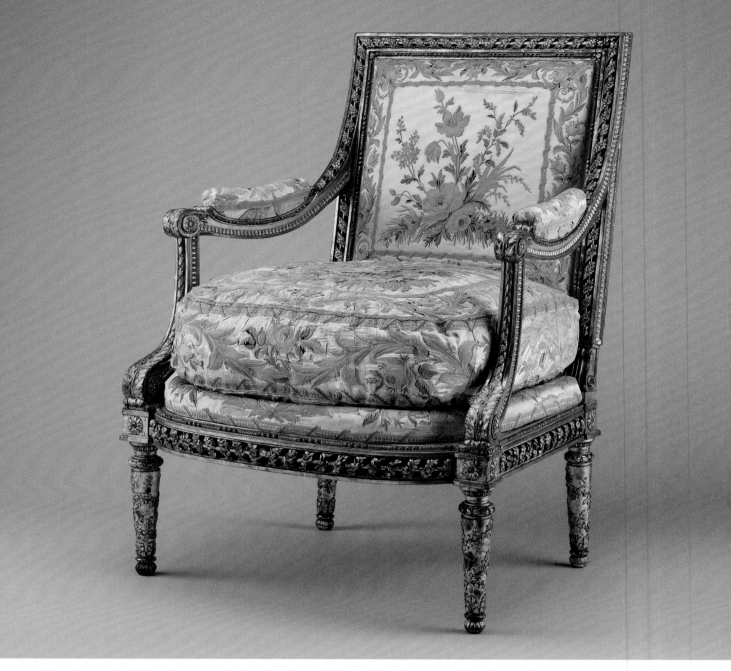

Fig. 4. Georges Jacob (French, 1739–1814). Armchair (*Fauteuil à la reine*). Upholstery possibly embroidered by Joseph François Xavier Baudoin (French, 1739–ca. 1786). French (Paris), 1780–85. Carved and gilded walnut; embroidered silk satin, 40¼ × 29½ × 30⅝ in. (102.2 × 74.9 × 77.8 cm). Gift of Samuel H. Kress Foundation, 1958 (58.75.25)

of the chair. Working most often in walnut or beech, the chair maker was allowed to carve only simple moldings or floral decoration, leaving the more elaborate ornament to a specialized carver (*sculpteur*).

Although chairs could remain in natural wood, waxed or tinted by the *menuisier*, most were meant to be painted or gilded by specialists. Before the actual gilding was done (by the *doreur*), several preparatory layers of gesso were applied on the wood. The so-called repairer (*répareur*) then refreshed some of the carved elements lost under the gesso and added further details. Finally, an upholsterer (*tapissier-garnisseur*) would cover the seat furniture

with leather, silk, velvet, or other materials and attach fine trimmings. It was he who was responsible for selling the completed chairs in his shop and for delivering and arranging them, in his role as interior decorator, in the residences of his customers. Since guild regulations required only the *menuisier* to sign his work, the names of the other craftsmen involved are unfortunately rarely known.

Generally, the decorative and visual arts developed along the same stylistic lines, were enjoyed in identical ecclesiastic and domestic settings, and often elicited similar aesthetic responses from owners or viewers. Whereas the presence of paintings and sculptures may have been restricted to more affluent homes—although pieces of decorative arts could command high prices, as illustrated in the account book of the mid-eighteenth-century Parisian luxury dealer Lazare Duvaux—functional objects were present in virtually every household. If tableware was not made of precious metal or furniture veneered with tropical wood (materials largely reserved for wealthier patrons), then it was executed in less costly pewter or brass or created from local timbers.

That objects are experienced differently from paintings and drawings is easily overlooked in a museum context, where they are kept out of reach and physical encounters are discouraged. Unlike the fine arts, the decorative arts are meant not only to please the eye but also to engage multiple senses, and as such they often prompt a tactile response. For example, the lifting of objects for close examination necessarily provides information about their weight, which, especially for pieces of precious metal, is an indication of value and quality. Clocks appeal to our auditory sense when they fill a room with their rhythmic ticking and chiming or play a short musical phrase to mark the hours. Objects made of aromatic woods, redolent of sweet scents at the time of their creation, were once agreeable to the sense of smell, an aspect largely forgotten as their fragrances faded over time. Other scented pieces were medicinal or prophylactic in nature. Musk paste, for instance, was mixed with gesso to decorate the caskets identified by the term "pastiglia" (gesso molded in low relief), including a fifteenth-century example displaying dancing figures on its front (fig. 5). When the owner carried or used the *cassetta* (small box),

his body heat brought out the scent of musk, which was thought to protect against foul odors believed to carry disease. Even centuries later, certain decorative arts pieces can still elicit an element of surprise, when, for example, the colorful interior of a collector's cabinet is revealed (fig. 6), and the often mind-boggling skills employed in their creation continue to evoke a sense of wonder (see no. 34).

It should be emphasized that not all objects termed "functional" were (or could actually be) used; many were intended solely for display or as symbols of prestige and were valued primarily for their ornamental qualities. The preciousness of the materials, ingenuity of design, high standard of workmanship, and refined decoration disclose as much about the virtuosity of their makers as they do about the status of their owners.

CHANGING VIEWS

With its emphasis on humanism, individualism, and realism, its appreciation of Greek and Roman art, and its introduction of linear perspective, the Renaissance was a time of profound transformation in Europe. Logic and reason as well as the study of the humanities (grammar, history, poetry, and philosophy) were taught at a growing number of universities. A renewed interest in classical

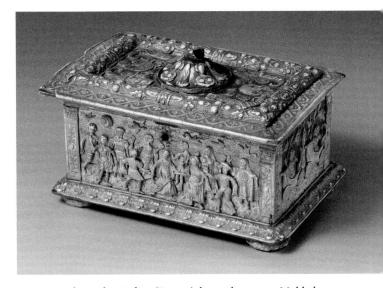

Fig. 5. Pastiglia Casket. Italian (Ferrara), late 15th century. Molded gesso on partly gilded wood, 4⅛ × 6⅜ × 3⅛ in. (10.5 × 16.2 × 7.9 cm). Gift of J. Pierpont Morgan, 1917 (17.190.589)

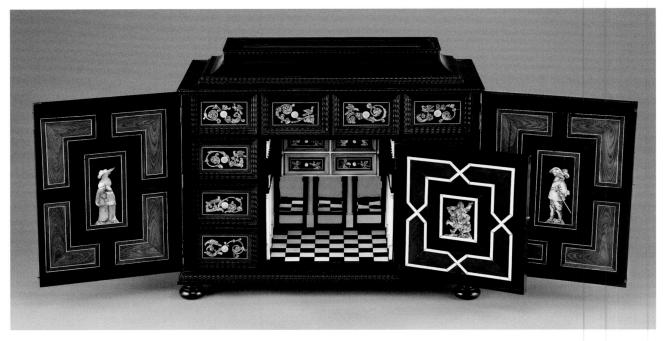

Fig. 6. Attributed to Herman Doomer (Dutch, ca. 1595–1650). Cabinet. Dutch (Amsterdam), ca. 1640–50. Oak veneered with ebony, snakewood, rosewood, kingwood, cedar, and other woods; mother-of-pearl, ivory, and green-stained bone, 27 9/16 × 32 5/16 × 15 3/4 in. (70 × 82.1 × 40 cm). Purchase, Rogers Fund and Joseph Pulitzer Bequest, 2011 (2011.181)

texts and philosophy promoted a worldview no longer exclusively based on religion. The Roman Catholic Church ceded the dominant role it had played during the Middle Ages. Its authority was challenged by Martin Luther, John Calvin, and other Protestant reformers, whose denunciations of the Church's practices, rituals, and abuses (the sale of indulgences, for instance) led to a schism in Western Christianity.

To counteract idolatry, religious images were banned in Protestant churches. Existing altarpieces, stained-glass windows, church furnishings, and liturgical vessels were destroyed in service to the phenomenon known as Iconoclasm. Consequently, commissions of devotional art destined for houses of worship in northern Europe sharply declined in favor of luxury items made for an increasingly prosperous merchant class. However, biblical stories continued to be represented on domestic objects as didactic examples exhorting moral behavior, as in an early seventeenth-century Dutch cabinet embellished with Old Testament scenes (figs. 7 and 8). The theological divide between Protestants and Roman Catholics eventually inspired a revitalization of Catholicism, known as the Counter-Reformation. Convened from 1545 to 1563, the Council of Trent was instrumental in defining and clarifying Church doctrine. Although it could not stop the spread of Protestantism, it did put an end to some of the Church's extravagances and stimulated the creation of compelling, often deeply moving religious art in Catholic countries (fig. 9).

Fig. 7. Detail of fig. 8, showing Joseph fleeing Potiphar's wife (left) and Joseph in prison (right)

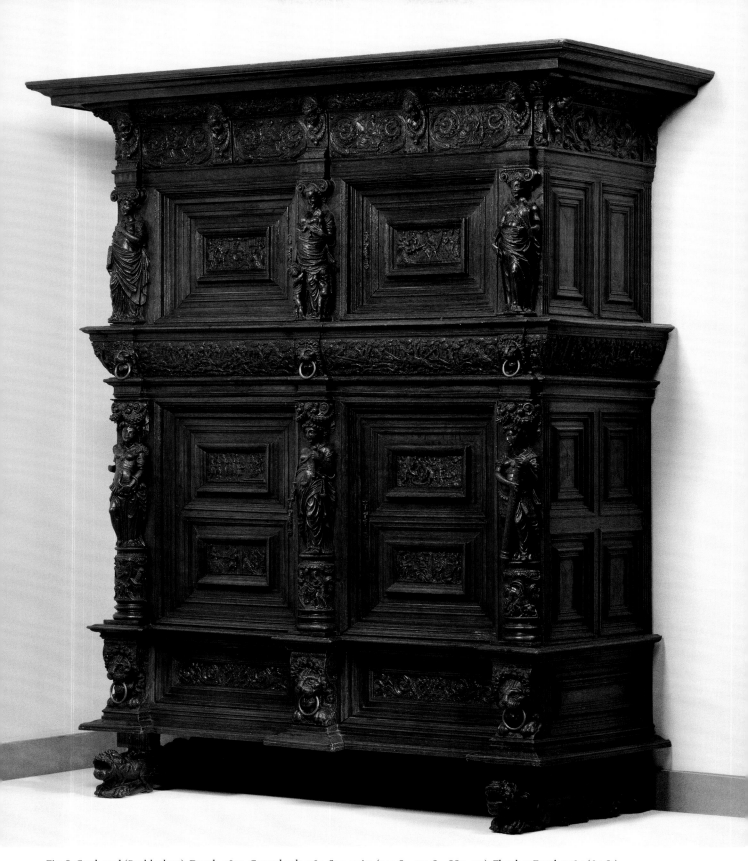

Fig. 8. Cupboard (*Beeldenkast*). Dutch, 1622. Carved oak, 96 × 83 × 35 in. (243.8 × 210.8 × 88.9 cm). Fletcher Fund, 1964 (64.81)

EXCHANGE OF KNOWLEDGE

The invention of the printing press with movable type by the German inventor, printer, and goldsmith Johannes Gutenberg around 1440 greatly increased literacy in Europe. It furthered the advance and dissemination of knowledge about the Scriptures and classical texts but also about the natural world, science, astronomy, biology, and medicine. As research findings and observations were no longer copied by hand but instead accurately reproduced in greater numbers, they could now be shared with a wide audience. Similarly, prints showing ornamental designs were circulated across Europe, spreading awareness of the latest stylistic developments and decorative vocabulary to patrons and craftsmen alike. The exchange

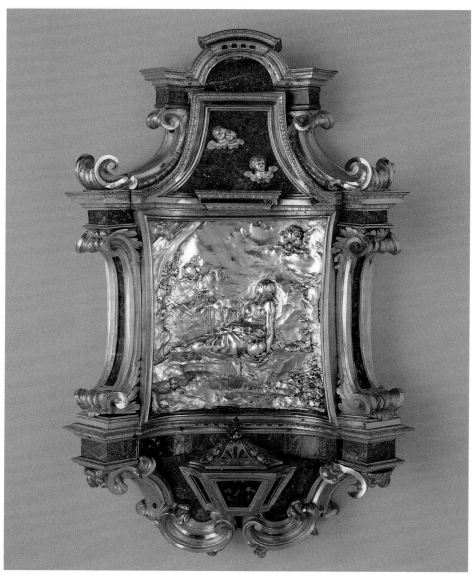

Fig. 9. Giovanni Giardini (Italian, 1646–1722). Holy-Water Stoup with Relief of Mary of Egypt. After a composition by Benedetto Luti (Italian, 1666–1724). Italian (Rome), ca. 1702. Lapis lazuli, silver, and gilded bronze, 23¾ × 14⅜ × 4½ in. (60.3 × 36.5 × 11.4 cm). Wrightsman Fund, 1995 (1995.110)

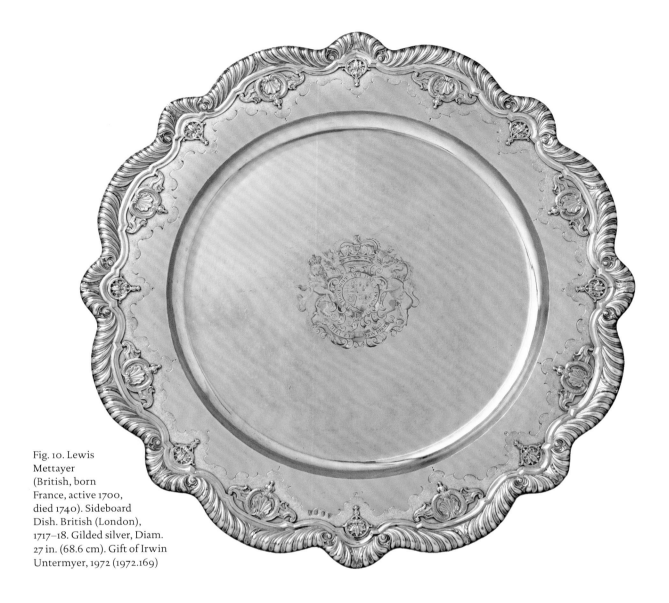

Fig. 10. Lewis Mettayer (British, born France, active 1700, died 1740). Sideboard Dish. British (London), 1717–18. Gilded silver, Diam. 27 in. (68.6 cm). Gift of Irwin Untermyer, 1972 (1972.169)

of ideas, skills, and technical innovations, either through such publications and prints or as a result of diplomatic and individual travel, exerted an important influence on the decorative arts.

Furthermore, immigration caused by wars, religious persecution, economic factors, and particular historical events also had far-reaching effects. A telling example is King Louis XIV's revocation in 1685 of the Edict of Nantes, which for nearly a century had granted limited religious freedom to French Protestants. As a result, some two hundred thousand Huguenots sought refuge abroad. Since many of them specialized in the production of luxury goods such as textiles, furniture, and goldsmith work, this diaspora helped to introduce and disseminate to neighboring countries knowledge of the latest French styles and fashions. This phenomenon is reflected in the decoration of the monumental dish made in London by the Huguenot silversmith Lewis Mettayer (fig. 10).

COMMERCE AND TRADE

From the second century B.C. until the mid-fifteenth century, a series of land and sea trading routes known as the Silk Road connected East and Southeast Asia, the Indian subcontinent, Central Asia, the Middle East, East Africa,

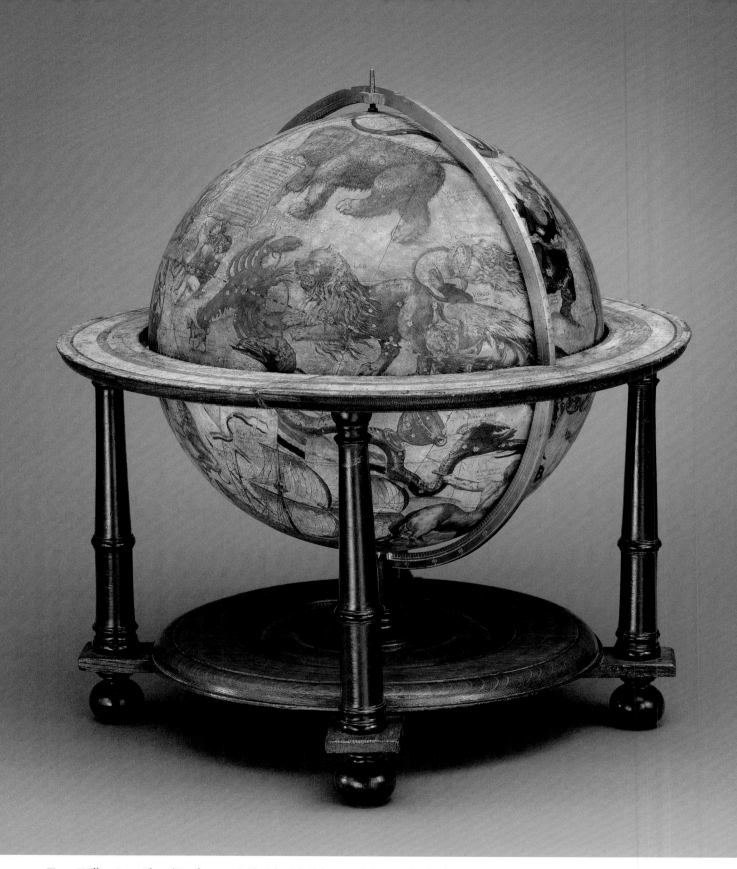

Fig. 11. Willem Jansz Blaeu (Dutch, 1571–1638). Celestial Globe. Dutch (Amsterdam), after 1621. Paper; brass; oak and stained wood, 20½ × 18⅝ in. (52.1 × 47.3 cm). Purchase, Friends of European Sculpture and Decorative Arts Gifts, 1990 (1990.84)

and Europe. This passageway and other commercial networks had historically offered Europeans access to foreign products. When, in the 1500s and 1600s, scientific advancements in cartography and technological improvements in shipbuilding brought about a new era of European overseas expansion, a greater variety and larger quantities of imported luxury goods became available (fig. 11).

The discovery of new commercial sea routes to the Americas, India, and much of East Asia opened the way for European exploration, settlements, and colonization, ushering in a period of cultural and artistic exchange. While the Portuguese initially dominated the profitable spice trade, by the end of the sixteenth century they had to compete with the Dutch, English, and other seafaring Europeans, one of whom was portrayed by Amoy Chinqua in 1719. Rendering a detailed likeness that suggests close observation of the foreign merchant, the Chinese artist depicted the unknown sitter's fashionable wig and clothes with great precision (fig. 12). The various East and West India companies, established for overseas commerce, were more than just global joint-stock and profitmaking enterprises. They also served as *de facto* military powers and governments in the lands they operated in, extracting great wealth and enriching themselves by means of the slave trade and coerced labor. Reflecting their power and affluence, a Japanese porcelain plate inscribed with the *VOC* monogram of the Vereenigde Oost-Indische Compagnie was commissioned for one of the officers of the Dutch East India Company (fig. 13).

The regular import of calicoes, porcelain, lacquer, precious stones, and tropical hardwoods not only transformed taste but also inspired new fashions as their designs and ornamentation were imitated and appropriated in Europe. In addition, the publication of travel books offered a host of illustrations that served as sources for the decoration of ceramics, textiles, and furniture. The availability of new commodities, including coffee, tea, cacao, tobacco, and sugarcane, certainly affected (and sometimes

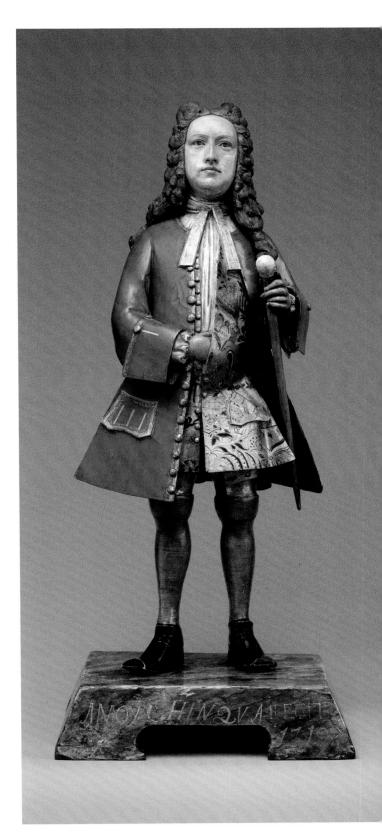

Fig. 12. Amoy Chinqua (Chinese, active 1716–20). *Figure of a European Merchant.* Chinese (Canton), 1719. Polychrome unfired clay and wood, 12¹⁵⁄₁₆ × 5⁹⁄₁₆ × 5⅜ in. (32.9 × 14.1 × 13.7 cm). Purchase, Louis V. Bell, Harris Brisbane Dick, Fletcher, and Rogers Funds and Joseph Pulitzer Bequest and several members of The Chairman's Council Gifts, 2014 (2014.569)

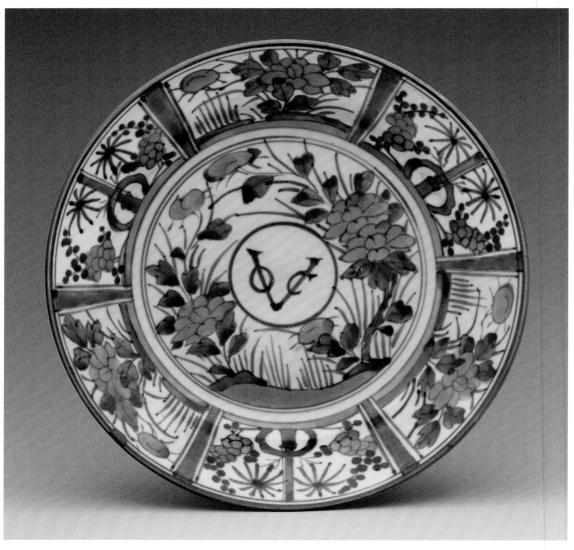

Fig. 13. Plate with *VOC* Monogram of the Dutch East India Company. Japanese (Arita), Edo period, ca. 1660. Underglaze blue (Arita ware), Diam. 12⅜ in. (31.4 cm). Dr. and Mrs. Roger G. Gerry Collection, Bequest of Dr. and Mrs. Roger G. Gerry, 2000 (2002.447.40)

directly spawned) European customs and pastimes such as the establishment of the coffeehouse and the ritual of afternoon tea. These overseas goods required the creation of special, often splendid equipment for their storing, serving, and enjoyment, while the harsh conditions of their colonial production were either ignored by or conveniently unknown to consumers (fig. 14). It is a disturbing reality that seventeenth- and eighteenth-century European decorative arts were enveloped in and profited from the brutal climate of colonialism.

APPRECIATION OF DECORATIVE ARTS

Admiration for "antique" ceramics, metalwork, furniture, and furnishings began to increase in the mid-nineteenth century, when it was felt that such practical pieces could serve as models to inspire modern design and to restore lost aspects of craftsmanship. Alexander Freiherr von Minutoli was one of the first collectors to use his extensive decorative arts holdings to advance these aims. A Prussian civil servant who was dispatched to Liegnitz (now Legnica, Poland) in order to develop and improve local industries,

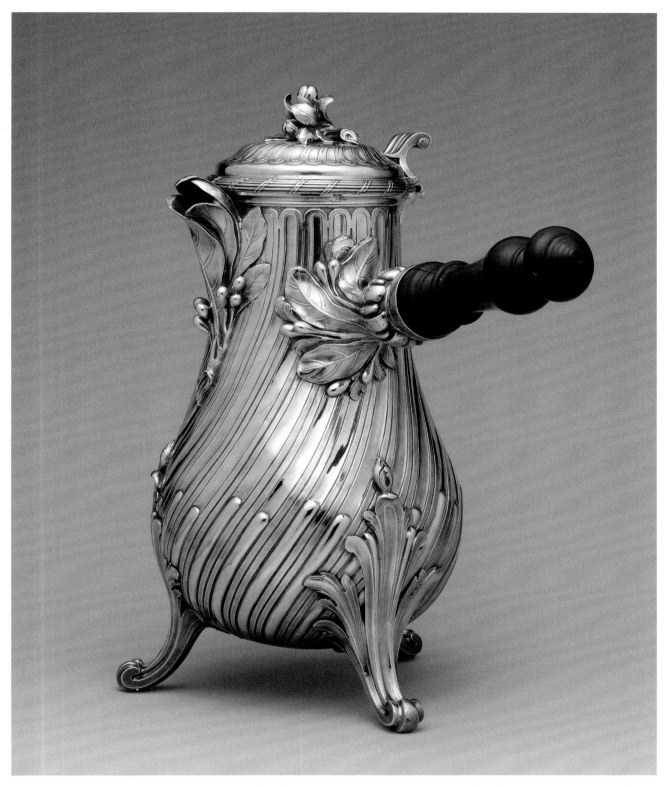

Fig. 14. François Thomas Germain (French, 1726–1791). Coffeepot. French (Paris), 1757. Silver; ebony handle, 11⅝ × 12 in. (29.5 × 30.5 cm). Purchase, Joseph Pulitzer Bequest, 1933 (33.165.1)

Minutoli opened his home there to the public as a private museum in 1844. The following year, his collection was moved to the local castle, and select pieces were lent as practical examples to various Prussian craft schools. Working with the photographer Ludwig Belitski, Minutoli published multiple folios with reproductions of his holdings, making them available to a much wider audience.

The first international display of both modern and historical decorative arts took place at London's Crystal Palace in 1851, although national trade fairs had been held previously, especially in France. Promoting and showcasing prime examples of art and industry from each of the participating countries, this first world's fair, known as "The Great Exhibition," merged artistic, financial, and didactic objectives. The displays, reflecting a sense of national pride, were meant to inspire and teach the public about the achievements of the respective countries that exhibited. The goal of improving modern taste and design thus ignited the desire to educate and instruct. One result was the foundation in London of the South Kensington Museum in 1852 (now the Victoria and Albert Museum). Other European institutions were established after subsequent international expositions, including the Museum für Angewandte Kunst in Vienna and the Museum für Kunst und Gewerbe in Hamburg in 1863 and 1874, respectively.

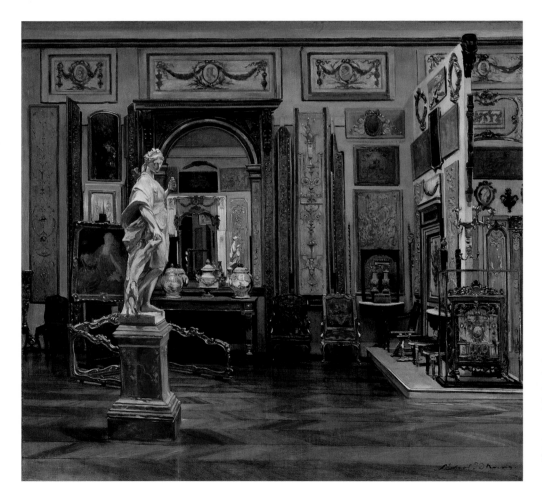

Fig. 15. Léopold Stevens (French, 1866–1935). *Interior View of the Hoentschel Collection at 58, Boulevard Flandrin, Paris*. French (Paris), 1903–6. Oil on canvas, 29^{15}/$_{16}$ × 31^{1}/$_{2}$ in. (76 × 80 cm). Purchase, The James Parker Charitable Foundation Gift, 2019 (2019.55)

The hopes for The Metropolitan Museum of Art were similar. In an address of March 26, 1871, its officers declared that the Museum should amass representative examples of the decorative arts as well as painting and sculpture. It was their intention "to begin at an early day the formation of a collection of industrial art, of objects of utility to which decorative art has been applied, ornamental metal-work, carving in wood, ivory and stone, painted glass, glass vessels, pottery, enamel, and all other materials." Such objects would serve as tasteful specimens for artists and artisans.

To this end, J. Pierpont Morgan, one of The Met's greatest benefactors, who also served as its president, donated to the Museum in 1906 the collection of French paneling, seat furniture, gilded-bronze mounts, and carved fragments that had served as models for the craftsmen and clients of the Parisian interior decorator Georges Hoentschel (fig. 15). This generous gift had a profound impact on the Museum. Not only did the institution derive its initial strength in French art from the Hoentschel collection, but its arrival also spurred the creation in 1907 of a special department for the decorative arts, the first of its kind in North America. Wilhelm R. Valentiner, who had served as the personal assistant to Wilhelm von Bode, director of the Kaiser-Friedrich-Museum (now the Bode Museum) in Berlin, was appointed as the curator of this department, which was the forerunner of today's Department of European Sculpture and Decorative Arts. A special wing was constructed for the display of the newly acquired Hoentschel collection and opened to the public on March 15, 1910. Over the years, exceptional gifts and bequests, as well as judicious purchases, have made The Met collection of decorative arts one of the foremost in the world.

Drawing upon the Museum's holdings, this book presents decorative arts created during the early modern period, spanning approximately from 1500 to 1800—basically from the High Renaissance until the Age of Enlightenment and the Industrial Revolution. The pieces range from furniture to tableware and from objects of personal adornment to timepieces. At once beautiful and (largely) functional, these works reflect both the geographical diversity of the collection and the rich variety of the materials and techniques it encompasses.

Collected since The Met's inception, the decorative arts have been exhibited and studied at the Museum for more than a century and a half and are enjoyed by thousands of visitors each year. Elevated from "useful" wares to prized museum displays, these works are tangible manifestations of the past that tell important and fascinating stories, certain aspects of which have long been ignored. It is hoped that this volume will inspire a broader understanding and appreciation of the individual works presented here and the often anonymous artists and craftsmen who created them.

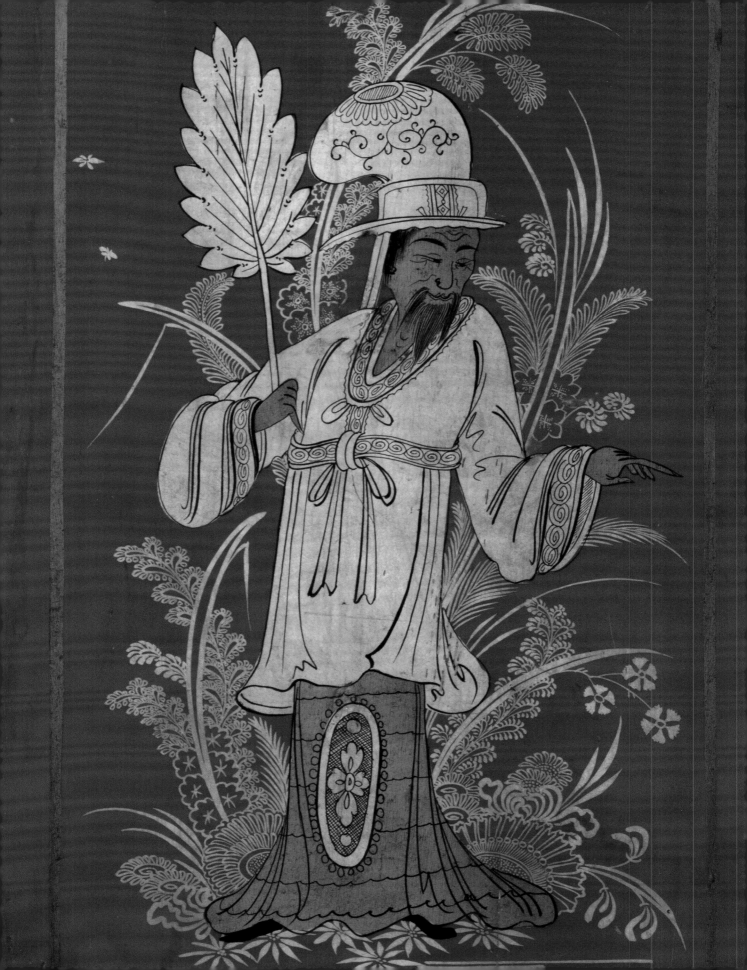

Furniture and
Furnishings

Pietre Dure Tabletop

Italian (Rome), early 17th century
Marble, alabaster, lapis lazuli, and other hardstones; modern walnut support,
54⁵⁄₁₆ × 94⁷⁄₈ in. (138 × 241 cm)
Gift of Mr. and Mrs. Francis J. Trecker, 1962 (62.259)

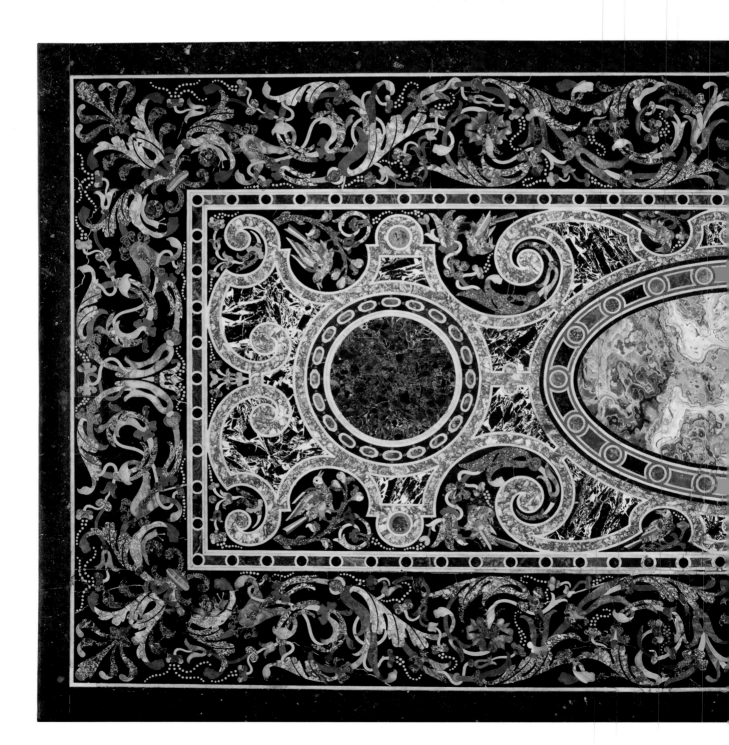

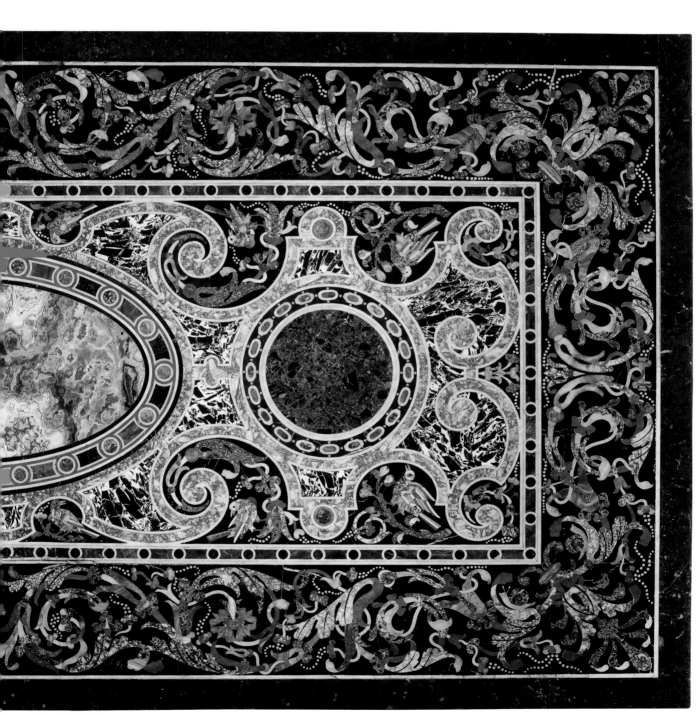

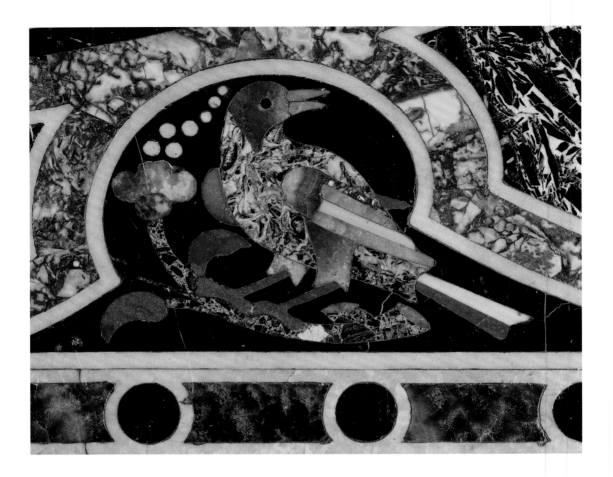

Upcycling is not solely a modern concept: materials have been salvaged and repurposed for centuries, as this tabletop brilliantly illustrates. Its inlaid decoration consists mainly of marble as well as some semiprecious stones that probably originated in ancient Rome. During the sixteenth and seventeenth centuries, these rare, colorful stones, relics of classical antiquity, were considered beautiful specimens of God's creation and were turned into new artworks perceived to be of even greater quality than those from which they derived.

In a technique known as *opus sectile* (cut work), decorative patterns of vibrant stones were used in the ancient past to embellish the floors and walls of both public and private buildings. Remains of such *opus sectile* work provided ample material for stone inlay, or intarsia, work. Although never lost, the technique was revived in Italy during the sixteenth century with great ingenuity and

refinement. Generally known as *pietre dure* (hardstones), stone intarsia was practiced in both Rome and Florence. Unlike a "proper" mosaic, which consists of small stone cubes (*tesserae*) of the same dimensions, this impressive tabletop employs thin pieces of complex shapes and different sizes (*laminae*). Cut from semiprecious hardstones and softer varieties of marble valued for their vivid colors or striking veining, these segments are set into a dark marble ground.

The provenance of the tabletop, which was intended for display rather than for dining, is not known. However, several distinct characteristics point to a Roman origin. While figurative representations were the trademark of Florentine *pietre dure* work, the choice of individual slabs of eye-catching stones was typical for tables produced in Rome. In this case, an oval panel of alabaster, selected for its attractive natural pattern, is flanked by

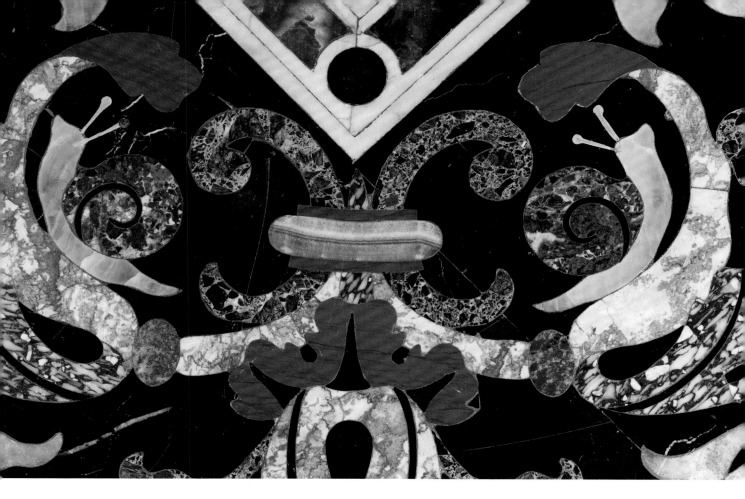

two smaller roundels of *breccia di Tivoli* (or *Quintilina*) marble. This Italian marble, believed to have been quarried in Levanto, Liguria, was highly prized for its variegated colors. Placed within a rectangular field, these main elements are mounted like gems in their own "jewel"-encrusted frames, which are also seen on other Roman examples. The white marble outlines used for the scrolling strapwork, executed in *broccatello di Spagna* (a yellow limestone quarried in Spain), and for other decorative details are another Roman feature.

Marble streaked with black and white, so-called *bianco* and *nero* marble, forms the background of the strapwork cartouches, while birds perched on flowering branches decorate the surrounding area. The birds' orange beaks and black eyes as well as the distinctly executed feathers on their bodies, wings, and tails indicate that the pieces of stone have been carefully chosen to render the creatures as naturalistic as possible. The wide outer border with a dense pattern of scrolling acanthus foliage and stylized flowers derives from Roman mosaics.

To achieve a sense of depth and three-dimensionality, the curving tips of the acanthus leaves are carried out in variously colored stones. Particularly noteworthy are the blooms with long pistils resembling strings of pearls. At the four corners, pairs of snails glide through the scrolling foliage. Similar mollusks occur on several other closely related tabletops, including one at the Palazzo Ducale, Mantua, all of which are likely to have originated in the same Roman workshop. The original supports, perhaps of carved marble, cast bronze, or solid wood to accommodate the immense weight of the intarsia top, have not been preserved. With its geometrical design and its broad decorative border, the table truly resembles a carpet in stone.

2

Cabinet on Stand

Attributed to Jan van Mekeren (Dutch, 1658–1733)
Dutch (Amsterdam), ca. 1700–1710
Oak veneered with rosewood, olive wood, ebony, holly, kingwood, tulipwood, barberry,
and other partly stained marquetry woods, 70¼ × 53⅞ × 22⁷/₁₆ in. (178.4 × 136.8 × 57 cm)
Ruth and Victoria Blumka Fund, 1995 (1995.371a, b)

Seventeenth-century inventories of prosperous Dutch households indicate the presence of a large quantity of linens of high monetary value. Forming an important part of a bride's trousseau, these carefully folded textiles were locked away in a precious *kast* (cupboard). By the end of the century, imposing Baroque cupboards, such as the one seen in a painting by Pieter de Hooch (fig. 16), had been replaced by much simpler case pieces supported on a table stand, as this cabinet is. With its nearly flat front and sides, this new type of cabinet had a boxy shape that allowed for a striking display of floral marquetry.

Dutch cabinetmakers had been stimulated to employ marquetry—the embellishment of furniture with veneers chosen for their unusual color or grain—by the overseas trade conducted by the Dutch East and West India companies. Founded in 1602 and 1621, respectively, these establishments imported nonindigenous luxury woods that were harvested in the colonies by slave or otherwise coerced labor. Earlier, in the mid-sixteenth century, the invention of the fretsaw had enabled the woodworker to cut more delicate patterns and intricate curves than previously possible. This new tool permitted the execution of

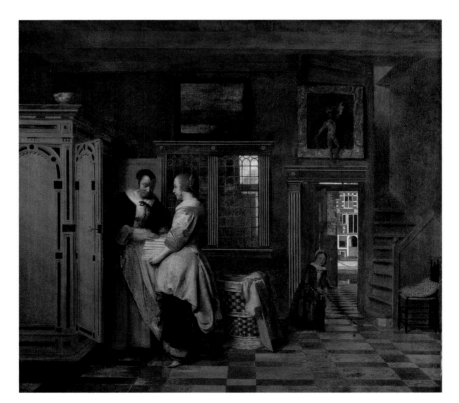

Fig. 16. Pieter de Hooch (Dutch, 1629–1684). *Interior with Women beside a Linen Cupboard.* Dutch (Amsterdam), 1663. Oil on canvas, 27⁹/₁₆ × 29¹¹/₁₆ in. (70 × 75.5 cm). Rijksmuseum, Amsterdam (SK-C-1191)

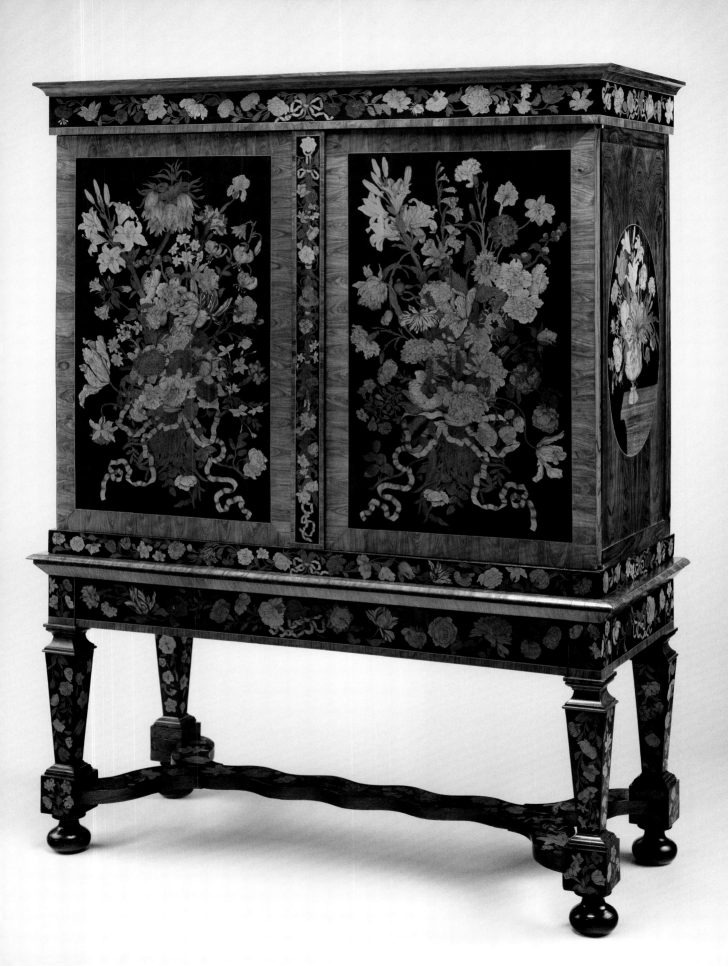

to a drawing affixed on top, resulting in as many identical flowers as there were layers in the packet. Variation was obtained by arranging the veneers in different ways and sometimes by turning a bloom over to reverse the design.

Instead of inlaying the floral decoration directly into solid wood, the marquetry was glued like a mosaic onto the cabinet's oak substrate. To heighten the naturalism of the decoration, the cabinetmaker carefully selected the woods such as the bright yellow barberry for the daffodils and crown imperial here. He also enhanced the nearly white holly wood with evanescent organic dyes made from plant extracts. These have almost completely vanished over time: only the green stain of the stems and leaves, based on copper salts, has retained some of its original color. The door panels received the most attention. Their two large, ribbon-tied arrangements of once brightly colored flowers against an ebony ground compare favorably both to seventeenth-century still lifes and to *pietre dure* compositions (fig. 17; see also no. 1).

Although the Guild of Saint Joseph in Amsterdam stipulated in 1624 that all cabinetmakers offering goods for sale in the company's shop had to mark their wares, this cabinet is unsigned. It has been attributed, together with a group of similar case pieces and several tables, to Jan van Mekeren, who is known to have created exquisite floral marquetry for the Dutch elite.

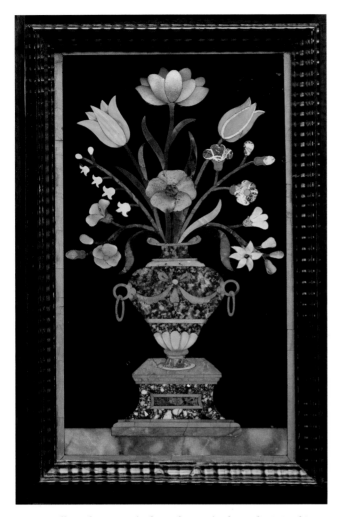

Fig. 17. Galleria dei Lavori (Italian, Florence). The Barberini Cabinet (detail). Italian (Florence), ca. 1606–23. Oak and poplar veneered with various exotic hardwoods, ebony moldings; plaques of marble and slate; *pietre dure* work of colored marbles, rock crystal, and various hardstones, 23¼ × 38⅛ × 14⅛ in. (59.1 × 96.8 × 35.9 cm). Wrightsman Fund, 1988 (1988.19)

increasingly complex designs and led to full-fledged pictorial representations such as the exuberant bouquets on this cabinet. Each of the flowers consists of multiple parts made from variously colored or tinted woods. Rather than sawing individual elements, the woodworker cut a packet of thin veneers that were glued together according

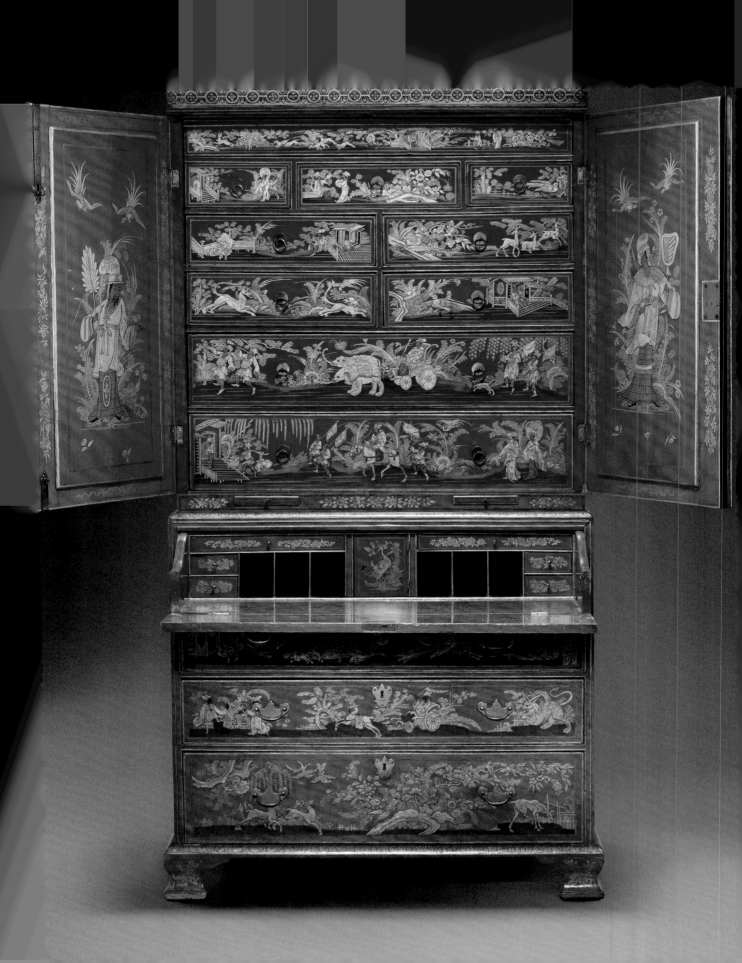

Secretary Cabinet

British, ca. 1735
Oak, pine, and walnut decorated in red, gold, and silver japanning;
brass; mirror glass, 81 × 41¼ × 22 in. (205.7 × 104.8 × 55.9 cm)
Purchase, Acquisitions Benefit Fund 2013; Gift of Mrs. Edward Karfiol, in memory of Edward Karfiol;
Gift of Bernard M. Baruch, in memory of his wife, Annie Griffen Baruch; and Gifts of Irwin Untermyer,
George Blumenthal and Mrs. Russell Sage, by exchange, 2014 (2014.186a, b)

"Chinoiserie," a style fashionable during the seventeenth and eighteenth centuries, evolved across various decorative arts media as newly established trade routes made hitherto little-known commodities, such as Asian porcelain and lacquer, more readily available in Europe. Although individual objects like this two-part secretary cabinet decorated in imitation of Asian lacquer may not have been created with a specific racial reference, the use of Asian-inspired imagery can nevertheless be troubling. Chinoiserie is based on Eurocentric stereotypes and reflects an imperialistic perception of the Far East and its people. It reduces Chinese culture to a series of mere decorative motifs, such as dragons and exotically dressed figures, that are unconnected to the culture and history of the country.

The Dutch East India Company regularly shipped lacquer screens, chests, and cabinets to Europe. However, as the market for such objects steadily grew, these goods were also actively copied. Lacquered furnishings presented a particular challenge because the main ingredient of Asian lacquer, sap from the tree *Toxicodendron vernicifluum*, was not available in Europe and could not be exported because it hardened quickly when exposed to air. Furthermore, the process of making genuine lacquer long remained unknown. In their attempts to achieve a similar effect, European craftsmen used various varnishes, including shellac, composed of an imported resin deposited by lac insects on trees in India and Thailand.

The technique of making these imitations, which were popular in England, was known as "japanning" since lacquer from Japan was considered superior to that from China. Special manuals on the process were published, such as John Stalker and George Parker's *Treatise of Japaning and Varnishing* (London, 1688), which contained practical information on how to make lacquerlike varnishes along with useful designs for the decoration of furniture. That the vogue for japanning remained strong during the eighteenth century is evidenced by the handbook published in London in 1730 by a certain Mrs. Artlove (presumably a pseudonym), *The Art of Japanning, Varnishing, Pollishing, and Gilding: Being a Collection of Very Plain Directions and Receipts*. The subtitle of the treatise, *Written for the Use of Those Who Have a Mind to Follow Those Diverting and Useful Amusements, and Published at the Request of Several Ladies of Distinction*, indicates that it was intended primarily for the amateur, as japanning had become a fashionable occupation for young ladies.

Nevertheless, the vibrant vermilion-red japanning on this cabinet, which is surprisingly simple in shape and construction, is most certainly the work of a professional. The lively decoration, executed in gold and silver with details painted in black, has been applied either directly to the vermilion color or to a slightly raised gesso ground. The anonymous artist has treated the cabinet's flat surfaces as a brilliant canvas for the highly accomplished, bold compositions, which are particularly well preserved on the interior. Although no specific iconographical program can be discerned, the artist must have been familiar with Chinese art. The female figure holding a fan on the inside of one of the doors, for instance, appears to be based on Yang Guifei, the beautiful consort of the Tang emperor Xuanzong, while the animals on the lower

exterior sides are so-called *qilin*, mythical creatures with dragons' heads (fig. 18).

While initially the lacquered imitations closely copied the imported prototypes in shape, during the eighteenth century more fashionable European furniture types were japanned, including this secretary cabinet. Its lower section is fitted with three large drawers, and instead of the more common sloping front, there is a simulated fourth drawer that opens up to provide a writing surface.

The upper section has two mirrored doors enclosing an arrangement of ten drawers of different sizes, including a spring-operated "secret drawer" at the top, access to which was gained only by removing the central drawer below. A pair of pull-out slides just below the doors offered a space for candles, whose flames were reflected in the mirrors above. This piece would certainly have added a brilliant touch of color to the subdued walnut furnishings of contemporary British interiors.

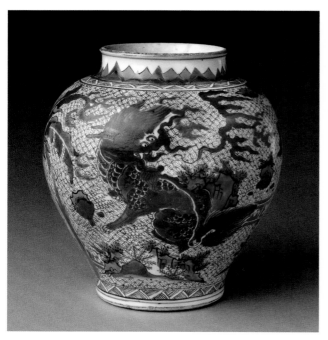

Fig. 18. Jar with Mythical *Qilin*. Chinese (Jingdezhen), mid-17th century. Porcelain painted with colored enamels over transparent glaze (Jingdezhen ware), H. 14½ in. (36.8 cm), Diam. 9½ in. (24.1 cm). Rogers Fund, 1919 (19.28.2a, b)

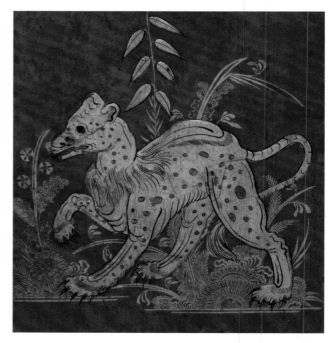

Detail of cabinet, showing *qilin*

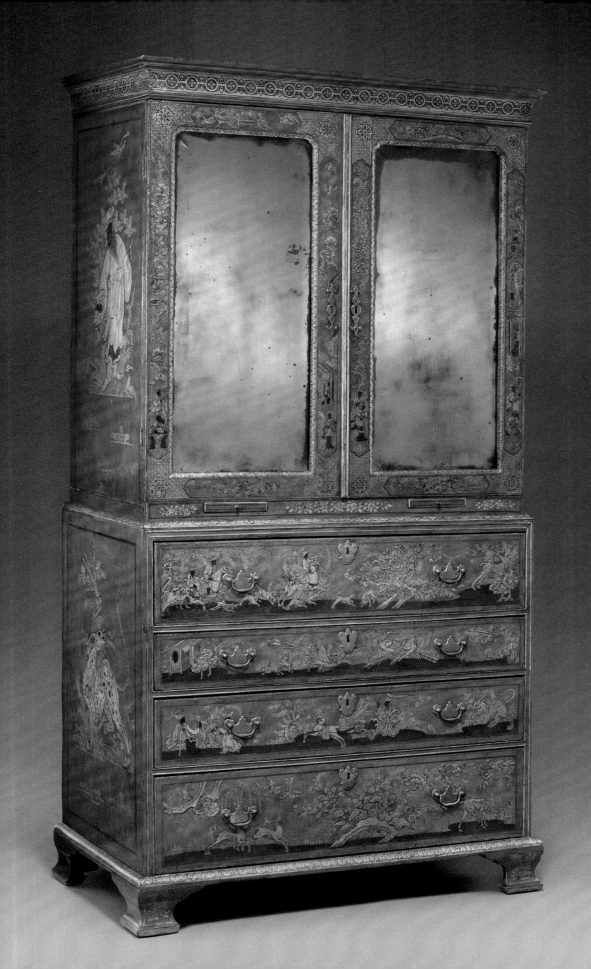

4

Pair of Two-Light Wall Brackets

French (Paris), ca. 1750
Gilded bronze, (each) 15½ × 12½ × 6 in. (39.4 × 31.8 × 15.2 cm)
The Lesley and Emma Sheafer Collection, Bequest of Emma A. Sheafer, 1973 (1974.356.214, .215)

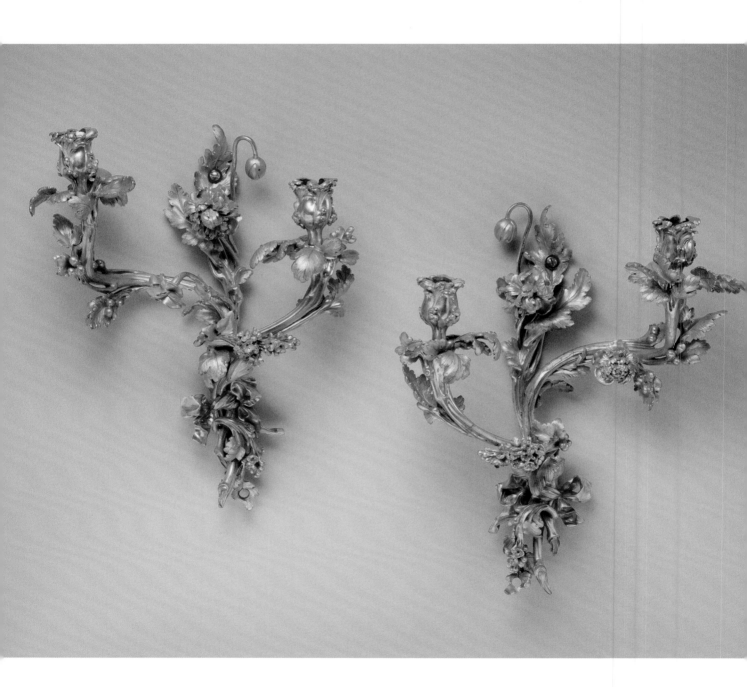

This pair of elegant wall lights stunningly demonstrates the exceptional achievements of eighteenth-century Parisian metalworkers in the art of gilded bronze. Considered the apex of fashion and at times rivaling the products of the goldsmith's art, French bronzes were prized by affluent domestic and foreign customers alike. High-quality gilded-bronze objects have survived in large numbers because, unlike those of precious metals, their melt value is insignificant. Most of the extant examples are anonymous, since the craftsmen rarely signed their works, which were retailed in the Parisian luxury shops of the *marchands merciers*, entrepreneurs who combined the functions of modern-day dealers, tastemakers, and interior decorators.

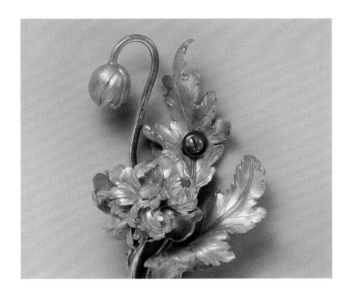

Both functional and exceedingly decorative, gilded bronze was an important element in French eighteenth-century interiors, where it was used extensively for lighting, andirons and fireplace fittings, clock cases, door and window hardware, and porcelain and furniture mounts. The manufacturing process of these so-called *bronzes d'ameublement* was truly a collaborative effort, involving designers, sculptors, modelers, and metalworkers. The latter, to maintain their high standards of craftsmanship, were divided into two guilds: the *fondeurs-ciseleurs* (casters-chasers) and the *ciseleurs-doreurs* (chasers-gilders).

Working from a drawing for an object of simple design, a carver or sculptor would make a three-dimensional model in wood, clay, or wax. For wall lights cast in multiple parts, wax molds were created for each element and pressed into a box filled with sand. The caster would then pour molten bronze, a copper alloy, into the resulting indentations. Once the metal cooled and hardened, any imperfections in the rough cast were removed in a process called *réparure* (repair).

The actual finishing of the wall brackets was done by a *ciseleur* (chaser), who tooled the bronzes to achieve areas that were smooth as well as various finely or coarsely textured surfaces. This was a very important stage in the production because the chasing lent the objects great vitality through the variable ways in which the different finishes captured the light. Adding a substantial expense to the overall cost was the gilding. In this process, the lighting fixtures were coated with a mixture of mercury and ground gold, hence the name "*or moulu*" (ormolu), and then heated over an open fire. The gold adhered to the metal, while the mercury evaporated, creating fumes that could be dangerous to the gilder. These steps were repeated several times until a gold layer of sufficient thickness was achieved. The gilded surface could be left matte, burnished with a heliotrope stone, or, as beautifully demonstrated on these wall lights, finished with a combination of the two methods.

The plasticity of the gilded-bronze medium lent itself well to asymmetric shapes, playfully curving lines, and naturalistic motifs—all characteristics of the Rococo style on full display here. The scrolling arms of the wall lights spring organically from interlaced sprays of berried foliage, lilacs, and peonies entwined with a ribbon. The poppies on the central stem, a symbol of sleep, suggest that the pair may have been intended for a bedchamber or, given their small size, perhaps for a bed alcove. Such wall lights were often placed on either side of a mirror so that the flames of their candles reflected and multiplied in the glass.

5

Commode

Pietro Piffetti (Italian, 1701–1777)
Gilded-bronze mounts attributed to Francesco Ladatte (Italian, 1706–1787)
Italian (Turin), ca. 1760
Marquetry of ebony, boxwood, burr walnut, and fruitwood; poplar carcass;
gilded-bronze mounts; iron locks, $32^{15}/_{16} \times 49^{3}/_{16} \times 23^{7}/_{8}$ in. (83.7 × 125 × 60.6 cm)
Bequest of Errol M. Rudman, 2020 (2020.371)

Together with its identical counterpart, this commode, or chest of drawers, was offered at a lottery held on November 30, 1779, to benefit the Hospice of the Catechumens in Turin. The fourteen lots comprised furniture left by the cabinetmaker Pietro Piffetti at his death. It is interesting that each of these two case pieces was still described in the lottery's leaflet as a "*burreau*," or writing table. In France, when the commode was introduced during the first decade of the eighteenth century, it was referred to either by that term or as *bureau commode*. By way of example, in 1718, Elisabeth Charlotte, duchesse d'Orléans, explained in her correspondence that a commode was "a large table with large drawers . . . with beautiful ornaments." Initially, the commode was restricted to the bedroom and dressing room, where it replaced the chest or coffer as a storage piece. However, by the middle of the eighteenth century, its popularity had spread, and a pair of commodes was often placed in French drawing rooms as decorative rather than practical pieces. The chests were also widely adopted in other European countries, including Italy.

Fitted with four drawers, this Piedmontese commode has an overall *bombé* shape, with an outward-swelling front and sides and an inward-curving base, that displays influences from French Rococo furniture. This was not unusual for craftsmanship from the region since northwestern Italy had close connections with France (see no. 18). Yet, its elegant, almost theatrical form shows a greater exuberance than was customary in Paris and clearly distinguishes it from its French prototype.

Piffetti, who was appointed in 1731 as cabinetmaker to Carlo Emanuele III, duke of Savoy and king of Sardinia, is considered the most distinguished Italian cabinetmaker of the eighteenth century. Born in Turin, the artist spent nearly his entire career there, creating extravagant furniture and furnishings for the Palazzo Reale and the Stupinigi hunting lodge. Piffetti's pieces are richly and profusely decorated (to the point of *horror vacui*) with tropical woods, mother-of-pearl, and engraved and sometimes tinted ivory.

Compared with earlier work by Piffetti, this commode is a model of restraint in its decoration, while displaying the cabinetmaker's typical flair for contrasting color. Marquetry of mostly local woods, except for the ebony, embellishes its exterior. Scrolling ribbons and more linear strapwork of boxwood (originally white or light yellow before darkening) paired with ebony are highlighted against a burr walnut ground. Although Piffetti employed similar ornamentation as a framing device elsewhere, here it constitutes the main and quite striking decoration. Also noteworthy are the trompe l'oeil acanthus leaves playfully overlapping the ribbons underneath the frieze and the pear-shaped cabochon on the front feet. Piffetti uniquely made use of small, dark wooden pegs to adhere the burr walnut veneer to the commode's sinuous body. The top of this example, unlike the marble slabs of French models, is decorated with marquetry, presenting a frame of scrolling ribbons that encloses a floral arrangement of roses, peonies, lilies, and honeysuckle flowers in a two-handled urn.

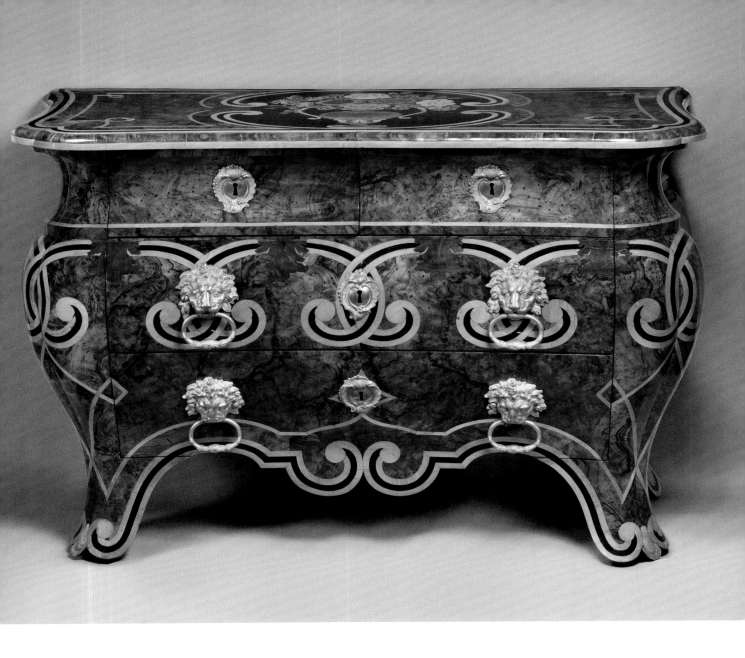

Whereas the bold, curvilinear lines of this commode still fully embrace the Rococo aesthetic, the simple lines of the strapwork and gilded-bronze drawer handles foreshadow the advent of the more austere Neoclassical style. Described in the 1779 lottery catalogue as "lions' heads carrying rings in their mouths" (*teste di Leoni portanti anelli in bocca*), these handles have been attributed to the French-trained sculptor Francesco Ladatte.

It is not entirely clear if the pair of commodes was part of Piffetti's stock or among his personal belongings. Whichever the case, this remarkable piece of furniture is a testament to the cabinetmaker's exceptional skill and rich imagination.

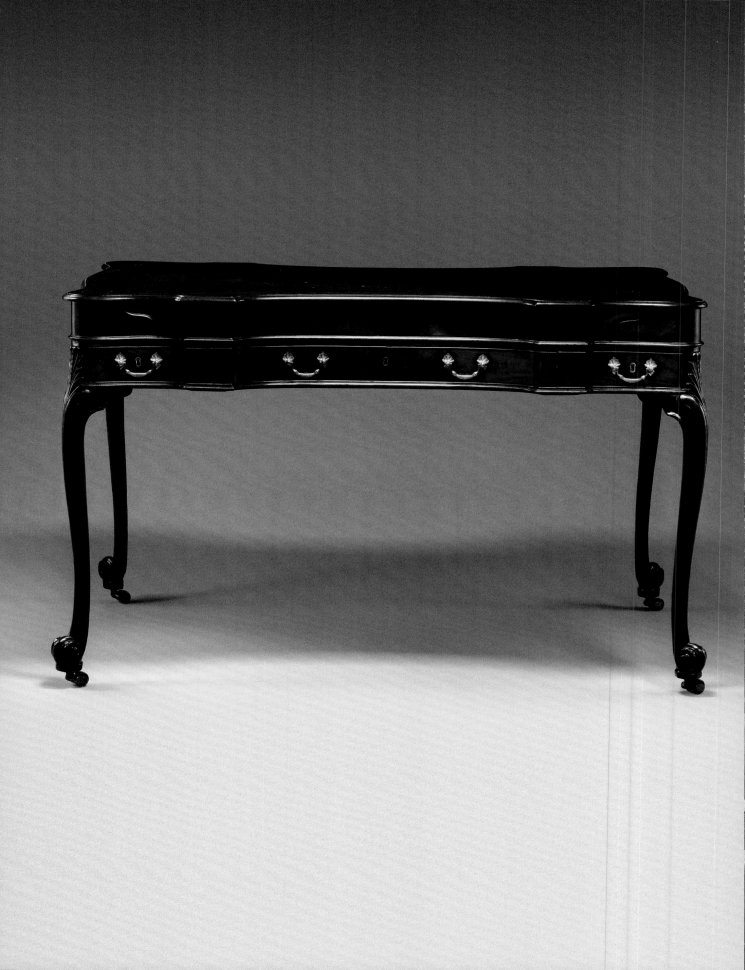

Writing Table

Attributed to William Vile (British, 1700–1767)
British (London), ca. 1761
Mahogany and oak; lacquered-brass hardware; modern baize lining,
32¾ × 50¾ × 32½ in. (83.2 × 128.9 × 82.6 cm)
Purchase, Morris Loeb Bequest, by exchange, Bequest of Annie C. Kane, by exchange,
Bequest of Mary Mandeville Johnston, from the collection of Mr. and Mrs. Edward W. S. Johnston,
by exchange, Gifts of Mrs. William C. Breed and Mr. and Mrs. Leslie R. Samuels, by exchange,
The Helen and Carleton Macy Collection, Gift of Carleton Macy, by exchange,
and Gift of Mrs. Paul Moore, by exchange, 2017 (2017.665)

Nowhere in eighteenth-century Europe was mahogany used so extensively and brilliantly as in Britain, but it came at a devastating cost. The timber was harvested in West Indian rain forests by enslaved Africans under appalling conditions. This felling of trees led to the deforestation of the West Indian islands and thus to extensive environmental and ecological damage. Moreover, the cleared land was often used for sugar cultivation, which relied once again on an enslaved workforce. While the first mahogany logs were imported into Britain on a limited scale, the timber became more available during the 1720s and began to replace walnut in the production of furniture. The hardness and durability of mahogany and the fact that it is largely warp- and insect-resistant enhanced its appeal.

Notwithstanding the harsh circumstances surrounding the harvest of the material, this writing table beautifully illustrates the great attraction of the tropical hardwood. The sparing use of carved ornament allows attention to be focused on the lustrous figured mahogany with its deep, reddish-brown color. The beading around the outer edges of the top and frieze combines with the moldings of the legs to subtly emphasize the table's sinuous form.

The hinged top, made from a single solid board, must have come from a massive, age-old tree. When lifted up and doubled over, it reveals a writing surface enclosed by raised rails on three sides. The scrolled feet of the slender cabriole legs are fitted with castors that, along with the lacquered brass handles on the sides, allow the piece to be moved and the top to be unfolded. However, given the size and weight of the top, the table cannot be opened by a single person, which renders it impractical for frequent use. The frieze in front is fitted with three lockable drawers: two short ones flanking a long one for the storage of documents and writing implements. The reverse side also contains two short drawers but has a dummy or sham drawer front in the middle.

Mechanical furniture, which could be ingeniously transformed to serve different functions, was very popular in France and Germany, where a number of cabinetmakers created outstanding pieces. In Britain, this kind of furniture was less common, but William Vile, one of the best London cabinetmakers (to whom this piece is attributed), made several tables of an unusual design that could qualify as such. On May 8, 1761, for instance, he charged the 6th Earl of Coventry, at Croome Court, Worcester, £10 for a "Good Mahogy Table on Castors, with folding Tops . . . Lin'd with blue Leather." The current whereabouts of this table are not known, but another, well-documented and related one, was supplied to Queen Charlotte in 1763 and remains in the Royal Collection today. Given the close similarities between the latter and The Met table, both were very likely made in the same workshop.

Vile's furniture stands out not only for its high quality but also for the individuality of its design, which departs from a more conventional stylistic vocabulary, as this writing table demonstrates. The curvilinear shape of this elegant table embodies the assertion of the artist and satirist William Hogarth that "the serpentine line, as the human form, . . . hath the power of super-adding grace to beauty."

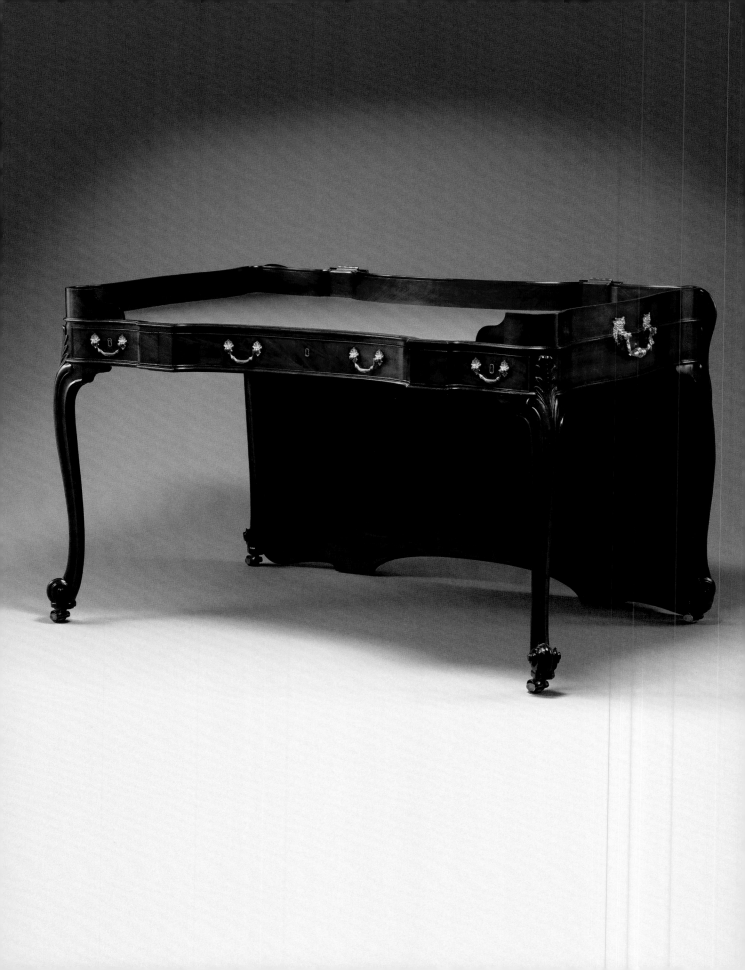

Mantel Clock with Musical Movement

Jean Baptiste André Furet (French, ca. 1720–1807)
French (Paris), ca. 1784
Case: gilded and lacquered bronze and marble; Movement (in bust): brass and steel
with enameled hour and minute chapter rings (in head); Miniature organ with pipes
and bellows (in base): brass, steel, and leather, 29 × 16¼ × 9 in. (73.7 × 41.3 × 22.9 cm)
Gift of Samuel H. Kress Foundation, 1958 (58.75.127)

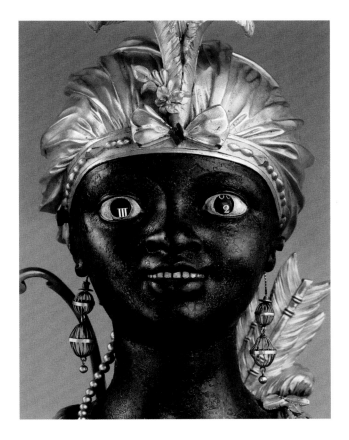

Novelty inevitably attracts attention, and this was certainly no different in the late eighteenth century. In July 1784, a clock of this model was among three extraordinary timepieces on display in the shop window of an esteemed Parisian clockmaker. According to the anonymous chronicle *Mémoires secrets*, these objects provoked much interest: "One goes to see at the watchmaker M. Furet three clocks of very unusual composition. The first represents the bust of a Black woman whose head is exceptionally made.... Upon pulling one [earring] the hour is described in the right eye and the minutes in the left. Upon pulling the other a musical movement plays a succession of airs." The clock, which is signed *Furet H^{ger} du Roi* (Furet Clockmaker to the King), could also be activated automatically as the hour struck, and the tunes it played were produced on a spring-driven cylinder organ hidden in its base. That at least five of these highly unusual timepieces were created, one of which was acquired for Queen Marie Antoinette, indicates the high regard in which the objects were held.

Automata, mechanical devices that could move or perform certain tasks, were eagerly collected in sixteenth- and seventeenth-century Europe. Such man-made artworks (*artificialia*) joined products of nature (*naturalia*), ethnographic artifacts, and archaeological pieces in the cabinets of curiosities known as *Kunst- und Wunderkammern* (see no. 34). The technological ingenuity of this timepiece illustrates the continued interest in scientific measurements during the Age of Enlightenment. To satisfy the demand for new and different models, French clockmakers frequently employed mythological or allegorical figures to decorate their cases. The choice of a Black figure for a bust, however, is unusual and conveys a racialized narrative.

Actively involved in the slave trade, France shipped thousands of Africans to its overseas colonies to serve as a workforce for the production of sugar, coffee, cotton, and tobacco. While emancipation decrees of 1571 and 1691

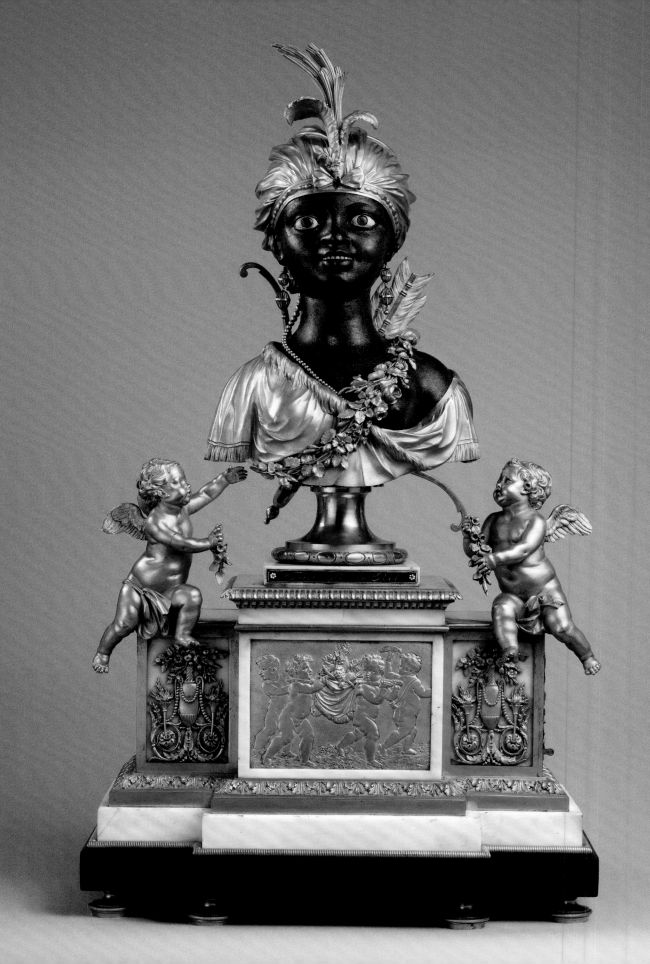

promised slaves their freedom upon arrival in France, these edicts were routinely ignored during the eighteenth century when plantation owners returned to Europe with their servants. In fact, various French laws issued at the time show an increasingly prejudiced attitude toward non-Europeans. Legislation in 1777 went as far as to forbid *gens de couleur* (people of color) from entering the country. Viewed in the context of French colonialism, this clock's mechanism presses the woman into a twofold servitude—not only to tell time but also to amuse its owners—and, in so doing, cleverly but cruelly reflects the bias of the period.

With the extravagantly bejeweled turban and garment baring the shoulder and breast, the bust evokes the exoticized (and eroticized) Black female servant frequently depicted in Western fantasies of Near Eastern and North African harem scenes. The slightly parted lips, suggestive of sensuality, illustrate European presumptions as to the inherent lasciviousness of women of color. In this light, the clock could be understood as an expression of Turquerie, the fascination with Turkish culture fueled by travel reports, Ottoman embassies, and descriptions in the influential *Thousand and One Nights*, first published in French between 1704 and 1717.

Turquerie influenced all aspects of eighteenth-century arts, from dress to operas, plays to portraiture, and even architecture. In the last quarter of the century, *boudoirs* and *cabinets turcs*, small private rooms in the Turkish style, were made for Marie Antoinette and her brother-in-law the comte d'Artois at the palaces of Versailles and Fontainebleau. Decorated with camels, turbaned pashas, crescent moons, and pearl motifs, these interiors show a fictionalized and idealized view of the Near East as a place of fabled luxury and riches—if not of assignations and intrigue. This musical mantel clock would have been a fitting object for such a setting, sustaining prevailing imperialistic prejudices while presenting itself as an ostensibly "neutral" object.

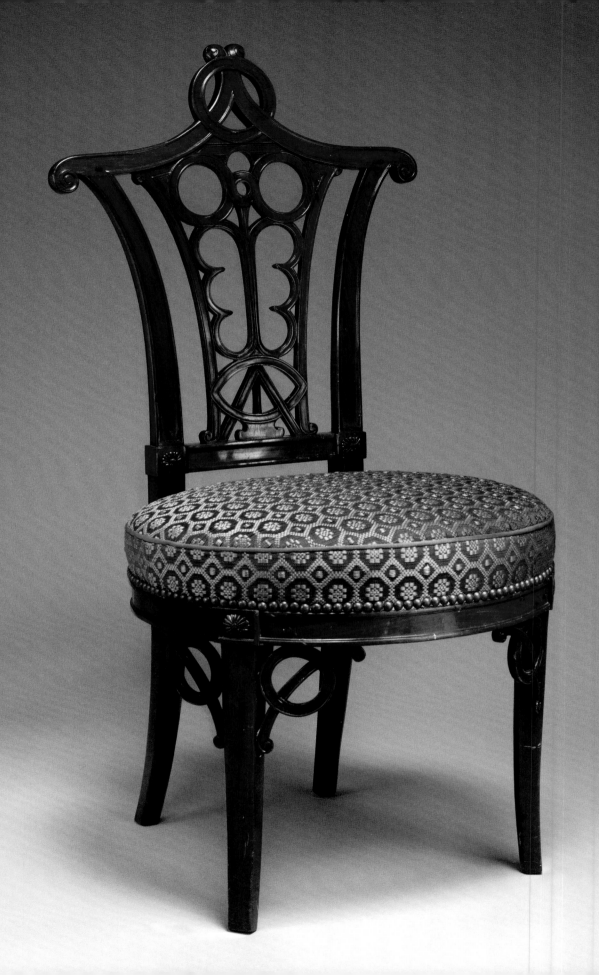

8

Side Chair

Georges Jacob (French, 1739–1814)
French (Paris), 1785–90
Mahogany; modern horsehair upholstery, 38 × 18⅞ × 19½ in. (96.5 × 47.9 × 49.5 cm)
Bequest of Mrs. Charles Wrightsman, 2019 (2019.283.25)

A stamp underneath the back-seat rail identifies this graceful chair as the work of Georges Jacob, who became a master *menuisier* (joiner) in 1765, established his own workshop in Paris, and quickly made a name for himself. One of the most successful and innovative chair makers of the second half of the eighteenth century, Jacob supplied seat furniture to a princely and aristocratic clientele. This chair, part of a larger set, was made for Louis Jean Marie de Bourbon, duc de Penthièvre, as indicated by a second stamp for the Château d'Amboise, one of the duke's properties in the Loire valley.

Although French styles set the fashion for other European countries during the seventeenth and eighteenth centuries, the present chair illustrates that foreign traditions also exerted influence in France. The use of mahogany, for instance, long a popular timber for furniture making in England (see no. 6), became fashionable for French seat furniture only in the late 1770s. English influence is also seen in the chair's exposed wooden splats, which were very common in eighteenth-century England but unusual in France until a few years before the Revolution. Furthermore, the elegant back, with its intricate openwork decoration and brackets between the legs, reveals an interest in Chinese fretwork, as expressed, for instance, in designs by the Swedish-born British architect William Chambers.

Chambers published sketches he drew during two trips to Canton in his influential *Designs of Chinese*

Buildings, Furniture, Dresses, Machines, and Utensils (1757), a French translation of which appeared in 1776. Whereas Chambers's furniture is angular and its fretwork geometrical, Jacob preferred gently curving lines and circular shapes. Particularly noteworthy here is the pagoda-inspired crest rail interlaced with a circle at the top, which is unlike any design found in Chambers's treatise or other British pattern books that included plates for "Chinese" furniture. Rather than copying directly, Jacob adapted some of the English traditions to his own taste, combining them with uniquely French elements such as the round seat and the square blocks above the saber legs, both seen here.

Well-connected and fabulously wealthy, the duc de Penthièvre was one of Jacob's regular clients. He may have enjoyed this distinctive chair at his estate near Amboise, the Château de Chanteloup, which had Anglo-Chinese gardens complete with a 144-foot-tall pagoda.

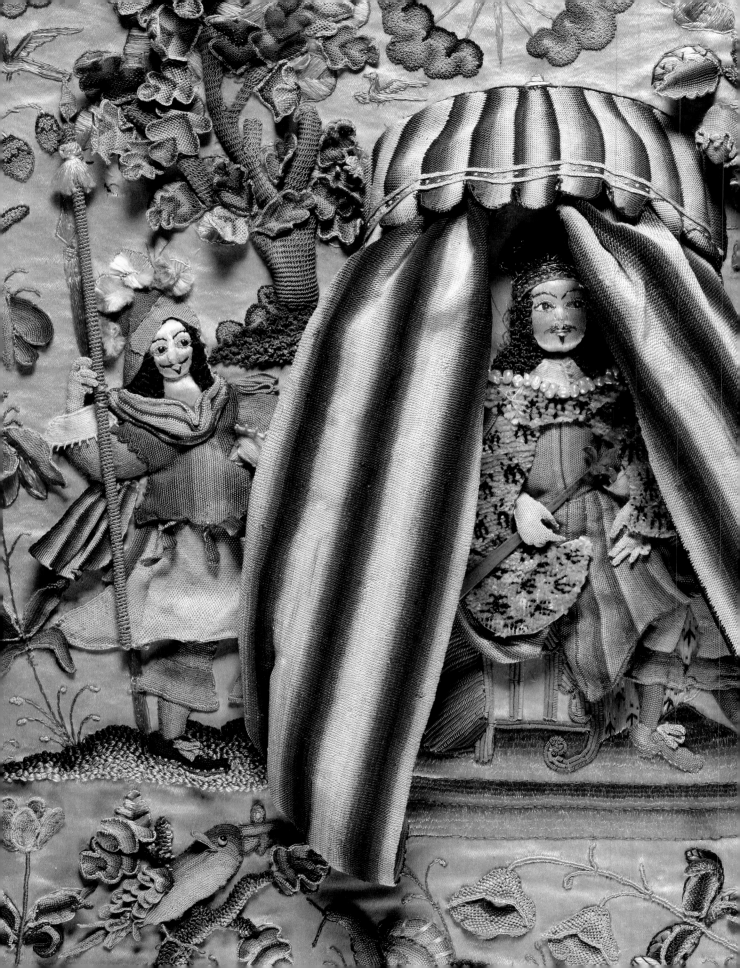

Chests and Caskets

9

Casket

Susanne (de) Court (French, active ca. 1575–1625)
French (Limoges), early 17th century
Enamel painted on copper; gilded-silver frame, 7¾ × 9½ × 5¼ in. (19.7 × 24.1 × 13.3 cm)
Gift of Mr. and Mrs. Walter Mendelsohn, 1980 (1980.203.2)

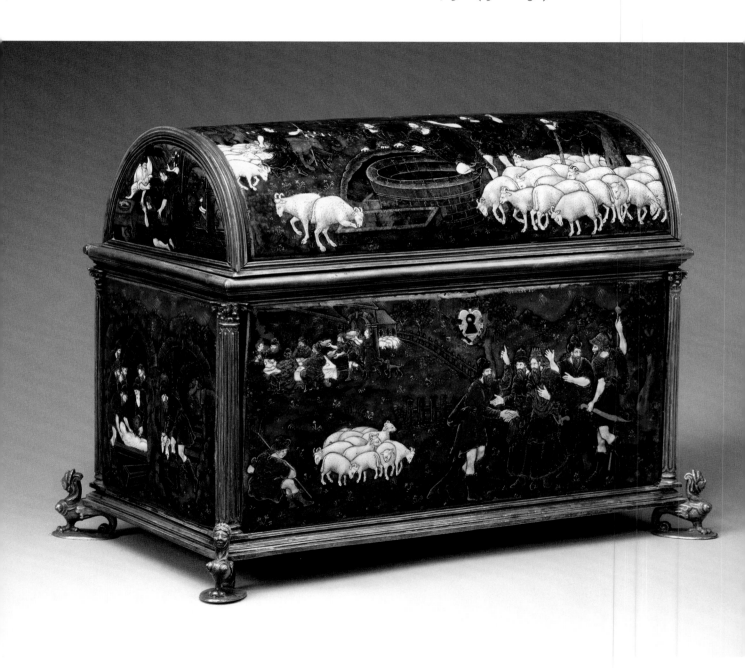

Rarely are female artists of the sixteenth and early seventeenth centuries known by name, and those who headed a workshop are even more obscure. Susanne Court or de Court, whose name or initials are regularly found on enameled objects, is an anomaly for those reasons alone. She was most likely related to Jean de Court, a member of a celebrated dynasty of enamelers in Limoges, in southwestern France. Unfortunately, no records about Susanne de Court's life exist, although we may presume that her spouse predeceased her because, as a widow, she would have been allowed to continue the family business.

From the Renaissance until the early seventeenth century, artists in Limoges were renowned for their painted enamel, a technique that originally developed in the ancient Near East and had flourished in their city since the Middle Ages. A difficult and unforgiving process, enameling produces works that defy the passage of time and maintain their color but are vulnerable to damage.

Enamelers mixed powdered enamel (finely ground glass with metal oxides or carbonate added for color) with water and a binder to depict narrative scenes directly on a copper surface. These compositions, either in grisaille or polychrome, were drawn from the Bible, ancient history, or classical mythology and were usually set against a background of dark blue or black enamel. When the object was fired in a kiln, the enamel would fuse with the metal. The application of a wider range of colors required additional firings at different temperatures, depending on the composition of the glass and the concentration of the oxides, while gilded highlights, requiring the lowest heat, were added last.

To obtain a transparent luminosity, pieces of gold or silver foil (paillons) were placed underneath a layer of translucent enamel. The mostly secular pieces decorated in Susanne de Court's workshop, such as plates, mirror backs, and ewers, regularly incorporate such paillons. This casket, comprising seven enameled panels, clearly shows the use of the foils in the jewel tones of the garments.

In addition to bearing de Court's name on the curved lid, inscriptions on the coffer's plaques indicate that the various scenes illustrate the stories of Abraham and Sarah, Isaac and Rebecca, and Jacob and Esau from the book of Genesis. These animated compositions derive from prints by Etienne Delaune, which in turn were inspired by the woodcuts made by Bernard Salomon for Claude Paradin's *Quadrins historiques de la Bible* (*Historical Biblical Scenes*), first published in Lyon in 1553 (fig. 19). Many of these prints are executed in a "comic strip" style, each representing two or more episodes, as seen on this casket as well. Forming a chief source for enamelers, ceramic painters, and tapestry weavers alike, the *Quadrins historiques* reflects the influence of the Reformation at a time when Protestantism was considered heresy in France, that is, before 1598, when King Henry IV granted a certain degree of religious liberty to his Protestant subjects.

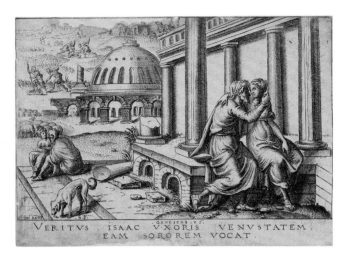

Fig. 19. Etienne Delaune (French, 1518/19–1583). *Abimelech Spying on Isaac and Rebecca*. French, 1550–72. Engraving, 3¹/₁₆ × 4¹/₈ in. (7.8 × 10.5 cm). The British Museum, London (Gg,4D.115)

With their lively animals and somewhat quirky figures, the painted enamels from Susanne de Court's workshop display distinctive characteristics, yet it is not clear whether she was responsible for the pieces that bear her name or whether they were executed under her direction. Typical for pieces from her atelier are the tufts of gilded grass and the bundled rays of sunlight set against an opaque blue sky.

Incorporating classical columns with Corinthian capitals at the corners, the gilded-silver frame, which is old but probably not the original, is supported on feet in the shape of a harpy, a mythological creature composed of a bird with a human face. Restorations surrounding the lock plate and handle suggest that the coffer was in fact used, possibly for the storage of jewelry—a precious container to safeguard even more precious contents.

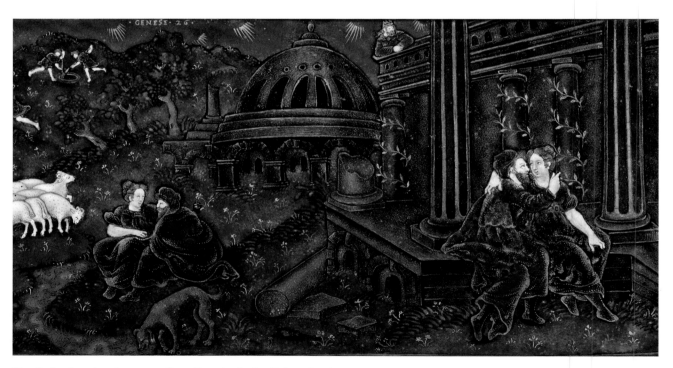

Detail of casket, showing a scene from Genesis 26, after Delaune's print

Casket

Attributed to Adam Eck (Bohemian, 1604–1664)
Bohemian (Eger; Czech, Cheb), ca. 1650
Partly stained, ebonized, and gilded soft woods and fruitwoods; marbleized paper–lined interior;
iron and yellow metal hardware, 8¹¹/₁₆ × 16⁵/₁₆ × 13 in. (22.1 × 41.4 × 33 cm)
Purchase, Friends of European Sculpture and Decorative Arts Gifts; Gift of Thelma Williams Gill
and The Isak and Rose Weinman Foundation Inc. Gift, by exchange, 2009 (2009.470)

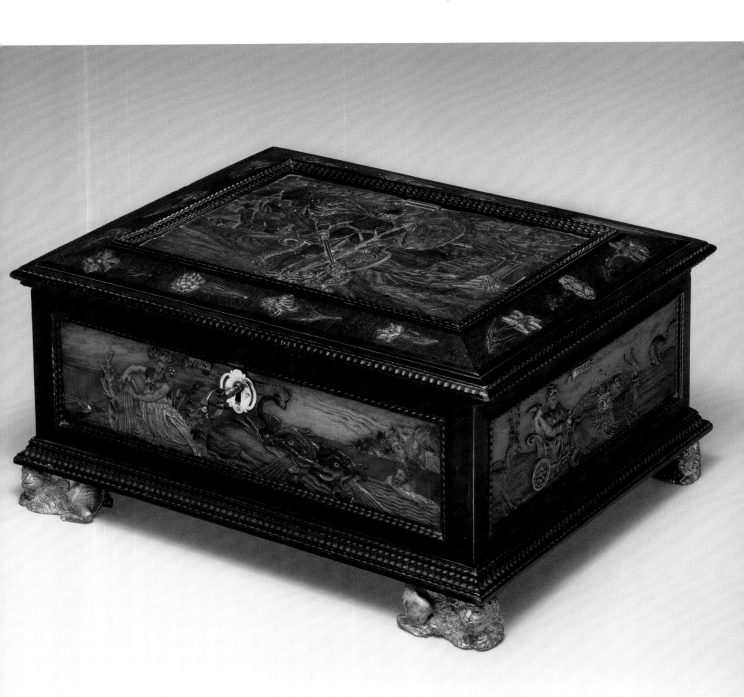

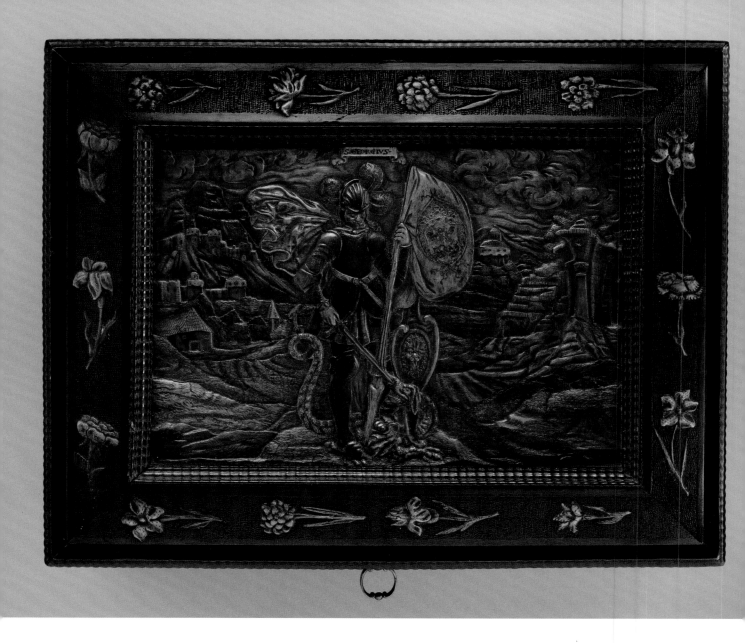

This casket has been attributed to Adam Eck based on similarities with other works by the successful cabinetmaker, some of which are signed. Eck was among several artists active in Eger, Bohemia (now Cheb in the Czech Republic), who excelled in the creation of low-relief marquetry. The city was particularly renowned for this technique, which may have been intended to emulate the hardstone mosaics, or *pietre dure*, created in nearby Prague.

Locally available timber, such as maple, poplar, and pear (rather than the more expensive imported tropical woods), was used for this meticulous work, in which small, irregularly shaped wood pieces of varying thicknesses carved in low relief were adhered to a flat veneer. The wood grains of the individual elements ran in different directions, and a sense of liveliness was thus achieved. This was enhanced by engraving and punching the surface with special tools to create texture, as in metalwork. In addition, stains were employed not only to heighten the colors and the naturalism of the scenes but also to increase the marquetry's polychromy and therefore its similarity to *pietre dure* work. Most of these natural dyes are now faded; only the poplar wood, pigmented by the

Chlorociboria fungus, has retained some of its blue-green color, seen in the stems and leaves of the individual flowers scattered on the border of the lid.

A native of Eger, Eck was the most prominent member of a family of cabinetmakers originally from Nuremberg. He was responsible for game boards and chests as well as panels for cabinets and altars depicting biblical narratives or scenes from mythology. As the inscription *S. GEORGIUS* on the banderole indicates, Saint George, the legendary martyr from Cappadocia (modern-day Turkey), is illustrated on the lid. Designated as the patron saint of warriors and soldiers, Saint George was much venerated in the Habsburg realm, where the chivalric Order of Saint George was founded in 1469 by Holy Roman Emperor Frederick III and Pope Paul II to advocate the Christian faith.

Saint George is portrayed in full armor, with a Greek cross (also known as the Cross of Saint George) engraved on his breastplate and the billowing folds of his mantle creating a sense of drama. More commonly depicted on horseback, he is shown here amid a hilly landscape with the slain dragon at his feet. According to the legend, the saint first tamed and then killed the dragon, which had terrified the inhabitants of a Libyan city with its venomous breath. With this heroic deed, he also rescued a princess who was to be sacrificed to appease the beast. The banner in Saint George's left hand bears an image of the Archangel Michael, who killed a dragon in his own right. The two defeated monsters surely allegorize the triumph of good over evil.

The scenes that Eck depicted were frequently based on engravings, and this one may have been inspired by a composition of the Flemish artist Hieronymus Wierix (fig. 20). The sides of the casket show personifications of the four elements, Earth, Water, Fire, and Air, believed by the ancient Greeks to compose everything in the universe. The artist based these scenes either on designs by the Italian draftsman and engraver Antonio Tempesta or on one of the later versions of Tempesta's work. Rather than copying these compositions exactly, Eck adapted them to fit the spatial limitations of the rectangular panels.

The casket is framed by ripple moldings, which originated in Nuremberg about 1600. This type was

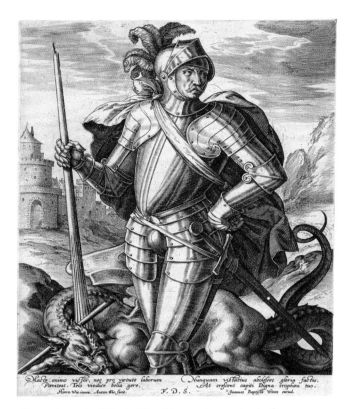

Fig. 20. Antonius Wierix (Flemish, 1555/1559–1604), after Hieronymus Wierix (Flemish, 1553–1619). *Saint George.* Flemish (Antwerp), before 1611. Engraving, 8⅜ × 6¹³⁄₁₆ in. (21.3 × 17.2 cm). The British Museum, London (1871,1209.4633)

frequently found on pieces adorned with Eger marquetry, but after 1700 it fell out of favor. A special machine with a manual crank and a plane would cut the repetitive patterns into strips of ebony or ebonized (blackened) wood, as done here. Attached to the casket, these moldings would reflect the light and thus animate the surfaces. Four recumbent lions with heads raised, a position called *couchant* in heraldry, serve as the feet. Known for their power and strength, these beasts were meant to guard the casket and its contents.

Casket with Scenes from the Story of Esther

British, after 1665
Wood; silk satin worked with silk and metal thread;
seed pearls, mica, and feathers; metal-thread trim;
wood frame; silk lining; mirror glass,
glass bottles; printed paper, 9¼ × 16 × 11¼ in.
(23.5 × 40.6 × 28.6 cm)
Gift of Irwin Untermyer, 1964 (64.101.1335)

This seventeenth-century casket is a true celebration of female virtue. The work of a young lady whose embroidery skills are on full display, it depicts scenes from the exemplary life of the Jewish queen Esther. The Old Testament heroine who courageously interceded on behalf of her people with the Persian king Ahasuerus was considered a model of righteousness, wisdom, and modesty. For that reason, her story was frequently depicted in different media, including pictorial needlework such as seen here.

On the lid of the chest, Esther kneels before Ahasuerus, her husband, who is seated underneath a blue-and-white-striped canopy. The left panel on the front illustrates Ahasuerus and Esther feasting, while Haman, the anti-Semitic court official who plotted to have all the Jews in the realm killed, is depicted on the right panel. He is riding toward Esther's cousin Mordecai, who has heard of Haman's wicked plan and mourns at the brick gate of the royal palace. One of the smaller sides shows the king in his bed listening to the Annals of the Kingdom being read. On the opposite side, Mordecai, who had previously saved King Ahasuerus's life by disclosing a plot to poison him, is being honored in a procession; he is dressed in the attire the king had gratefully bestowed on him. The back of the casket portrays Haman dangling from the gallows after Esther had revealed his intentions to annihilate the Hebrews.

Each scene is set in a garden landscape sprinkled with flowers, trees, and a variety of insects, birds, and small animals, all displaying a delightful disrespect for proportion and scale. Great attention has been lavished on the figures' fashionable dress, which is contemporary and

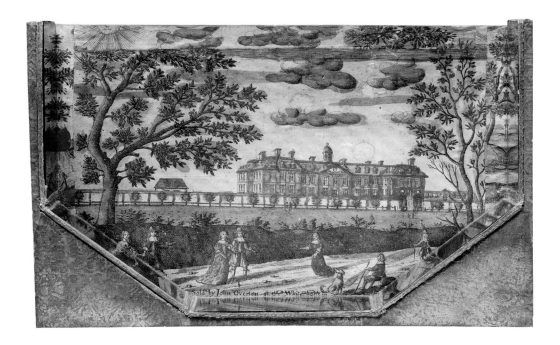

features lace collars and cuffs, bows, hair and shoe ribbons, and seed-pearl necklaces.

Executed in various stitches and a range of materials, such needlework was painstaking as well as labor intensive. It required skill, good eyesight, nimble fingers, and, of course, patience. Embroidery was deemed to be a suitable occupation for women and was taught to young girls either at home or at school. The students typically started with a sampler and then moved on to more exacting, sophisticated work such as embroidered "pictures" or panels for mirrors and caskets.

An enchanting three-dimensionality is achieved here (on all sides but the back) by the use of so-called raised work for the garments, which are either partly detached or elevated from the background with padding materials or wires, and for the figures' faces and hands, which are stretched over wooden shapes. This technique, also known as stump work since the late nineteenth century, was particularly fashionable in England between 1650 and 1700. The seed pearls and metal-thread trim, as well as the mineral mica simulating the transparent glass of the castle's windows, suggest that no expense was spared for the design and execution of this piece.

Completion of the casket relied on the services of multiple artisans and tradesmen. The patterns were provided by professionals and could be acquired as a needlework kit with designs drawn on panels of canvas or silk satin (the latter used in this case) to embellish the exterior. In addition, a carpenter or joiner was required to build the wooden carcass, along with an upholsterer to mount the embroidered panels and provide the lining plus any other elements needed.

The interior of this chest is fitted with a mirror inside the lid, various drawers for the storage of small personal items, and a tray with writing implements. A colored landscape print, which is reflected in tiny mirrors placed at an angle, decorates the central component. Offering perspective views, the mirrored interior is not unlike those found in contemporary collector's cabinets (see fig. 6). According to the inscription *Sold by John Overton at the White Horse In*, near the lower edge of the engraving, it was available at the London shop of the print publisher John Overton, who was known for his maps and topographical views. The fact that Overton ran this establishment, The White Horse, from 1665 until his retirement in 1707 gives us a good indication of the object's date. The tooled leather storage case made for the safekeeping of this unique piece, also in The Met collection, not only explains the excellent condition of its embroidery but also speaks to the owner's evident pride in her accomplishment with needle and thread.

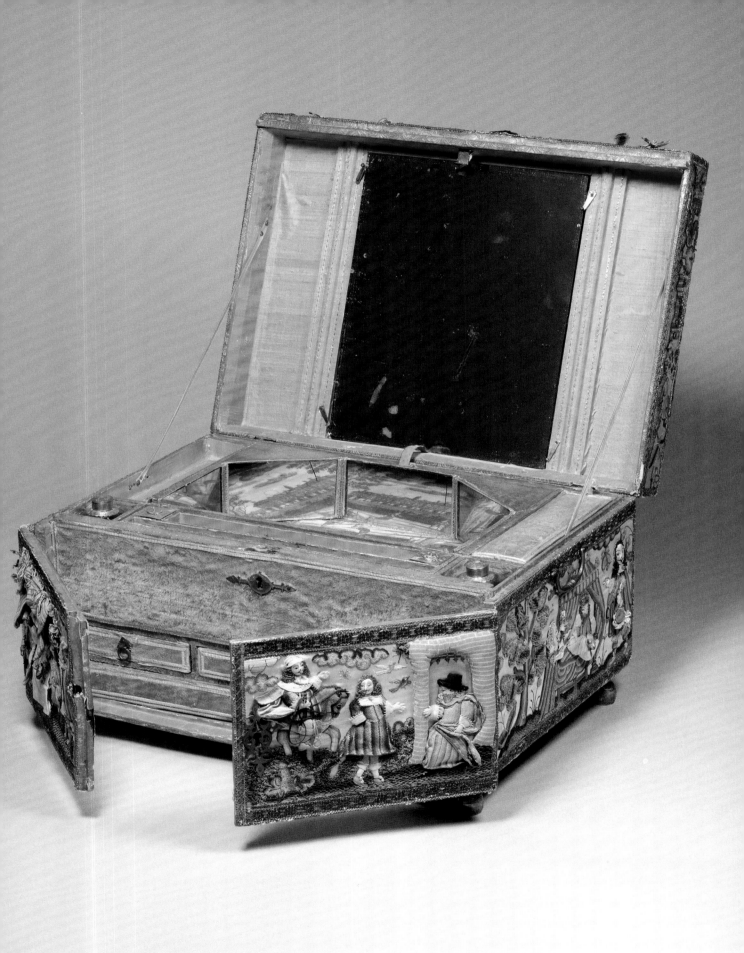

Casket

Attributed to Michel Redlin (German, recorded 1688)
German (Danzig; Polish, Gdańsk), 1680
Amber; gold foil; gilded brass; pine; silk satin; paper, 11¹³⁄₁₆ × 13 × 8¼ in. (30 × 33 × 21 cm)
Walter and Leonore Annenberg Acquisitions Endowment Fund, 2006 (2006.452a–c)

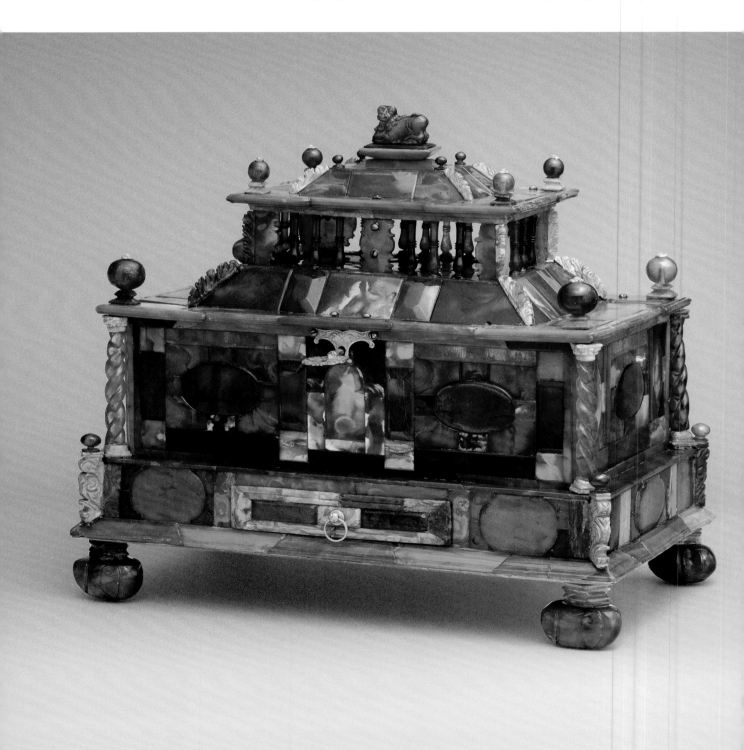

The material used for this extraordinary casket is amber, a fossilized tree resin found on every continent except Antarctica. Northern Europe is particularly rich in this primordial organic substance, lumps of which still wash up on the shores of the Baltic Sea. The origin of amber was long the story of myths in which this so-called miracle of nature was associated with both the sun and tears. According to Ovid's *Metamorphoses*, Phaethon, while attempting to drive the sun chariot of his father, Helios, across the sky, was unable to control its horses. To prevent the Earth from being scorched, Zeus struck the young man with lightning. Mourning their arrogant brother's death, the Heliades grieved for months until the gods turned them into poplar trees and the sun transformed their tears into beads of amber. Not surprisingly, given amber's color and origin, it has also been referred to as "gold from the sea." Since antiquity, the material has been employed for the making of precious objects and jewelry to which magical, protective, and prophylactic qualities have been ascribed.

With its architectural columns, pilasters, and balusters, this casket consists of three tiered parts: the base, fitted with a drawer in front; a stepped storage compartment with a hinged lid; and a smaller section on top. Quite unusually, the sides of the uppermost part are formed by an openwork railing of turned balusters, which support a hinged roof. Only the base and drawer of the object rely on a wooden substrate, which is found on most other boxes and caskets. For that reason, this late seventeenth-century work is surprisingly light.

For its construction, thin plates of amber in a medley of shapes and sizes have been assembled with tongue-and-groove joints. Delicate nuances in color and transparency are provided by the combination of translucent, opaque, and "milky" pieces of amber. This subtlety is further enhanced by the presence of metal foil placed behind the amber veneer on the base. The light shimmering through the honey-colored material creates a luminescence similar to that of sunshine filtering through stained glass. Visible only when one looks inside, the central

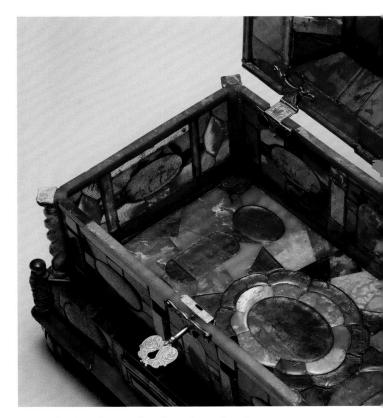

Detail of casket, showing "sunflower" motif inside

"sunflower" motif on the interior floor may well be a clever reference to the legendary origin of amber.

The bulbous feet, carved cornerpieces, intertwined columns, bead finials, and crouching lion on the top playfully animate the outline of the casket. In addition to carving and turning, the artist used the intaglio technique (incising or engraving a design into the amber) to embellish his work, thereby transforming the natural material into one worthy of a true *Kunstkammer* object (see no. 34). With their landscape and pastoral scenes engraved from the back, the slightly convex oval cabochons are reminiscent of gems. The faceting of some of the amber pieces further heightens the comparison to precious stones. Rather than merely a repository for jewelry, the casket is a jewel in its own right.

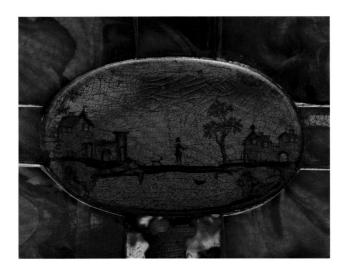

Although not signed, this piece has been attributed to Michel Redlin, a late seventeenth-century craftsman active in the Baltic seaport city of Danzig (now Gdańsk, in Poland), which was an important center of amber working. Redlin made a very similar object that Frederick III, elector of Brandenburg, sent as a present to the Russian court in 1688–89, known from a drawing by the artist (fig. 21). Their use as diplomatic gifts clearly illustrates how highly prized these amber objects were.

Once exposed to the atmosphere, amber becomes more brittle and frequently starts to crizzle. For that reason alone, it is remarkable that this sumptuous display casket is preserved in such excellent condition, complete with its original hardware and key.

Fig. 21. Michel Redlin (German, recorded 1688). *Drawing for a Cabinet To Be Sent as a Present to the Russian Court in 1688–89*. Formerly Preussisches Staatsarchiv, Berlin

Casket with the Triumph of Venus

French, early 18th century
Straw marquetry on wood, 5⅛ × 11⅞ × 9¼ in. (13 × 30.2 × 23.5 cm)
Edward C. Moore Collection, Bequest of Edward C. Moore, 1891 (91.1.911)

Rumpelstiltskin, the mysterious character from the German fairy tale, spun straw into gold, but that humble material became valuable only when transformed into precious metal. In fact, straw has been (and remains) treasured in its own right as a medium for decorating various objects and small pieces of furniture. This wooden casket, whose entire surface is embellished with straw marquetry, is an excellent example.

While in Milan in 1646, the British diarist John Evelyn admired the "curious straw-work among the nuns." Although Evelyn does not offer any details, embroidery and marquetry techniques were known to have been executed with straw by professionals and amateurs alike. For marquetry decoration, stems of wheat, barley, and oats were dried, tinted, split, and flattened. They were then arranged into patterns or figures before being glued to a

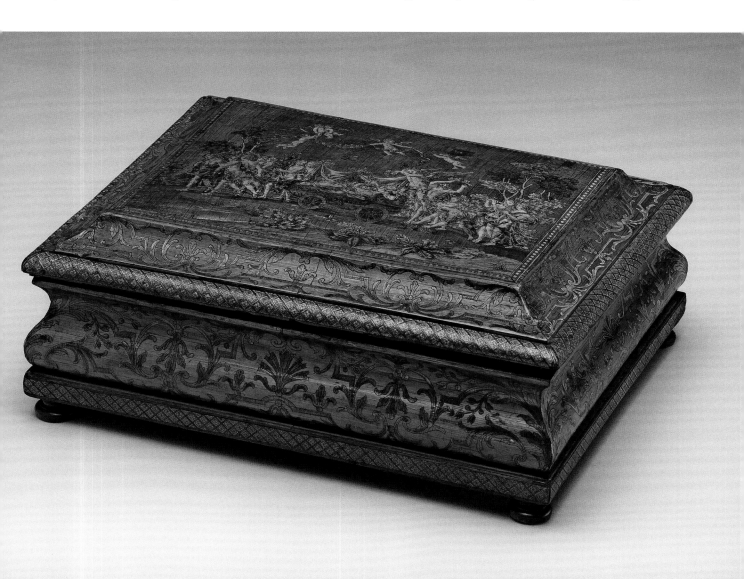

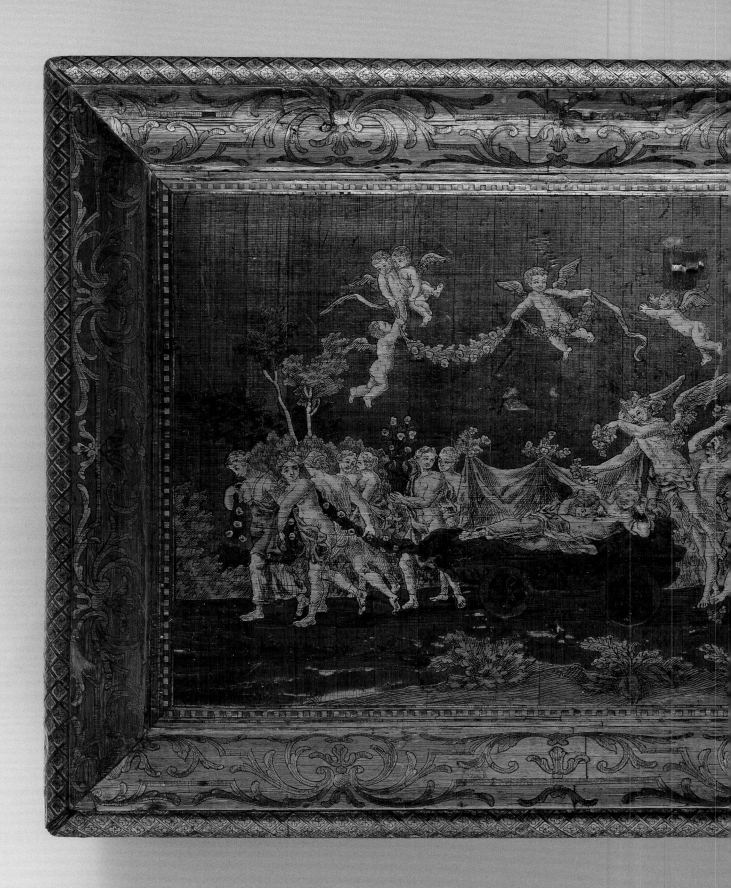

wooden or cardboard substrate, with the glossy side up. Some of the repetitive patterns, such as checkered borders, were first pasted to paper. Geometric designs optimized straw's inherent ability to reflect light, which is especially apparent when the pieces are turned in alternate ways to vary the direction of their grain.

This early eighteenth-century rectangular casket has gently undulating sides and small bun feet. The scene on the hinged cover, depicting the Triumph of Venus, shows the goddess of love and beauty and her son Cupid reclining on a chariot surrounded by her scantily clad entourage. Numerous roses, symbols of Venus, decorate the chariot, while putti frolic with a floral garland in the sky above. This charming subject suggests that dressing or beauty paraphernalia like combs, ribbons, or silk flowers were meant to be stored inside.

For the details, the composition relies heavily on hatching and crosshatching (the incised lines are tinted black), which add definition to the faces, folds to the draperies, and leaves to the trees. Where deemed necessary, the natural color of the straw was enhanced with dyes such as green for the foliage and red for the roses. While these have faded and the straw darkened on the exterior, the interior is surprisingly well preserved and colorful.

Three figures from the *commedia dell'arte*, a form of improvised theater developed in sixteenth-century Italy but popular all over Europe, embellish the inside of the lid. Holding a slapstick, Harlequin is identified by his characteristic half-mask, beard, and colorful patchwork costume. His two companions are both known in the *commedia* as Zanni (the Venetian form of Gianni or Giovanni), the standard name given to mischievous, unscrupulous servants who acted as clowns, as did Harlequin.

With its strap- and scrollwork in contrasting colors, the nonfigurative decoration is reminiscent of so-called Boulle work, the tortoiseshell-and-brass marquetry that was used for furniture and caskets alike (fig. 22). Although the technique originated in Italy, it was named after André Charles Boulle, a celebrated French royal cabinetmaker, who perfected it during the late seventeenth century. For this piece's decoration, it is likely that a "packet"

of differently tinted straw layers was assembled, just as in wood or Boulle marquetry (see no. 2). Once the layers were cut and separated, the same motifs could be repeated in different color combinations, as seen here in the interior and underside. The decoration is comparable to designs by the influential architect Daniel Marot for the upholstery of a bed canopy from his print series *Nouveaux livre da partements* (*New Book of Apartments*), published in the early eighteenth century (fig. 23).

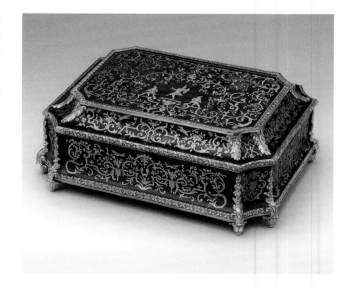

Fig. 22. Toilet Casket. French (Paris), ca. 1700–1715. Wood veneered with marquetry of tortoiseshell and brass, rosewood; gilded bronze and steel, $5^{1}/_{16} \times 13^{5}/_{8} \times 10^{1}/_{4}$ in. (12.9 × 34.6 × 26 cm). Purchase, Mr. and Mrs. Sid R. Bass Gift, in honor of Mrs. Charles Wrightsman, 2011 (2011.12)

Delightful yet a little naïve, this work is not without artistic merit. Moreover, the labor-intensive marquetry technique beautifully exhibits the mesmerizing appeal of straw's natural sheen. Even if the casket's straw was not literally transformed into precious metal, as Rumpelstiltskin's was, it at least replicated the effect and allure of gold.

Fig. 23. Daniel Marot (Dutch, born France, 1661–1752). *Design for the Upholstery of Bed Canopies*, from the print series *Nouveaux livre da partements* (*New Book of Apartments*). Dutch (The Hague), published in 1703 or 1712. Etching and engraving, 13½ × 8½ in. (34.3 × 21.6 cm). Museum für Angewandte Kunst, Vienna (D666 F-142 S-65 Z-5)

Mechanical Casket

Heinrich Gambs (Russian, born Germany, 1765–1831)
Russian (Saint Petersburg), 1800–1810
Burr maple, ebony and ebonized fruitwood, mahogany, and birch; silk, baize;
steel springs, 7¼ × 16 × 9½ in. (18.4 × 40.6 × 24.1 cm)
Anonymous Gift, in memory of Walter E. Stait, 2008 (2008.544)

The clean lines of this rectangular casket appear to belong more to the realm of Art Deco than to the Late Neoclassical aesthetic, which preceded that style by more than a century. Resembling a beautiful veined marble, polished burr maple veneer constitutes its main decoration. On all four sides, two sheets of veneer are placed in such a way that one sheet is the mirror image of the other, much as the pages of an open book are (the effect is therefore known as "book matched"). By contrast, the veneer on the hinged lid is quartersawn and creates a rosette pattern. Subtly emphasizing the architectural shape, stringing of ebonized (blackened) fruitwood embellishes the outer edges, while ebony blocks mark the corners of the double-stepped base. A slightly projecting molding inlaid with a meander motif of ebonized wood encircles the rim of the lid.

No handles or keyholes divert attention from the severity and monumentality of the exterior, and although the casket is locked, no key is provided. The piece opens only when a button underneath the right front corner is pressed. This is just one of the clever, unexpected mechanical features that permit access to various storage places in the casket. Some of these features—and the compartments themselves, for that matter—are far from apparent. For instance, a shallow compartment inside the cover is hidden behind a frame clad in mahogany and silk. Designed to keep documents safe from prying eyes, this section can be accessed only by activating a button inside the lock plate that allows the frame to lower.

More storage places are concealed in the interior, which is fitted with a mahogany tray divided into a middle section flanked by two smaller compartments. Since the latter are only half as deep as the central part, there is space underneath for four small drawers that are accessible once the central compartment has been removed. The entire tray can also be pulled out by moving the partition of the smaller compartments inward. Removing the tray reveals the lower part of the casket, made of birch and fitted with steel springs on either side. This section has a double bottom that hides yet another shallow compartment. Its hinged lid is released by pressing a button placed near the front left corner (tucked slightly underneath the double bottom). Finally, an additional drawer fitted into the base opens by means of a wooden button near the back left side of the casket.

Although unsigned, this work is attributed to Heinrich Gambs. Born in Baden-Durlach, Württemberg, Gambs settled around 1790 in Saint Petersburg, where he had a long and successful career until his death in 1831. He is believed to have been a pupil of the German cabinetmaker David Roentgen, an entrepreneur and shrewd businessman acclaimed for his mechanical furniture. In fact, Gambs accompanied Roentgen on one of the latter's trips to Russia, where furniture by both cabinetmakers found favor at the imperial court. While Empress Catherine the Great became Roentgen's most important client, Gambs's workshop supplied many luxurious pieces to her daughter-in-law, Grand Duchess (and later Empress) Maria Feodorovna, a princess from Württemberg.

Roentgen exerted a commanding influence on Russian cabinetmakers. Since Gambs collaborated with him and was also responsible for repairing some of his pieces at the

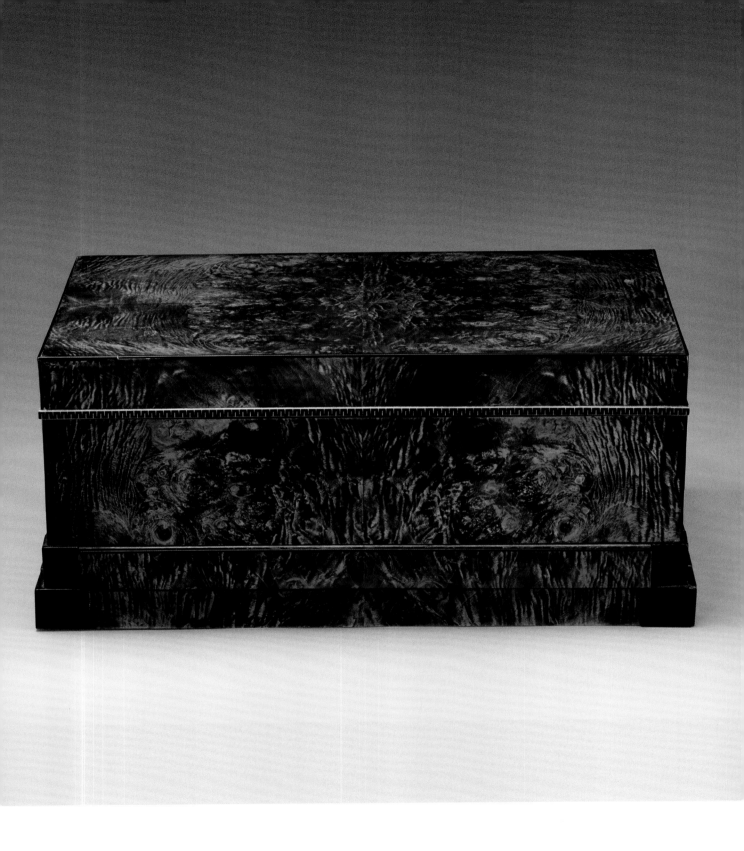

Hermitage, it is not surprising that Gambs's refined pieces bear a forthright resemblance to Roentgen's work (fig. 24). Yet this casket is no mere copy. Rather than working with the mahogany veneer frequently used by Roentgen, Gambs selected the typically Russian birch for the substrate and burr maple for the veneer (a burr is an unnatural growth on the bark of a tree caused by stress or a fungal infection that, when cut, creates striking veining). And whereas Roentgen's pieces are adorned with elegant gilded-bronze mounts, the absence here of such decoration renders this piece as austere as it is exceptional. Although Roentgen's mechanical inventions are unrivaled, the various springs, buttons, and opening devices that Gambs employed for this casket also leave nothing to be desired—except perhaps an instruction manual.

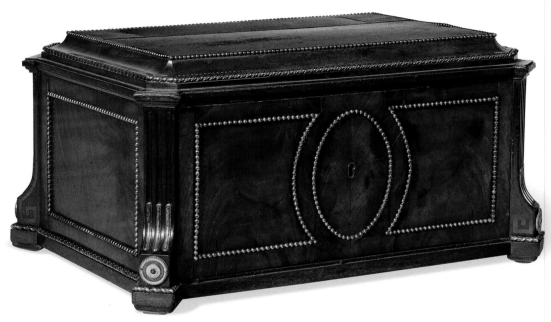

Fig. 24. David Roentgen (German, 1743–1807). Letterbox. German (Neuwied), ca. 1780–85. Mahogany veneered with mahogany; gilded bronze, 7½ × 14¼ × 9⅝ in. (19.1 × 36.2 × 24.4 cm). Private collection, New York

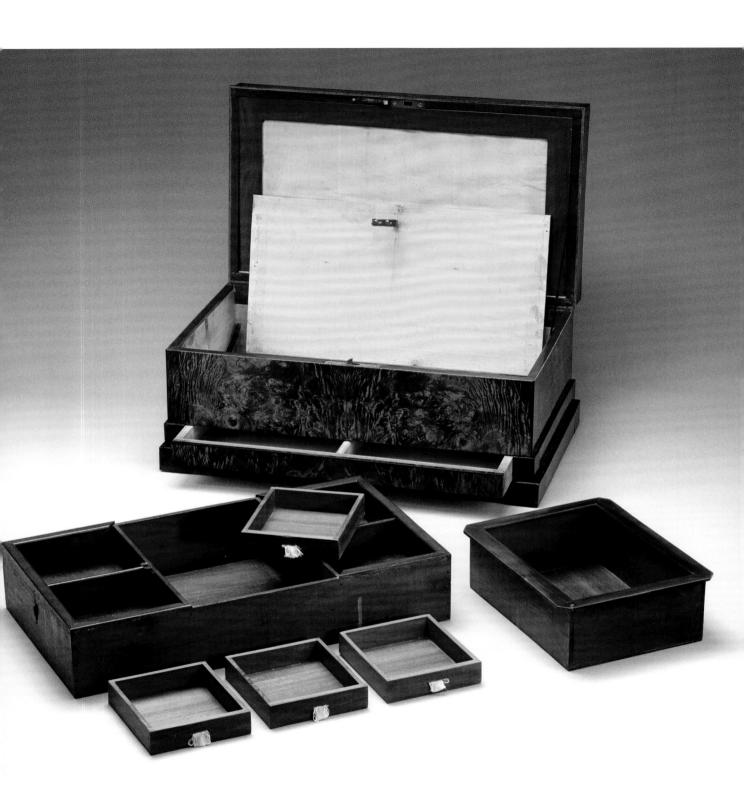

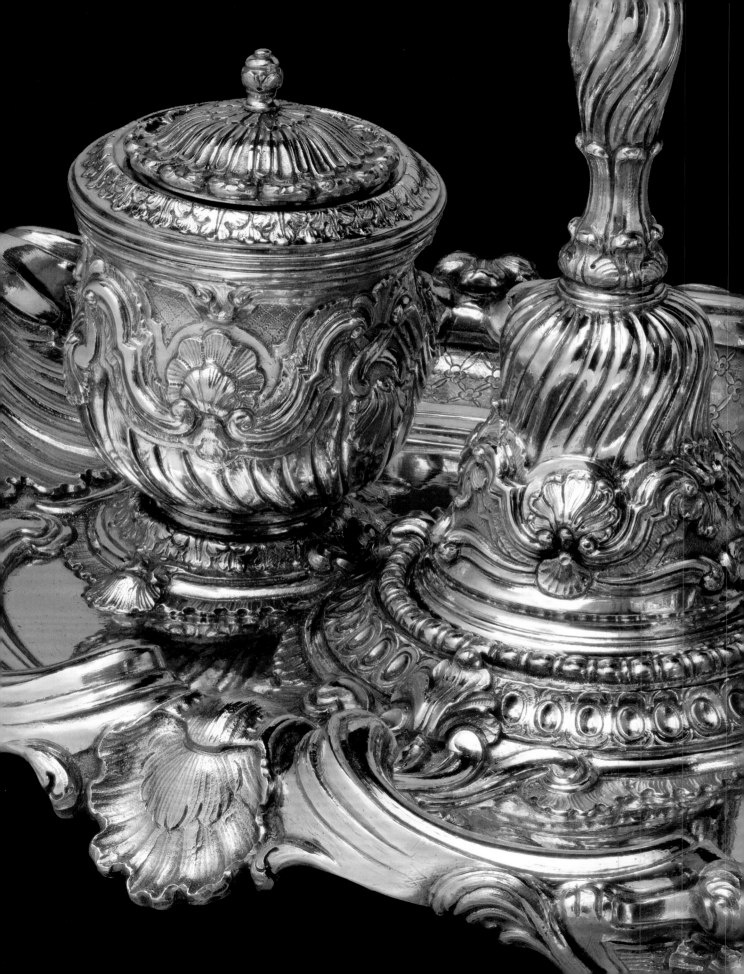

Objects for Daily Use

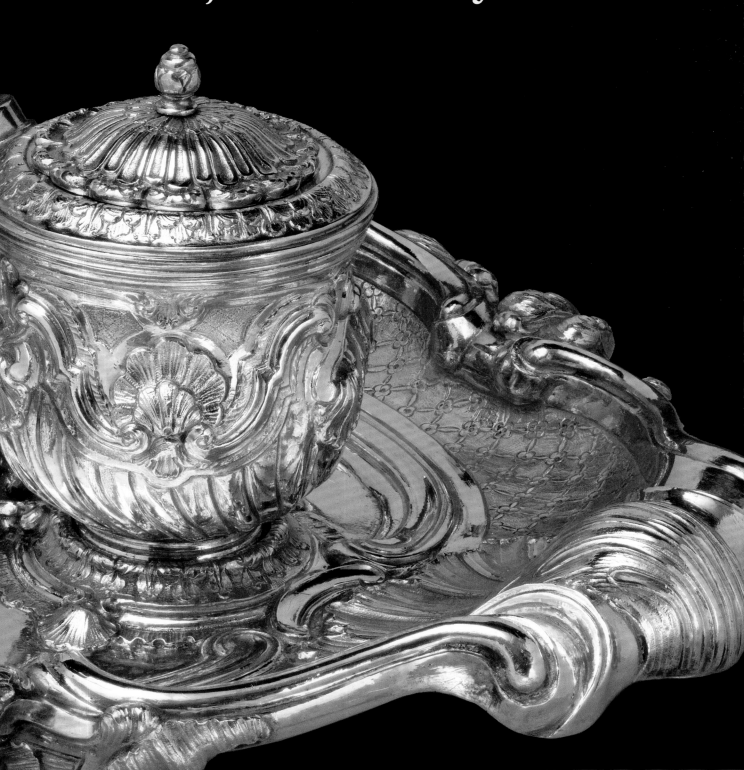

Two Spouted Drug Jars

Workshop of Orazio Pompei (Italian, ca. 1516–1590/96)
Italian (Castelli), ca. 1530
Maiolica (tin-glazed earthenware), (.72) 10½ × 6⅞ × 9¾ in. (26.7 × 17.5 × 24.8 cm);
(.73) 9¹¹⁄₁₆ × 6¾ × 10⅛ in. (24.6 × 17.1 × 25.7 cm)
Bequest of George Blumenthal, 1941 (41.190.72, .73)

The safekeeping of food, spices, and medicines was an important aspect of daily life in the late fifteenth and the sixteenth century. Storage containers for this purpose were provided by the production of richly ornamented tin-glazed earthenware, known as maiolica—ceramics that were as decorative as they were functional.

While considered to be a quintessential Italian art form, the technique of tin glazing originated in the Islamic world, from whence it spread into Spain and Italy. The manufacture of maiolica is well documented in a manuscript of 1557 by Cipriano Piccolpasso, *Li tre libri dell'arte del vasaio* (*The Three Books of the Potter's Art*). The process involved shaping clay objects on the potter's wheel or by mold, firing them, and then dipping them in a tin glaze. Fine animal-hair brushes were used next to apply metallic oxides for the decoration. The painter needed a steady hand for this because the glaze would absorb the pigments immediately and changes were thus impossible to make. During a second firing, the glaze would melt and fuse with the colors. The resultant vessels, which have a glossy white surface embellished with a bright palette, remain as vivid today as when first painted.

Although Renaissance maiolica was made both for display and for practical uses such as dining, its paramount purpose was storage. Maiolica jars, bottles, and spouted jugs were produced in large quantities to preserve curative preparations ranging from powders and pills to ointments and potions, the pouring of liquids being facilitated by the jugs' handles and spouts. The late fifteenth-century inventory of a Florentine apothecary, for example, lists more than two hundred pots (*albarelli*) of different sizes, forty-four syrup jars, thirty ceramic oil flasks, and fifty-eight glass flasks for distilled waters.

It is not always possible to attribute a piece of maiolica to a particular workshop or to distinguish the hand of an individual painter. However, excavations in Castelli, in the mountainous Abruzzi region east of Rome, have unearthed shards believed to be from the workshop of Orazio Pompei and his family that bear stylistic similarities to the design of the two vessels here. The overall shape of each jar, the strap handle scrolled at the lower end, and the scaled spout terminating in a dragon's head are typical features of the Pompei family output.

The banderoles on these objects specify that one held syrup of *Eupatorium* (boneset), beneficial against inflammation, and the other syrup of chicory (wild endive), a diuretic. To protect the contents, a piece of parchment was stretched over the top and tied around the lip with string, serving as a cover. During the mid-fifteenth century, the systematic study of botany furthered knowledge of the natural world, including the medicinal benefits of plants. In 1544 the Sienese scholar Pietro Andrea Mattioli published a popular herbal, *Di Pedacio Dioscoride anazarbeo libri cinque della historia & materia medicinale* (*Of Pedanius Dioscorides of Anazarbos's Five Books of the History & Science of Medicine*), that was actually an enlarged and updated version of the ancient medical encyclopedia by the Greek physician Pedanius Dioscorides. The translation of this Latin text into vernacular Italian made the treatise available to a much wider public.

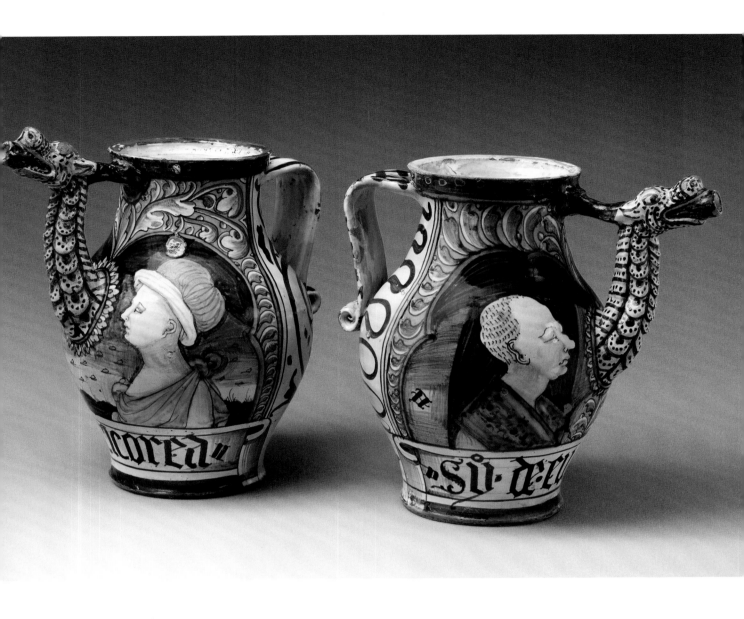

Although related in size and decoration, these jugs are clearly not a pair but may have been part of different sets. The head in profile rendered on either side of the spout was, for much of the fifteenth century, a widespread convention in paintings and on medals, where it was meant to emulate ancient coins. Such images are not individualized portraits but rather generalized types: male and female, old and young, attractive or not. Placed in a row on the pharmacist's shelf, the array of faces on these colorful vessels could easily represent a panoply of the establishment's customers, who sought a cure for their afflictions with the elixirs stored inside.

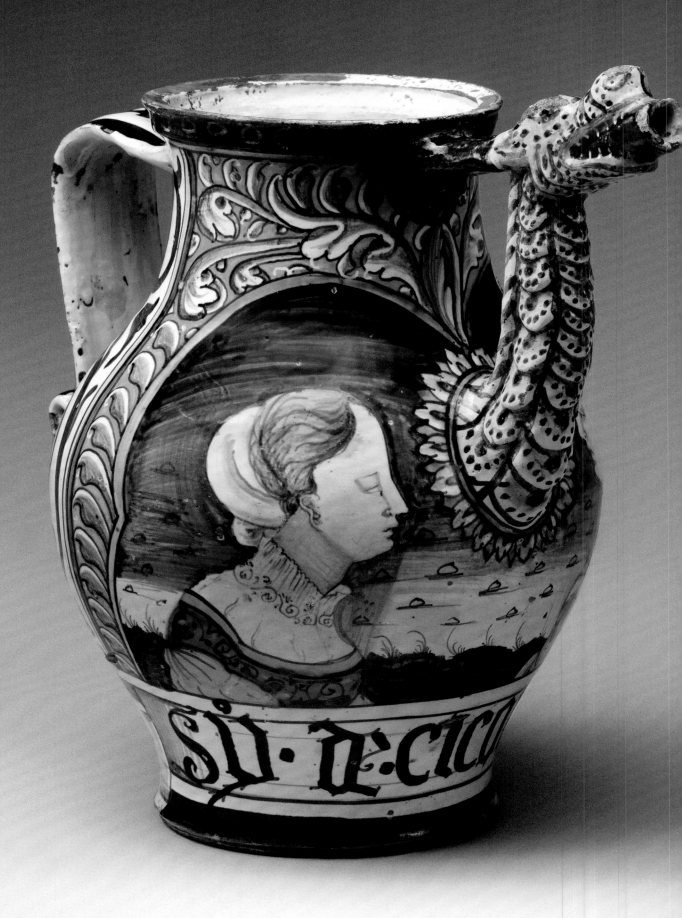

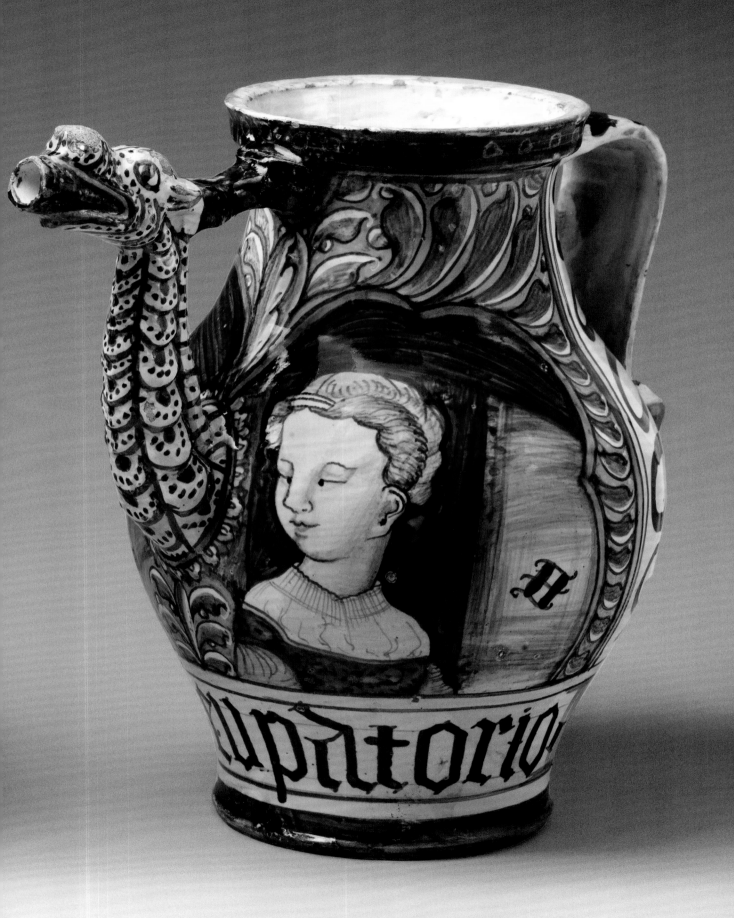

16

Teapot

Manufactory of Arij Jansz de Milde (Dutch, 1634–1708)
Dutch (Delft), 1671–1708
Red stoneware; silver, 4¾ × 7⁵⁄₁₆ × 4⁷⁄₈ in. (12.1 × 18.6 × 12.4 cm)
Robert A. Ellison Jr. Collection, Gift of Robert A. Ellison Jr., 2014 (2014.712.11a, b)

Made in Delft during the late seventeenth or early eighteenth century, this stoneware teapot illustrates that tea drinking had become a fashionable social pastime in the Netherlands. Tea was initially taken for its reputed medicinal benefits, but by the middle of the eighteenth century it was enjoyed as a stimulant. Since special equipment for the preparation and serving of the hot beverage was required, the Dutch East India Company shipped unglazed stoneware teapots made at Yixing, near Shanghai, to Europe along with their cargoes of tea. Modeled by hand in a variety of shapes and decorated in relief, the deep-red clay used for the Chinese vessels retained the temperature of the liquid. These prototypes were referred to as "East Indian" since they were shipped by way of Batavia (present-day Jakarta, Indonesia). Few Dutch customers would have known they originated in Yixing.

Eventually, at least three potters in Delft, a town famous for its production of tin-glazed earthenware, were successful in making stoneware teapots that closely resembled the Chinese models. In contrast to the imported wares, the Dutch examples were wheel-thrown, which restricted the shapes of their bodies to circular or ovoid forms. Their decoration, consisting mostly of flowering prunus branches, was formed by pressing clay into a mold and applying it to the surface while it was partially or leather hard. Fired at a high temperature, the red clay became impermeable and did not need to be glazed. In 1679 one of the three Dutch potters, the so-called *theepotbacker* (teapot manufacturer) Arij Jansz de Milde, requested a patent from the States of Holland to protect his redwares. The result, an oval stamp with De Milde's name above a left-running fox, was impressed on the

underside of each of his pots, including the present one. After De Milde's death in 1708, his daughter Elisabeth continued his pottery manufactory, De Gekroonde Theepot (The Crowned Teapot), until 1724.

Fig. 25. Pieter Gerritsz van Roestraten (British, born the Netherlands, 1630–1700). *Still Life with a Silver Candlestick*. British (London), ca. 1696. Oil on canvas, 28⁵⁄₁₆ × 23⁹⁄₁₆ in. (71.9 cm × 59.9 cm). Museum Boijmans Van Beuningen, Rotterdam (St 131)

A very similar teapot is illustrated in Pieter Gerritsz van Roestraten's *Still Life with a Silver Candlestick* (fig. 25), which shows the spout and lid embellished with chains and a protective silver or metal mount, as is the case with The Met example.

Following Chinese practice, tea was brewed by infusion, a method in which boiling water was added to leaves placed in a small pot and then left to steep. The strong extract was next poured into imported porcelain cups (matching tea services did not exist until the eighteenth century), diluted with additional water, and sweetened with sugar. While both men and women took tea, it was the duty of the lady of the house to preside at the tea table and serve the aromatic beverage, properly observing the etiquette and conduct expected of her and her guests during this fashionable social ritual.

Table Snuffbox

Russian (probably Veliki Ustyug region), ca. 1745–50
Niello scenes after a print entitled *Naufrage* (*Shipwreck*) by Pierre Alexandre Aveline
(French, 1702–1760) after Jacques de Lajoüe (French, 1686–1761), published in Paris, 1736
Partly polished green turban snail (*Turbo marmoratus*); gilded silver; niello,
2¼ × 4⅛ × 2½ in. (5.7 × 10.5 × 6.4 cm)
Purchase, The Lesley and Emma Sheafer Collection, Bequest of Emma A. Sheafer,
by exchange, and Rogers Fund, 1995 (1995.327)

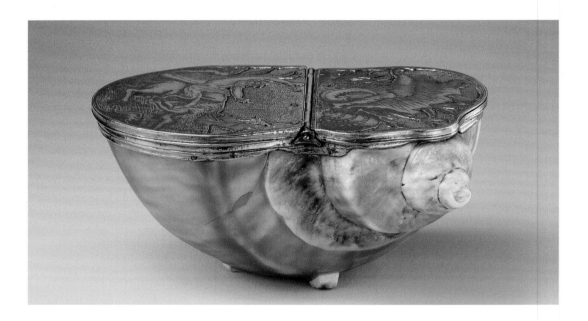

The body of this snuffbox is made from the cut-down and partly polished shell of a green turban snail (*Turbo marmoratus*), a gastropod native to the Indian and Pacific oceans. A number of such shells, used in China as drinking vessels, were brought to Russia and mounted during the eighteenth century with a gilded-silver lid to transform them into containers for powdered tobacco.

First discovered in the Americas during the late fifteenth century, tobacco was initially praised in Europe for its alleged power to treat headaches and other afflictions. However, by the middle of the seventeenth century, smoking and especially the taking of snuff, which was inhaled through the nose, were no longer considered medicinal. They had nevertheless become popular social, and by all appearances addictive, rituals. Although critics railed against these "filthy habits," they were adopted throughout European society and were ubiquitous in Russia. Traveling through Russia on his way to Persia in the 1630s, the German scholar Adam Olearius observed that "tobacco was heretofore so common there [in Russia], that it was generally taken, both in smoak and powder."

The lid of this example, which is divided into two parts and hinged in the middle, opens to reveal two compartments, a sizable one accessible from each side and a much smaller one, that are meant for the storage of two different types of snuff. The larger section of the lid displays a sinking vessel with a Triton riding a mythological

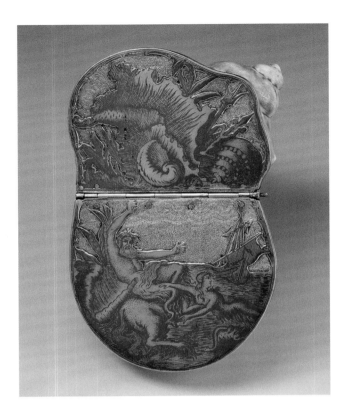

sea monster, while a Nereid (water nymph) struggles to hold on in the roiling waves. The other section shows a composition of shells, wetland vegetation, and Neptune's trident that, along with the spiraling shape of the snuffbox itself, alludes to the origin of the Rococo style, which derives its name from the French word *rocaille*, referring to rock or grotto work.

Both images are based on a composition entitled *Naufrage* (*Shipwreck*) by the Paris artist Jacques de Lajoüe. Published in 1736 as part of the *Livre nouveau de douze morceaux de fantaisie: Utile à divers usages* (*New Book of Twelve Pieces of Fantasy: Convenient for Different Uses*), the work enjoyed great popularity throughout Europe (fig. 26). This composition was copied on a number of similar Russian turbo-shell boxes, indicating just how far French eighteenth-century artistic influence extended. The decoration is executed in niello, a technique practiced in provincial centers such as Veliki Ustyug. The lines engraved in the silver surface have been filled with an alloy of silver, lead, copper, and sulfur. Heating the silver caused the niello to melt and fuse into place to form a beautiful dark contrast with the punched, gilded-silver ground.

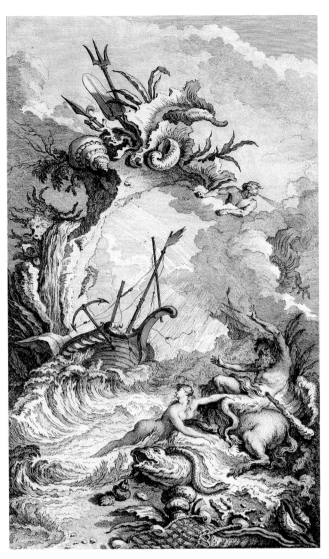

Fig. 26. Pierre Alexandre Aveline (French, 1702–1760), after Jacques de Lajoüe (French, 1686–1761). *Naufrage* (*Shipwreck*) (detail). French (Paris), 1736, from *Livre nouveau de douze morceaux de fantaisie* [...] (*New Book of Twelve Pieces of Fantasy* [...]). Etching, 19¹¹⁄₁₆ × 12¾ in. (50 × 32.4 cm). The Elisha Whittelsey Collection, The Elisha Whittelsey Fund, 1950 (50.598.1)

Catherine the Great, empress of Russia, had a large collection of snuffboxes, which she placed on the tables and windowsills of her cabinet (small private room). This box would have been perfectly suited for such a display, especially since it is too bulky for a pocket. Three tiny feet, carved from the outer surface of the shell, lend stability to the spiraling lines and asymmetry of the vessel, whose exterior beauty belies the harmful and addictive contents within.

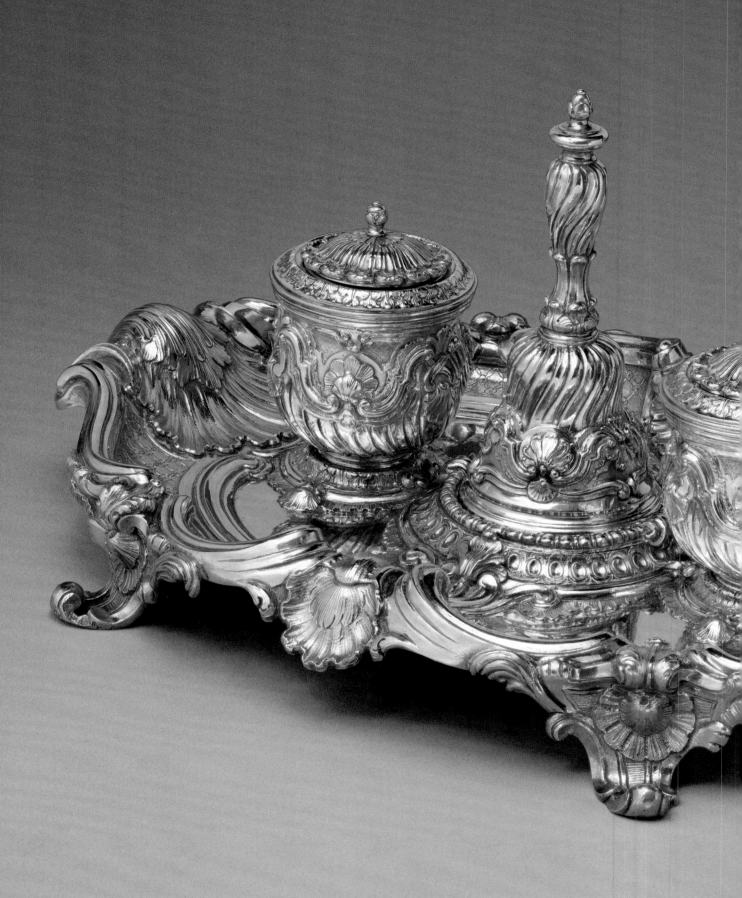

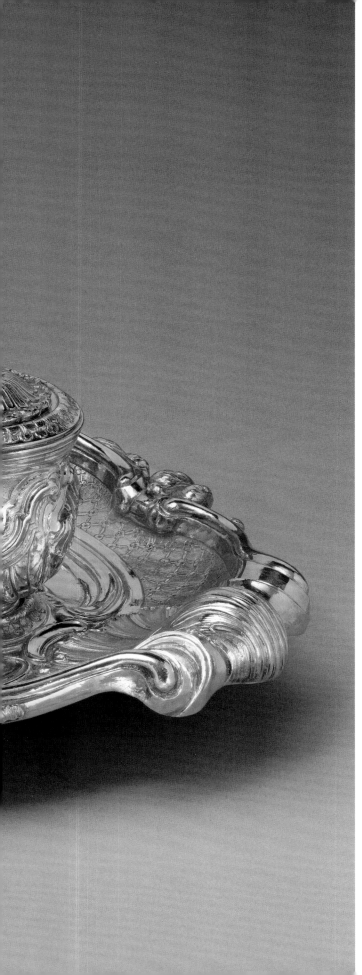

Inkstand

Andrea Boucheron (Italian, ca. 1692–1761)
Design attributed to
Francesco Ladatte (Italian, 1706–1787)
Italian (Turin), 1753
Gilded silver, 6 × 13 in. (15.2 × 33 cm)
Purchase, Wrightsman Fund, 1997
(1997.151.1a, b–.4)

The coat of arms of the House of Savoy, engraved on the stand underneath the bell, identifies this gilded-silver ink-stand as having belonged to the ducal court of Carlo Emanuele III (who also reigned as king of Sardinia) in Turin. Made by Andrea Boucheron, a Turinese goldsmith whose mark appears underneath the tray, the object is French inflected in its design. During the eighteenth century, the House of Savoy experienced periods of artistic exchange with Paris that stimulated its taste for luxury goods and spurred their manufacture. This is not surprising given Savoy's geographic location, its history as an ally of France, and the many relations of the ruling family with that country.

Appointed goldsmith to the court of Savoy in 1737, Boucheron had his own strong ties to France. According to his son Giovanni Battista, the elder Boucheron perfected his skills in the Paris workshop of the preeminent gold- and silversmith Thomas Germain and was fully conversant with Germain's work in the Rococo style. The design for this piece was possibly furnished by another artist from Turin, the sculptor and bronze-caster Francesco Ladatte, who resided in Paris for extended periods of time.

Burnished and matte areas, movement and symmetry, scrolls and shells, alternate beautifully in this exquisite inkstand, which is one of only a few existing pieces by Boucheron. The perfectly ergonomic scrolling handles are an inherent part of the design and make it easy to carry the object. Short, curvaceous legs lift the shaped tray off the ground while adding lightness and elegance to the

overall effect. The spirally fluted bodies of the bell, inkwell, and sander, which are kept in place by foot rims, create a sense of dynamism. All these sinuous lines are brilliantly reflected in the highly polished areas of the stand. By contrast, the inside rim of the tray has a dull finish. It is embellished with a finely engraved diaper-and-rosette pattern that, along with the overall symmetry, may have seemed a bit conservative by the early 1750s for French taste. Yet the date is corroborated by the fact that the only year when the services of Giovanni Damodè and Bartolomeo Pagliani, the assayers who tested the metal for silver content and struck their marks underneath the tray, overlapped was 1753.

The eighteenth century is often referred to as the age of letter writing. Because of the growing literacy rate among the middle and upper classes, communication by means of notes and letters became an integral part of daily life. Good penmanship and the art of composition were valued by polite society and were important aspects of a young person's education. These skills were taught by writing teachers and practiced with the aid of special copybooks and writing manuals. Once mastered, they required special implements such as this inkstand.

Before blotting paper was commonly used, fine sand or pounce (powdered resin) would have been shaken onto the paper to absorb the surplus ink. Decorated with the same diaper-and-rosette pattern as the tray, the sander's perforated lid (underneath the removable cover) allowed a measured amount of sand or pounce to sift through. A quill pen and a knife to cut and shape the quill's point could rest on the tray, while the bell would be rung once the handwritten document was finished, sealed, and ready for delivery. Both functional and highly decorative, luxurious inkstands like this one were frequently presented as gifts.

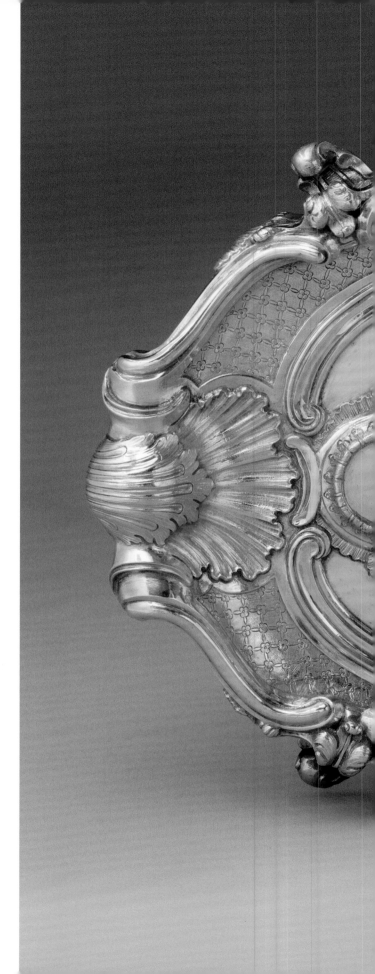

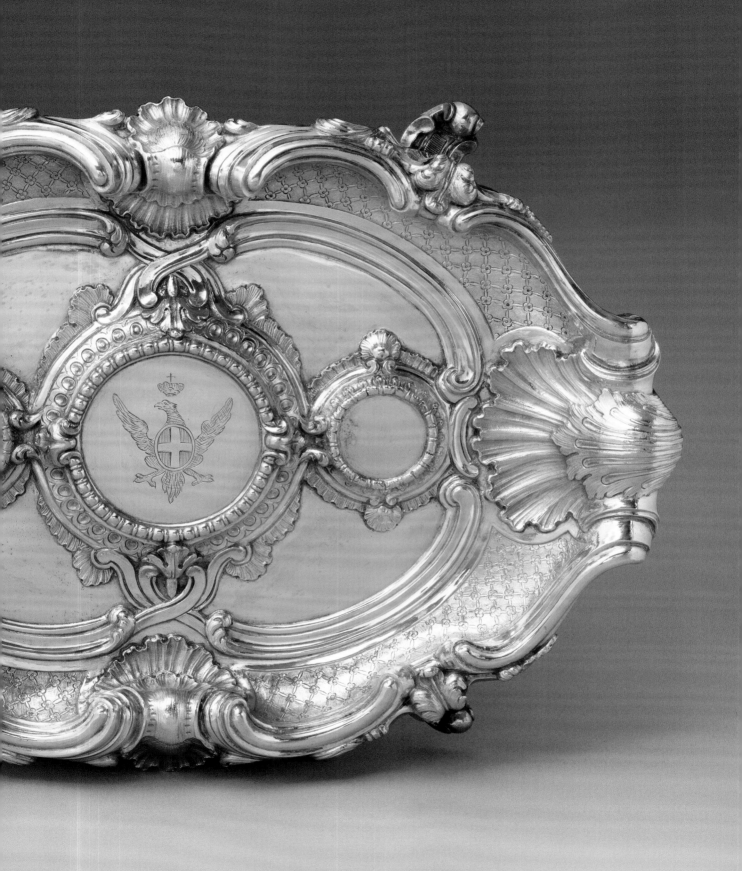

19

Broth Bowl with Cover and Stand (*Ecuelle*)

Castellet or Apt manufactory (France)
French (Apt), late 18th century
Tin-glazed earthenware, (stand) H. 1¼ in. (3.2 cm), Diam. 9⅝ in. (24.4 cm); (*écuelle*) H. 5¼ in. (13.3 cm)
Bequest of Flora E. Whiting, 1971 (1971.180.167a, b)

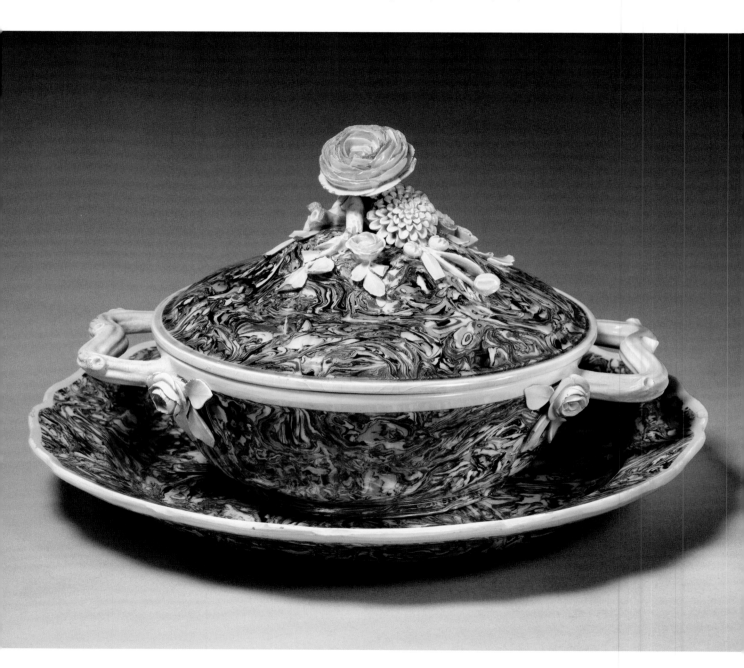

François Pierre La Varenne's renowned cookbook of 1651, *Le cuisinier françois* (*The French Cook*), is generally considered to mark the beginning of modern French cuisine. That its very first recipe is for bouillon attests to the important health benefits expected from taking broth, especially every morning in the bedroom during the lengthy ritual of the toilette. This savory liquid was served in an *écuelle*, a lidded bowl with two handles that was often provided with a matching saucer or stand, as seen in this example. The cover kept the contents warm and protected them from powder during the dressing of the hair or wig, while the handles prevented one's fingers from getting burned. The nourishment could be drunk straight from the bowl or taken with a spoon.

The court and the elite long favored *écuelles* of precious metal, which could be acquired individually or as part of a dressing table service; these remained fashionable until the mid-eighteenth century, when silver was often replaced by porcelain. Less costly and therefore available to a larger market were those made of pewter or earthenware, usually modeled after goldsmith work.

Dating from the late eighteenth century, this *écuelle* was created in the Apt region of the Vaucluse in southeastern France. The Moulin dynasty of potters was active in this area, which was rich in natural clay and ocher earth, for a century and a half. A workshop established in Castellet by César Moulin was operational by 1728 and was continued until 1852 by two of his descendants. Around 1776, Moulin's older sons, Claude François and Jean Barthélémy, who founded a separate manufactory in nearby Apt, are thought to have introduced the colorful marbling technique so wonderfully demonstrated in the present *écuelle*.

This technique, known in France as *faïence jaspée* (jasper-stone earthenware), became one of the defining characteristics of Apt ceramics, which are still created today. To produce earthenware like this, with a surface resembling various striated stones, the ceramist carefully wedged and blended together differently colored clays. It has been suggested, and it may well be true, that the Moulin brothers tried to imitate the popular English agate, or marbled, wares made by various Staffordshire potters. However, no one would mistake this covered

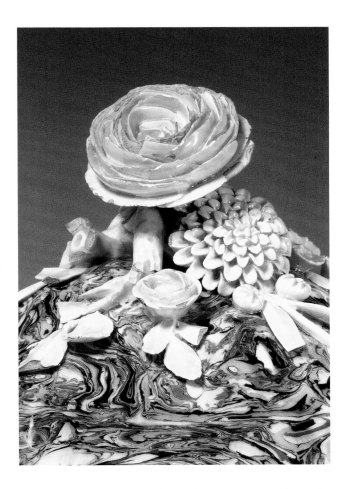

bowl and stand for a product of Britain. Not only is the *écuelle* a typically French object, but the ceramics produced in the Apt region also unquestionably distinguish themselves by their elegant shapes and the unique colors of the blended clays.

The overall shape of the bowl, cover, and saucer was obtained by the use of wood or plaster molds. By contrast, the serpentine handles in the form of branches and the naturalistic floral decoration that serves as a knob for the lid were modeled separately by hand in an off-white clay and attached before the first firing. The pieces were then dipped in a translucent lead glaze and fired again to achieve the coveted effect of polished stone. The desire to emulate a particular material in another medium is a common, and arguably whimsical, conceit in the decorative arts. While an outstanding example of the practice, this *écuelle* is unlikely to have deceived anyone.

Sugar Bowl with Twelve Spoons

Bendix Gijsen (Danish, 1765–1822)
Danish (Copenhagen), 1804
Silver and gilded silver, 13⅜ × 4⅝ in. (34 × 11.7 cm), L. (spoons) 4⅝ in. (11.7 cm)
Purchase, Friends of European Sculpture and Decorative Arts Gifts, 1991 (1991.242a–m)

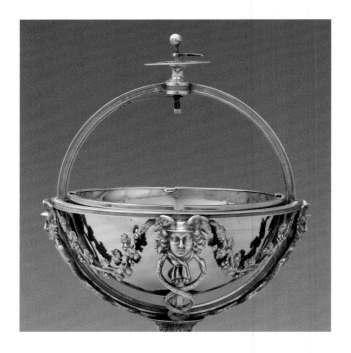

With a refreshing originality that exudes a sense of modernity, this Danish sugar bowl displays an aesthetic well ahead of its 1804 date. Consisting of a spherical container held aloft by a frame of horizontal and vertical bands, the object resembles a globe on a stand. The four masks adorning it, each with a winged helmet and a caduceus staff below, represent Mercury, the Roman god of commerce, who often served as mediator between gods and mortals. Connected by grapevine festoons, these masks decorate the lower half of the sphere.

A truncated, fluted classical column placed on a square plinth forms the base and imparts a sense of monumentality. The column doubles as a spoon holder with slots for twelve spoons. Echoing the curvilinear shape of the vessel above, the inward-facing bowls of the spoons suggest closing flower petals. The alternating use of silver and gilded silver—the lower half of the globe (the actual sugar bowl), its interior, and the spoons are all gilded—and the sparse ornamentation are as deliberate as they are subtle.

Quite ingeniously, the top half of the sphere retracts and opens (completely disappearing inside the exterior of the lower half) when the ball-shaped finial at the top is pressed, releasing a latch and a spring. A small rotating arrow floats above a movable ring disk that resembles a compass but is engraved with two consecutive sets of numbers, each ranging from I to XII, rather than indicating the four primary wind directions. The combination of the globular form, the "compass," and the Mercury masks seems to be a thinly veiled reference to international commerce and particularly to the importation of sugar.

Most sugarcane was cultivated in the West Indies, where various Caribbean islands, including Saint Croix, were Danish colonies. The sugar plantations were the source of great wealth, their profits reaped from the labor of enslaved Africans. This exploitation reached its peak at the turn of the nineteenth century, when a 1792 law to abolish the Danish slave trade was finally enforced in 1803.

Many sugar bowls belonged to the matching tea and coffee services that became fashionable during the eighteenth century. Working in a Late Neoclassical style, the Copenhagen silversmith Bendix Gijsen departed from more traditional shapes to create this extraordinary globular sugar bowl. Truly both a monument to sugar and an independent showpiece, it undoubtedly met with great success, since other, nearly identical examples by Gijsen are known.

The inscription on the plinth, bearing the names of Johanne Schjöth and Lieutenant Marcus Glahn on one side and the date of their marriage on another, strongly suggests that the piece was a wedding gift, with allusions to the hoped-for sweetness of a long-lasting union.

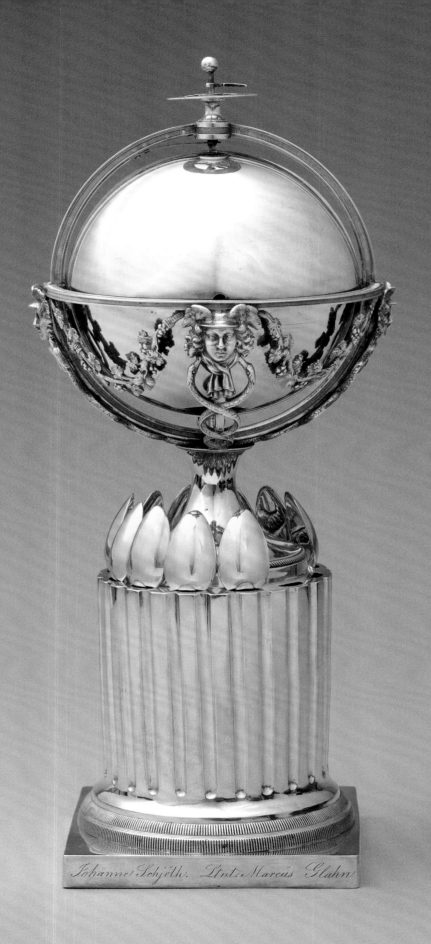

Johannes Schjöth. Ltnt. Marcus Glahn

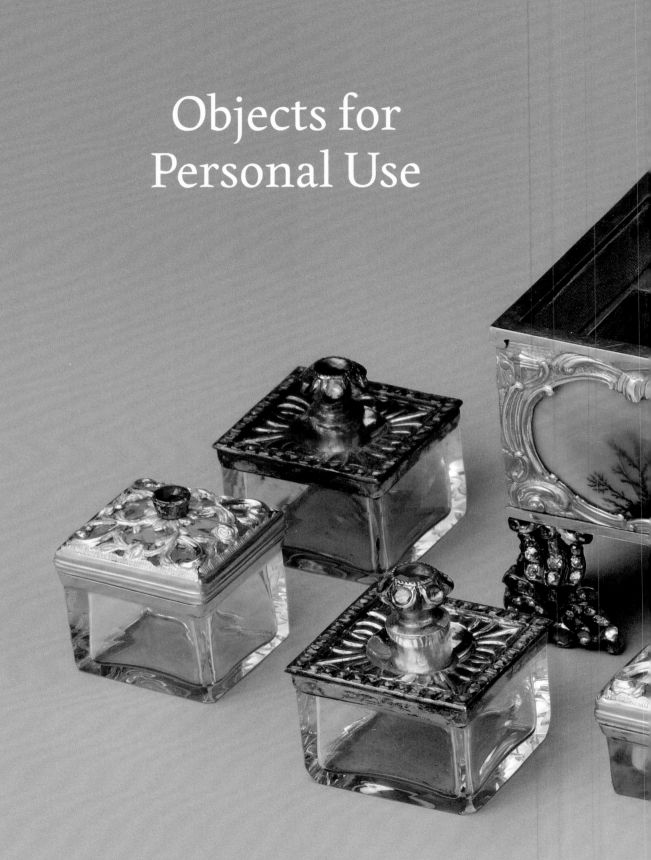

Objects for
Personal Use

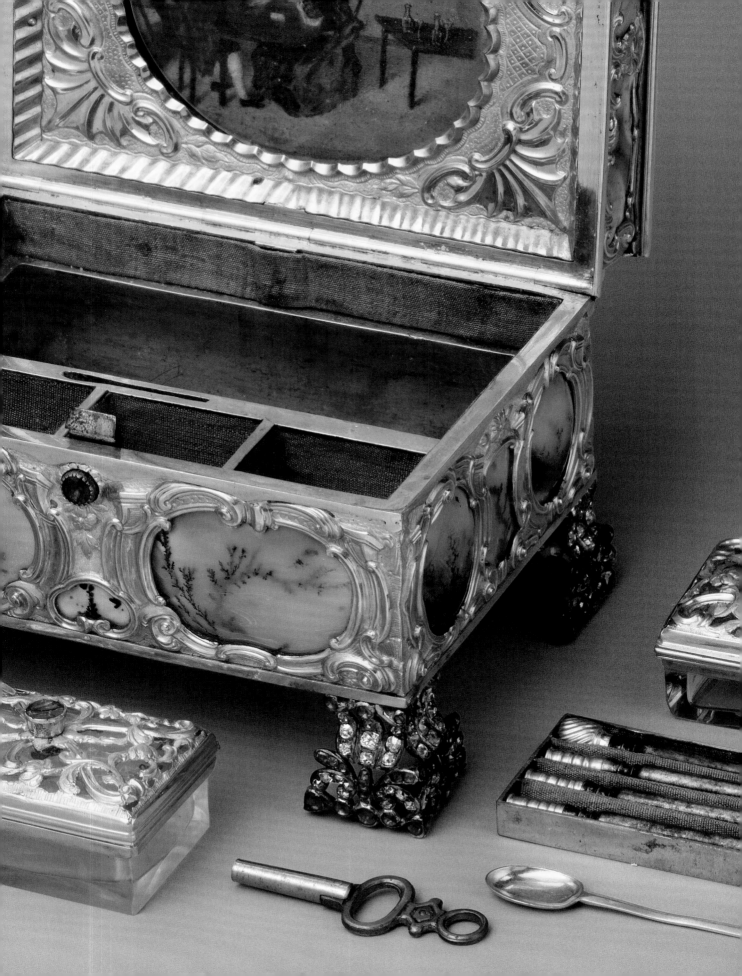

Clock Watch

British (London), 1600–1610
Movement by Michael Nouwen (British, born Brabant, active London, ca. 1582–1610, died 1613)
Case: gilded brass; Dial: gilded brass with blued-steel hand;
Movement: gilded brass and iron, Diam. 1⅞ in. (4.8 cm)
Gift of J. Pierpont Morgan, 1917 (17.190.1549)

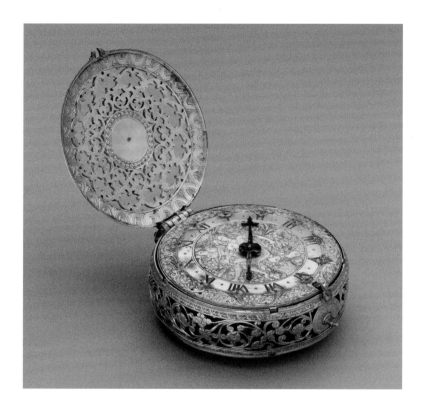

As much objects of personal adornment as timepieces, early watches were appreciated for their beauty as well as for their technical and mechanical aspects. Although these rare, costly luxuries were certainly not lightweight, they were nonetheless worn around the neck or suspended from a girdle on a cord or chain. The earliest references to timepieces intended to be carried on the body date back to the early sixteenth century. A century before, the introduction of the mainspring—basically a long, coiled ribbon of steel that replaced the suspended weight as the driving mechanism for clocks—had made it possible to produce smaller portable models for domestic use, the table clock being one example. This important innovation also led to the development of the miniature movement for the spring-driven watch.

The action of a spring is obviously more complicated than the simple motion of a weight, which is activated by the force of gravity. Whereas a weight exerts a constant force during its fall, the release of a fully wound spring produces a gradually decreasing force that decelerates the

movement. A special way had to be found to equalize this lessening force as the spring unwound. One of the earliest solutions, employed in this cylindrical watch, is a so-called stackfreed. A flat spring pressing against a rotating wheel, or cam, this simple mechanism provided greater opposition to the fully wound mainspring by reducing its pressure as it unwinds, thereby keeping the movement more accurate.

The present timepiece is known as a clock watch because it strikes the hours on a bell fitted inside its gilded-brass case, the sound resonating through the pierced sides. The openwork cover leaves the Roman numerals on the chapter ring visible (but not the half hours, designated by stars) so that without opening the lid the owner knew what hour it was. Provided with an hour hand but lacking a second hand to indicate the minutes, the watch still measured time by approximation. Quite ingeniously, and long before the invention of nightlights or digital clocks, the presence of a touch pin at each of the twelve numerals made it possible to feel the time after dark by running a finger over the dial.

The case of the watch is cast with intricate openwork designs of floral motifs and interlaced scrolls. Many of these details would have been carved in the wax model, and some of them may have been refined after its casting in brass. The face is engraved with a female figure within the chapter ring. Crowned with grain stalks, this allegorical representation of Abundance or Plenty carries a cornucopia and sits on a basket overflowing with fruits. Her attributes, symbolizing the copiousness and richness of the Earth, are based on those found in Cesare Ripa's emblem book *Iconologia*. First published in 1593 without illustrations but enhanced with woodcuts in an edition of 1603, Ripa's work became an influential source for allegorical depictions.

The movement of the watch is signed by Michael Nouwen, a member of a family of clockmakers who was born in 's-Hertogenbosch, Brabant (now The Netherlands). Working in London from about 1582, Nouwen may have fled his native city during the Dutch revolt against Spanish rule. English clockmaking certainly benefited from the influx of the highly skilled craftsmen who emigrated from France and the Low Countries, bringing with them new technology. Their knowledge and excellent workmanship made London an important center of horology. Yet, despite a constant desire to achieve greater accuracy, which in turn led to many technological advancements in clockmaking, time remained and remains inexorable and elusive.

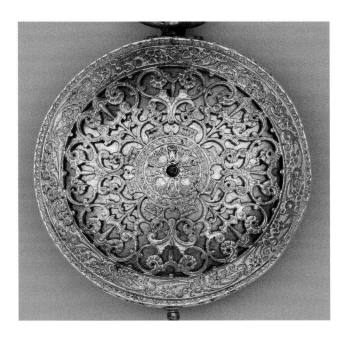

Pomander

Probably Dutch, first half of the 17th century; chain and ring, 19th century
Silver, (skull) ⅞ × ⅞ × 1¼ in. (2.2 × 2.2 × 3.2 cm)
Bequest of Rupert L. Joseph, 1959 (60.55.8a, b)

An hourglass, an extinguished candle, wilted flowers, a skull—these are traditional symbols in painting and sculpture for *memento mori*, reminders that time is fleeting. This sentiment is powerfully evoked in certain seventeenth-century watches made in the shape of a human skull. While the crania of those watches open up horizontally to reveal the dial and hours inside, this small cast-silver skull opens vertically to disclose a partitioned cavity within. Covered by a movable lid, this cavity is divided into six minuscule compartments. The letters D, A, B, F, C, and C^I, inscribed on the lid, allude to the minute quantities of various aromatics or spices kept in each of the pockets. A removable screw securing the two halves is attached to a chain and ring of later date that allow the piece to be worn either as a pendant or suspended from a belt or girdle.

With its fragrances gently wafting through the hollow eye sockets and perforated teeth, the skull was used as a pomander. Derived from the French term *pomme d'ambre* (literally, apple of amber), this device was originally made from a tiny ball of ambergris, a rare, strongly scented substance produced in the digestive tract of sperm whales and washed ashore in chunks. The material, mounted in an openwork case of precious metal, was worn as a piece of jewelry (fig. 27). Gradually, the name "pomander" was given to the small, often costly vessels that contained tiny quantities of sweet-smelling plant resins, such as labdanum, aloeswood, storax, or benjamin, to which an animalic fragrance like musk, civet, or ambergris was added to impart a lasting scent. To compensate for the distinct lack of personal hygiene at the time, both men and women would use such accessories, which emitted a pleasant odor when carried on the body or held to the nose. In addition, the released fragrance was alleged to protect the owner against miasmas that caused highly contagious diseases, including pestilence. The skull-shaped pomander as a prophylactic charm was particularly fashionable in Germany and the Netherlands.

Recipes for the preparation of preventive medicines were offered in medieval manuscripts. Also popular with a wide readership, from the sixteenth through the eighteenth century, were the volumes known as books of secrets, which contained home remedies as well as useful household tips. The owner of this pomander may have turned to such manuals for practical information about the best therapeutic substances even though the engraved letters inside suggested resins of specific ingredients; for instance, cinnamon, cloves, camphor, or citrus may have been stored in the chambers indicated with C and C^I.

This portable accessory fulfilled two obvious tasks: its contents were designed to serve as protection against disease, while its overall shape was an explicit reminder that no matter what precautions one takes, earthly demise was inevitable.

Fig. 27. Copy after Conrad Faber von Creuznach (German, ca. 1500–1552/53). *Heinrich(?) vom Rhein zum Mohren (1477–1536) Holding a Pomander*. German(?), late 1520s. Oil and gold on oak, 21¾ × 15⅝ in. (55.2 × 39.7 cm). The Jack and Belle Linsky Collection, 1982 (1982.60.37)

Box for Rouge and Patches

British (London), ca. 1750–55
Agate and gold; animal hair, 1 × 2⅛ × 1⅝ in. (2.5 × 5.4 × 4.1 cm)
Bequest of Kate Read Blacque, in memory of her husband,
Valentine Alexander Blacque, 1937 (38.50.6a–c)

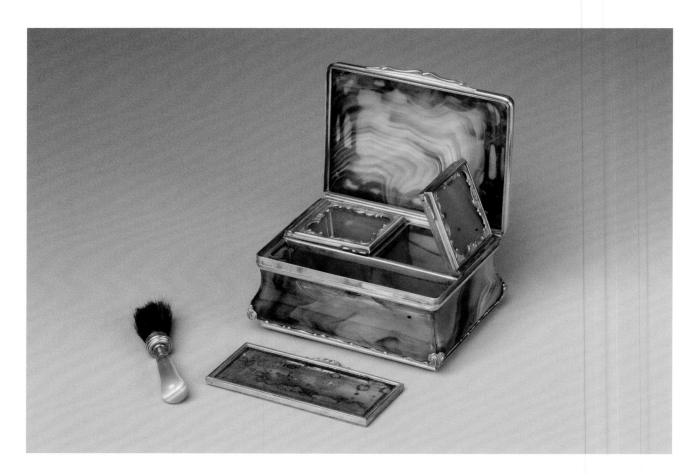

The interior of this elegant mid-eighteenth-century gold-mounted agate box leaves no doubt that it was used as a case for cosmetics. When lifted by its shaped thumbpiece, the cover opens to reveal three compartments: the largest for storing a rectangular mirror and an animal-hair brush for the application of rouge, and two covered receptacles, one for the rouge itself, the other for beauty spots.

Because of its fibrous texture, the agate permitted effortless carving that gave the sides of the box a subtle,

doubly curved profile. The main decoration consists of the mineral's irregular bands of colors, ranging from gray to brownish-pink. The transparent stone panels are held in place by a molded gold frame embellished with C- and inverted-C scrolls; on the lid, the scrolls are interlaced with floral garlands and a rocaille shell, and on either side with two classical columns supporting an architrave.

The custom of plastering the face with thick layers of white paint before applying streaks of contrasting rouge

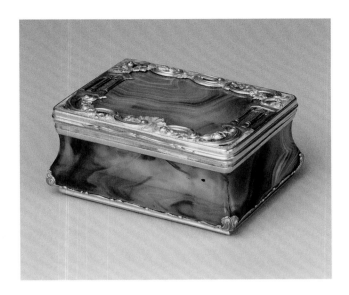

Fig. 28. Gilles Edme Petit (French, 1694–1760), after François Boucher (French, 1703–1770). *Le matin: La dame à sa toilette* (*Morning: Lady at Her Dressing Table*). French (Paris), mid-18th century. Etching and engraving, 12⁷/₁₆ × 8½ in. (31.5 × 21.6 cm). Harris Brisbane Dick Fund, 1953 (53.600.1042)

was very fashionable at the French court, and the habit spread widely from there. By the middle of the eighteenth century, French taste in cosmetics dominated Europe despite the fact that Puritans and other critics disdained the use of makeup as vain and sinful. These naysayers decried artificial beauty not only as indicative of a decline in morality but also (and more demonstrably) as detrimental to one's health. Whether enhancing natural good looks or concealing the ravages of time, many cosmetic products contained lead carbonate, which could cause blood poisoning and even death.

Beauty spots are thought to have originated in the late sixteenth century from the practice of pasting small pieces of black fabric with ointment to the affected cheek to cure a toothache. The use of such face stickers, called *mouches* (flies) in French, became more common during the next two centuries to obscure pockmarks, scars, and other skin blemishes. This embellishment of the face with black velvet, silk, or taffeta patches was further stimulated by the fact that Venus, the goddess of love and beauty, allegedly had a mole on her cheek that made her more desirable. Accentuating the fairness of the complexion, the patches came in a variety of shapes, ranging from dots to hearts and from stars to crescent moons. Held on the tip of the second finger, they were adhered to the skin with saliva or a type of glue known as *eau de gomme* and were sported by men and women alike (fig. 28).

This particular box was most likely made in London. Its tiny hinges, allowing the cover and the inside compartments to close tightly, are proof of the goldsmith's skill. A Paris gold mark on the outside rim suggests that the piece was probably retailed in France, where British-made luxury goods were offered for sale in so-called *magasins anglais* (English shops).

The luxurious nature of this arguably practical object made it the ultimate fashion accessory, either to be carried on one's person or placed on the dressing table. Adding to the allure of this box was the romantic idea that agates were thought to be wish-fulfilling stones for women, helping them to capture the lover of their dreams. Let us hope that a little rouge and a beauty patch were enough to make the owner's fantasies come true.

24

Traveling Set

Silversmith I.F.
Hungarian (Ersekújvár; Slovakian, Nové Zámky), ca. 1760
Silver, partly gilded; steel; tooled leather, (box) 1⅞ × 13½ × 3⁷⁄₁₆ in. (4.8 × 34.3 × 8.7 cm)
Gift of The Salgo Trust for Education, New York, in memory of Nicolas M. Salgo, 2010 (2010.110.57a–i)

With the possible exception of a pocketknife, eating utensils are not habitually carried by people today. Yet until the late seventeenth century, diners customarily brought to meals their personal knife and spoon, usually in a leather sheath worn suspended from a belt or chain (fig. 29); before this period, forks were generally not used, and people ate mostly with their fingers. With the development of flatware services designed to be placed on the table, the practice of bringing one's own cutlery declined except for use while traveling. Luxurious sets, often consisting of substantially more than the complement of basic silverware, were created so that the owner could enjoy the comforts of dining at home while on a journey.

This travel garniture, or ensemble of decorative objects, was made around 1760 in Ersekújvár, a town then located in Hungary (today Nové Zámky, Slovakia), which at the time had its own gold and silver deposits, an active mining industry, and a flourishing guild system. To

Fig. 29. Tobias Stimmer (Swiss, 1539–1584). *Elsbeth Lochmann, Wife of Jacob Schwytzer.* Swiss (Schaffhausen or Zürich), 1564. Tempera on linden, 75³/₁₆ × 26³/₁₆ in. (191 × 66.5 cm). Kunstmuseum, Basel (578)

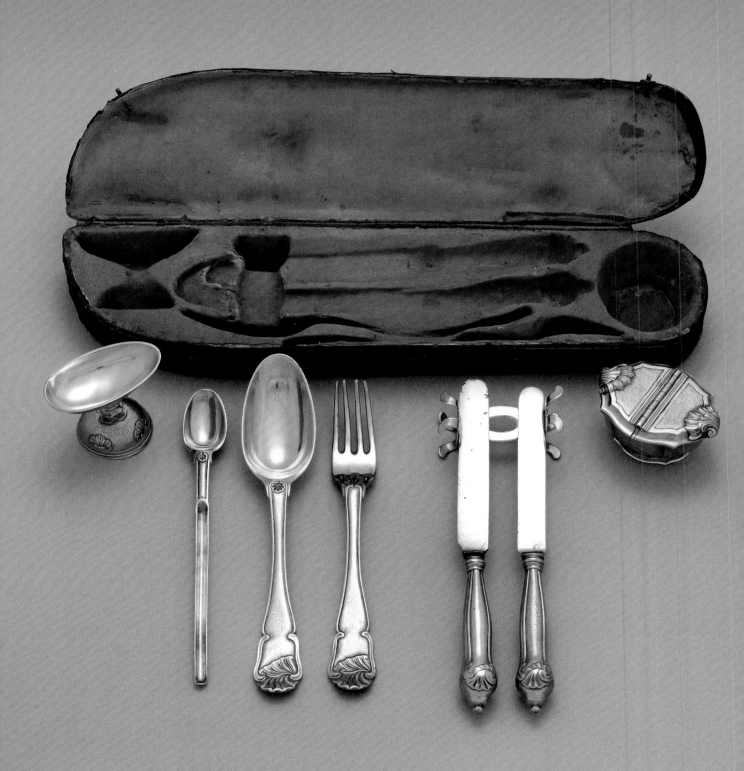

prevent the individual pieces from moving or scratching, they are tightly fitted in their original tooled leather case. The eight gilded-silver objects include two knives, a fork, a large and a small spoon, a knife rest, a double-lidded spice box, and an eggcup. Except for the unadorned knife rest, the pieces are embellished with rocailles and shells characteristic of the Rococo style, which was then fashionable throughout Europe. Such embossed decoration, achieved by hammering the silver against a die in which the desired ornament had been cut out, was frequently added to both sides of cutlery handles and to the bowl of the spoon, as it is here. In addition, the individual pieces of the set have highly burnished areas alternating with those that are punched and matted.

As eating habits changed, the shape of the knife was adjusted accordingly. Initially, the blades were sharply pointed to cut and skewer meat before conveying it to the mouth. But during the eighteenth century, when the fork became a more commonplace dining utensil, the blade tips became blunter and mostly rounded, a change reflected here. The slight serpentine outline of the hafts of these particular knives allows for ease of handling. The table knife was used for the main course, while the second, smaller knife in this set was probably reserved for eating dessert. Although the fork changed little over time, the earliest two-pronged examples were gradually replaced by those with three or, around 1760, four tines, as shown by the fork in this set.

The large spoon was meant for liquid and viscous food, while the one with a long, narrow scoop was for extracting marrow. The fatty tissue from a baked bone was considered a delicacy, eaten like butter or employed in recipes found in contemporary cookbooks such as marrow pudding. Introduced around 1700, this special spoon could be used at either end according to the size of the bone. The eggcup was similarly versatile: a hard-boiled egg would be placed horizontally for cutting in the oval-shaped bowl, a soft-boiled one could be served upright in the round holder on the other side. The spices for seasoning stored in the spice box were kept dry and fresh by the tightly closing lids. As they were imported from distant lands, possession of many fragrant spices such as ginger, cinnamon, pepper, and saffron were, just like the travel set itself, a sign of affluence and luxury.

The gilding, a thin coating of gold applied on the silver to prevent it from tarnishing, shows signs of wear, especially on the cutlery, suggesting that this flatware was not merely decorative but indeed used. Considering that precious metal was regularly melted down in order to create more fashionable pieces or simply for its monetary value in times of need, it is fortunate that this elegant set is still complete. It certainly conveys both the literal and figurative meanings of "traveling in style."

Nécessaire

James Cox (British, ca. 1723–1800), entrepreneur
British (London), ca. 1770–72
Case: moss agate, mounted in gold and set with diamonds, emeralds, garnets, and paste jewels; silver;
Dial: white enamel; blue silk lining; glass; steel; gouache, 3⅜ × 3⁹⁄₁₆ × 2⅛ in. (8.6 × 9 × 5.4 cm)
Gift of Florence Harris Van der Kemp, 1957 (57.128a–o)

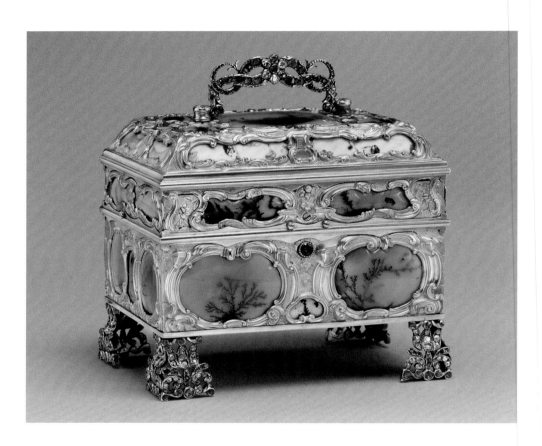

Made in the workshop of James Cox, this English *nécessaire* is an excellent example of the type of complex and sumptuous trinkets that Cox retailed to prosperous customers, and the story of its creation features this ambitious, well-known, but not always successful entrepreneur. In eighteenth-century Britain, this sort of mechanical object was considered a luxury "toy" and was available in specialty shops. Such establishments were described in a French literary journal of 1734 as "Dealers in all kinds of Jewels, delicacies, and gallantries" who "sell for their

weight in gold trifles one is ashamed of having bought after leaving the place."

A *nécessaire de poche* (pocket *nécessaire*) is a small casket made of precious materials and fitted with tiny implements for personal grooming, writing, or sewing. In addition to the minute vanity tools, the present case contains a watch and an automaton. Advertising himself as a London goldsmith on his trade card, Cox offered a "Great Variety of Curious Work in Gold, Silver and other Mettals: also in Amber, Pearl, Tortoisshell and Curious Stones."

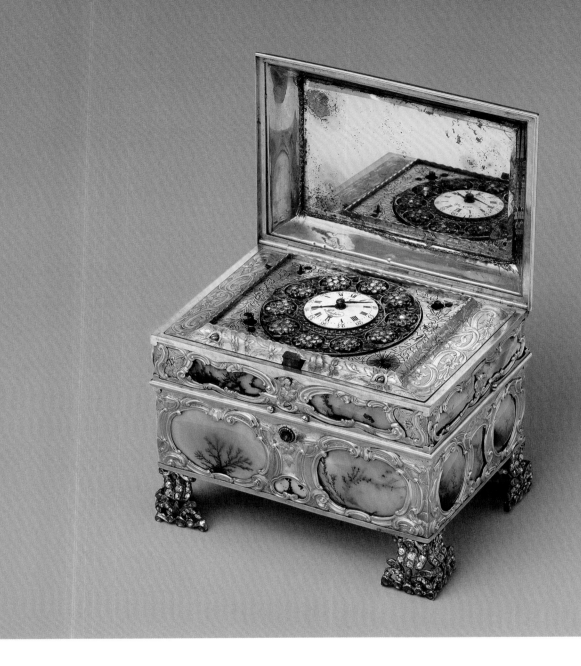

Since the text of this card was printed in English, French, and German, Cox clearly courted an international clientele.

Qualifying as one of the "curious" stones is the milky white mineral decorating the exterior of this opulent *nécessaire*. Known as moss agate, it contains striking dark inclusions that resemble plants, panels of which are set within a gold symmetrical frame, or cagework, chased with Rococo-style scrolls, shells, and floral motifs. The rectangular case is supported on four pierced bracket feet set with diamonds and garnets. Two entwined serpents

mounted with faceted and graduated emeralds form the movable, open-loop handle, known as a bail handle.

Once opened, an outer or "false" cover lined with a mirror reveals a silver inner cover engraved with floral motifs and centered by an enameled watch. The time-piece is framed by a ring pavé-set with red paste "rubies" and with ten transparent paste "diamond" rosettes or stars. When activated by a lever, the rosettes revolve both within the ring and individually, while another lever reg-ulates the rotating speed from slow to fast. The spinning

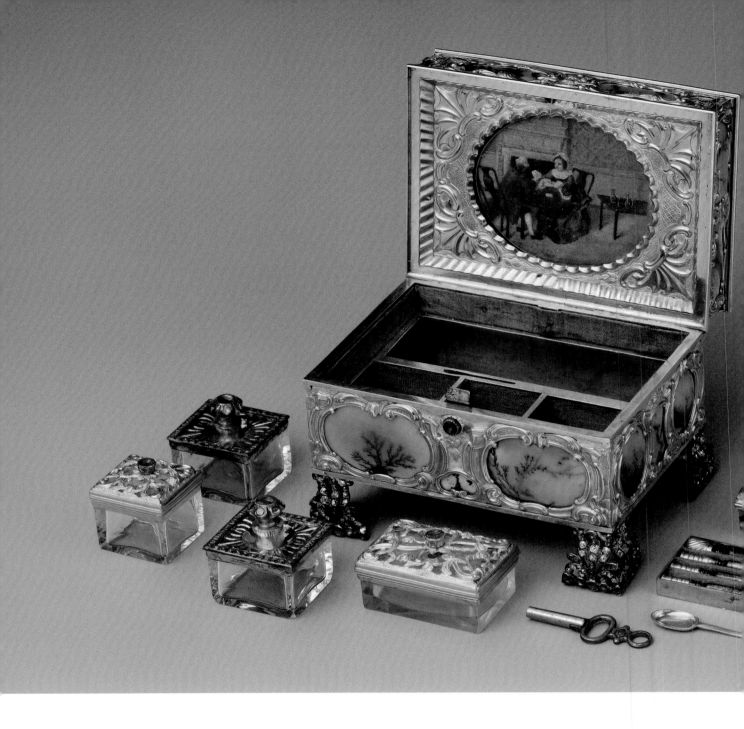

movement makes the imitation diamonds shine and sparkle like miniature disco balls, undoubtedly to the delight of the owner (and possibly the envy of others). The turning "diamond" rosettes were a signature feature of Cox's merchandise and appear on other luxury items sold by him, including an automaton watch also in The Met collection (fig. 30).

A garnet button on the front of the casket releases the actual or inner cover to display an oval miniature of a card-playing couple that conceals the back of the automaton's mechanism. The case, lined with blue silk, includes five glass-and-gold containers for scents and cosmetics as well as a removable tray fitted with tiny implements, including an ear spoon, toothpick, and dental scraper

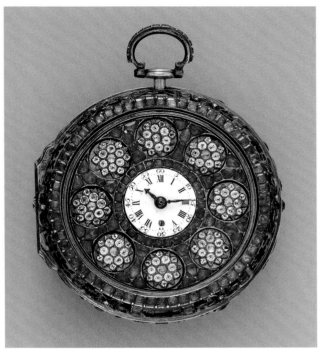

Fig. 30. James Cox (British, ca. 1723–1800), entrepreneur; Peter Mounier (recorded in London 1761–73), case maker. Pair-Case Automaton Watch. British (London), ca. 1770. Outer case: gold, partly enameled and set with gemstones and paste jewels; Inner case: gold; Dial: white enamel, with frame set with paste jewels; Movement, with verge escapement and diamond end stone, $2^{1}/_{2}$ × $1^{11}/_{16}$ × $^{15}/_{16}$ in. (6.4 × 4.4 × 2.3 cm). Gift of Audrey Love, in memory of C. Ruxton Love Jr., 1977 (1977.436.4a, b)

retailer. As such, he depended on a great number of specialized craftsmen and suppliers who did not mark their works. Cox may have been responsible for the design of his pieces, but even that is not documented. It is known, however, that he provided a great many jeweled clocks and automata for export to China and India, where they were much in demand. It is possible that this *nécessaire* was similarly made for the foreign trade.

Overproduction, a ban on Cox's shipment of luxury goods to China, and the resulting financial difficulties forced the ingenious entrepreneur to declare bankruptcy in 1778 and to move on to other ventures. Nevertheless, his fancy toys continued to enchant and delight: in 1925 King George V gave Queen Mary a comparable *nécessaire* for Christmas (Royal Collection, London, RCIN 6538).

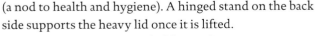

(a nod to health and hygiene). A hinged stand on the back side supports the heavy lid once it is lifted.

Although the watch dial bears the Cox name, it is unlikely that he made the movement. Despite the fact that he called himself a goldsmith, he is not recorded as a member of either the goldsmiths' or clockmakers' guild and likely acted principally as an entrepreneur and

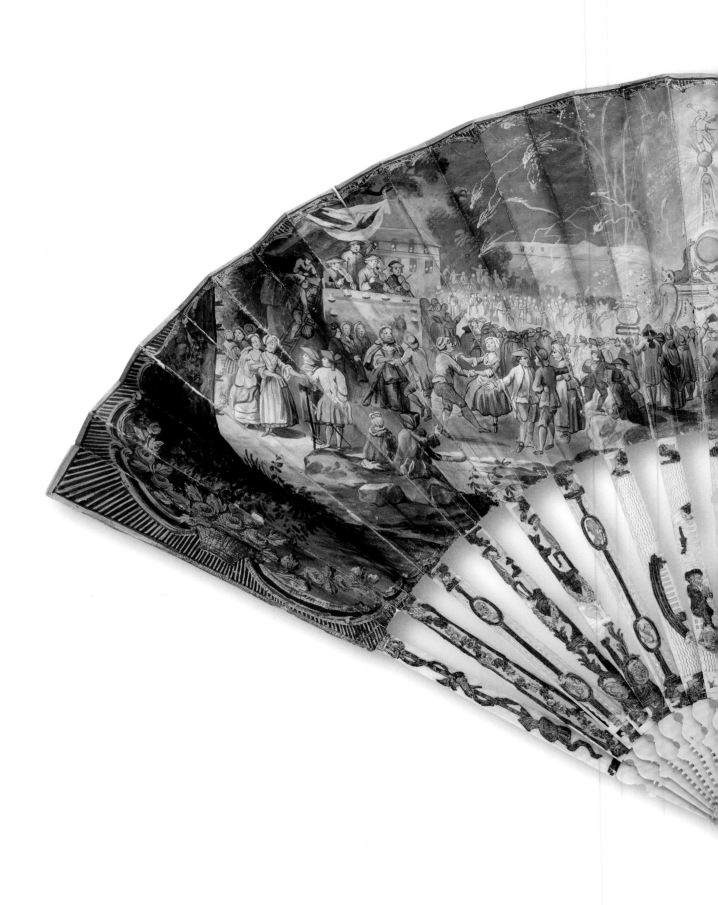

Folding Fan

French (Paris), ca. 1783
Painted paper; ivory, partly silvered and gilded;
strass rivet, 10½ × 18¾ in. (26.7 × 47.6 cm)
Gift of Mrs. Henry J. Bernheim, 1959 (59.13.7)

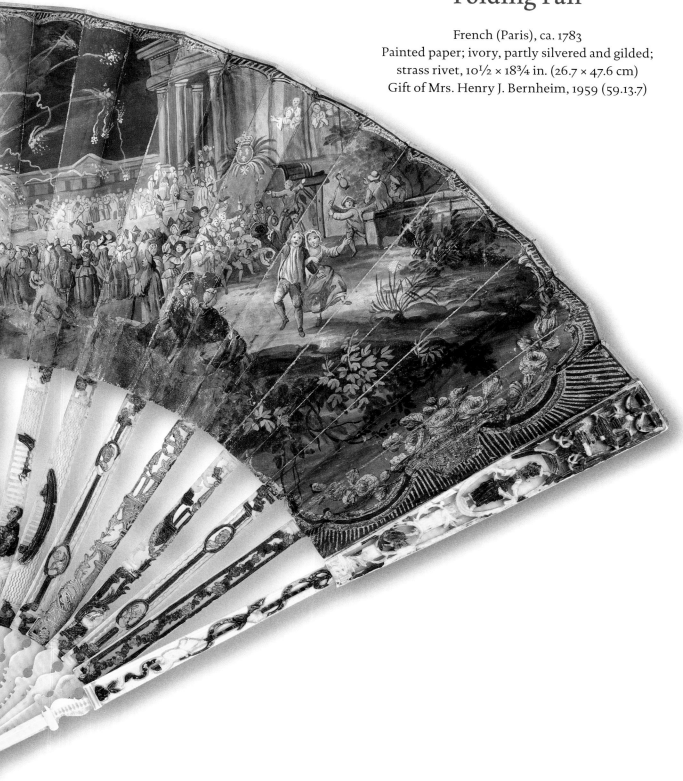

Introduced to Europe from the Far East during the sixteenth century, the folding fan was primarily used to cool oneself and to protect the skin from flushing from the heat. By the eighteenth century, however, these personal items had become ubiquitous and indispensable fashion accessories for well-dressed ladies.

Paris was one of the main centers in Europe for the production of fans, the fabrication of which was divided between two guilds: that of the *tabletiers*, responsible for the handles (*montures*), consisting of sticks and guards held together at the base with a rivet, and that of the *évantaillistes*, or fan painters. The latter were responsible for decorating and pleating the fans as well as for assembling and selling them. Since the painters rarely signed their work, it is difficult to attribute particular examples to a specific artist or workshop.

Among the various materials employed for the *montures* were wood, bone, tortoiseshell, and mother-of-pearl. The handle of this particular fan is made of openwork ivory, partially enriched with gold and silver leaf. Decorated

with symbols of love, such as torches, bows, and quivers filled with arrows, the sticks and guards also display garlands, roundels with busts, and numerous human figures.

Rather than embellishing the front of the fan with a traditional biblical, mythological, or genre scene, the painter here seems to have depicted a specific event. Attended by a large crowd of merry spectators, including the turbaned onlookers visible in the windows of the building on the left, a magnificent fireworks display brightens the evening sky with erupting rockets and flares. The pyrotechnics emanate from a centrally placed obelisk topped by a figure of Victory. The royal origins of these festivities are implied by the presence at the top right of a crowned shield adorned with three fleurs-de-lis (or lilies, the symbol of the French monarchy) and by the distinctive star of the chivalric order of the Saint Esprit (Holy Ghost) below the shield. The dolphins at the foot of the obelisk suggest that the celebrants are paying tribute to the birth of a *dauphin*, or crown prince. An heir to the French throne was in fact born on October 22, 1781: Louis Joseph,

Fig. 31. Jean Michel Moreau (French, 1741–1814). *Le feu d'artifice: Fêtes données au Roi et à la Reine, par la Ville de Paris le 21. janvier 1782 à l'occasion de la naissance de Monseigneur le Dauphin* (*Fireworks: Entertainment organized by the City of Paris on January 21, 1782, for the King and the Queen upon the occasion of the birth of the Crown Prince*). French (Paris), 1782, reprinted ca. 1860. Etching and engraving, 20½ × 30 in. (52 × 76 cm). Harris Brisbane Dick Fund, 1930 (30.22[34.50])

second child of King Louis XVI and Queen Marie Antoinette, and a member of the order of the Saint Esprit from birth. As documented in an etching by Jean Michel Moreau, extravagant fireworks were organized in Paris on January 21, 1782, to commemorate the joyous event (fig. 31). If this fan can indeed be associated with Louis Joseph's birth, the artist has succeeded in rendering his own version of the pyrotechnics, which, when the fan is furled and unfurled, seem to ignite and explode anew.

The reverse of the fan, generally less elaborately decorated than the front, shows a garden scene with water-

works and several elegantly dressed visitors. It is worth noting that the two female figures carry fans, one of them using it to shield her complexion against the sun. Although the myth that a woman could coyly express herself through a subtle movement of her fan has largely been debunked, the choice of luxurious materials for the *monture* and the royalist subject on the front speak eloquently about the elite status and monarchist predilections of its owner.

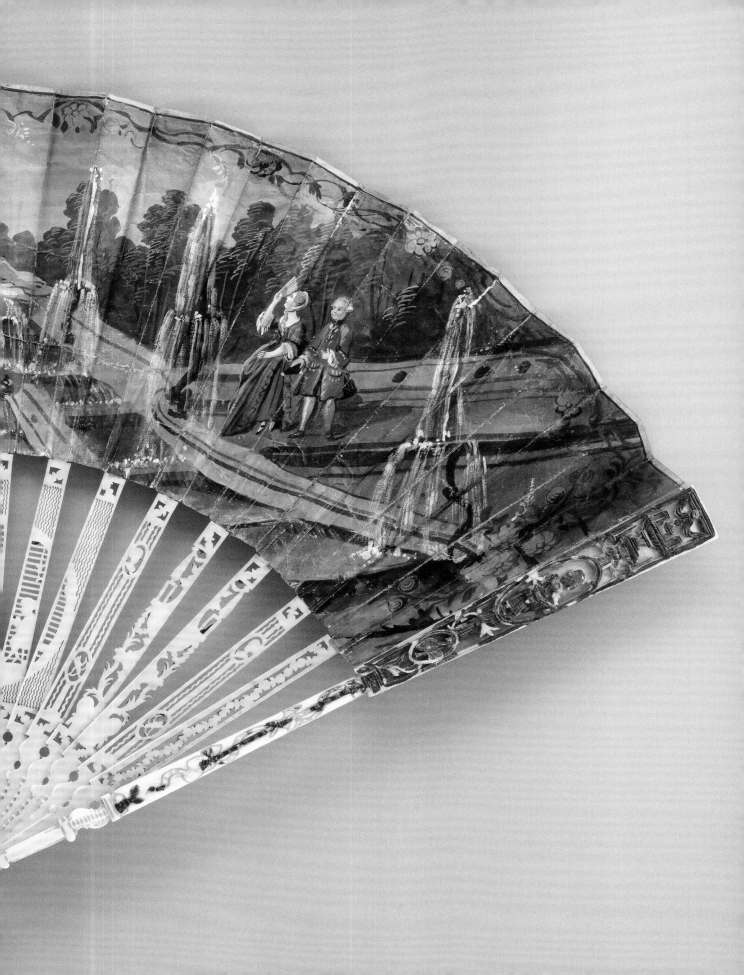

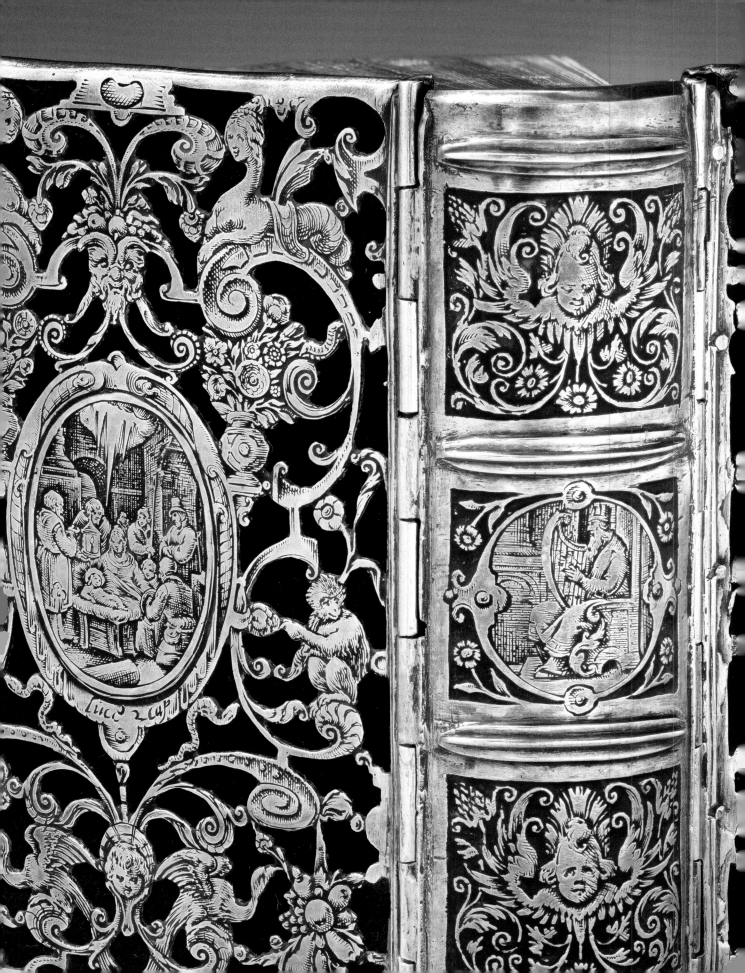

Luca 2 cap.

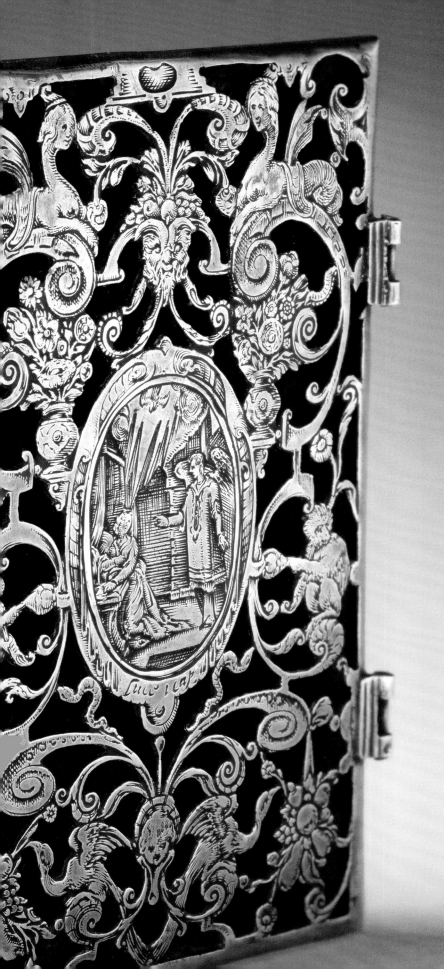

Objects of
Devotion

Chalice

French (Paris), 1532–33
Gilded silver, H. 8¼ in. (21 cm)
Purchase, Mr. and Mrs. John H. Gutfreund Gift, 1996 (1996.287)

The celebration of the Eucharist, also called Holy Communion, commemorates Christ's sacrificial death on the cross and is the most important sacrament of the Christian faith. According to the teachings of the Roman Catholic Church on transubstantiation, the bread and wine used in the Communion service are miraculously changed into the body and blood of Christ. Over the centuries, donors would commission splendid liturgical implements for this solemn rite—a chalice to serve the wine and a paten, or plate, for the bread—to celebrate the glory of God as well as to bestow prestige on themselves.

According to the marks on the foot and lip, this gilded-silver chalice was created in 1532–33 in Paris, then a center renowned for its goldsmith work. While the overall outline of the cup, which is supported on a cylindrical stem with a knot near its midpoint, and its ten-lobed base remain medieval in nature, they are here combined with several distinctly Renaissance elements. Both the wreath encircling the domed foot and the fluted stem reminiscent of a classical column derive from the ancient works of art that served as inspiration during the Renaissance.

Rather than using overtly religious imagery, as might be expected, the unknown goldsmith selected the so-called *à soleil* (sun) design. The undulating rays of this pattern, a popular one for French church plate throughout the sixteenth century, embellish both the foot and the double-walled cup while lending the chalice a vivid quality. These sunbeams are executed in a technique known as repoussé, which involves hammering from the back side (see no. 30). In a striking contrast with the matte punched ground, the burnished rays literally radiate light. The sun symbolism most likely derives from the Scriptures, which include multiple references to light.

The Bible book Malachi, for instance, uses the "Sun of righteousness" to refer to Christ (4:2), and Christ himself is quoted in the Gospel of Saint John (8: 12) as stating, "I am the light of the world: he that followeth me shall not walk in darkness, but shall have the light of life."

The use of the French lily (fleur-de-lis) decoration on the cup is, however, more difficult to explain. Although this emblem has traditionally been associated with the sovereignty of the French kings, its presence on sixteenth-century liturgical objects does not necessarily proclaim a royal provenance. In fact, the coat of arms of Fabio Mirto Frangipani displayed on the foot of the vessel gives some indication of its history. As the abbreviated Latin inscription surrounding the armorial shield indicates, Frangipani was bishop of Caiazzo in southern Italy. He served as papal nuncio to France from 1568 to 1572 and again in 1586 (he died in Paris the following year). Although departing envoys and ambassadors often received gifts of silver from the king, this piece was already forty years old when Frangipani's first diplomatic term ended. Moreover, careful examination shows that the present heraldic bearing replaced an insert that probably displayed the arms of a previous owner. The ten medallions with the fleur-de-lis on the stem, which differ in character and gilding color from the ones on the cup, also appear to be later additions.

Despite these alterations, this Paris chalice is a precious, rare survivor of the vicissitudes of much ecclesiastical silver, which was pillaged or destroyed in great numbers during the French Revolution.

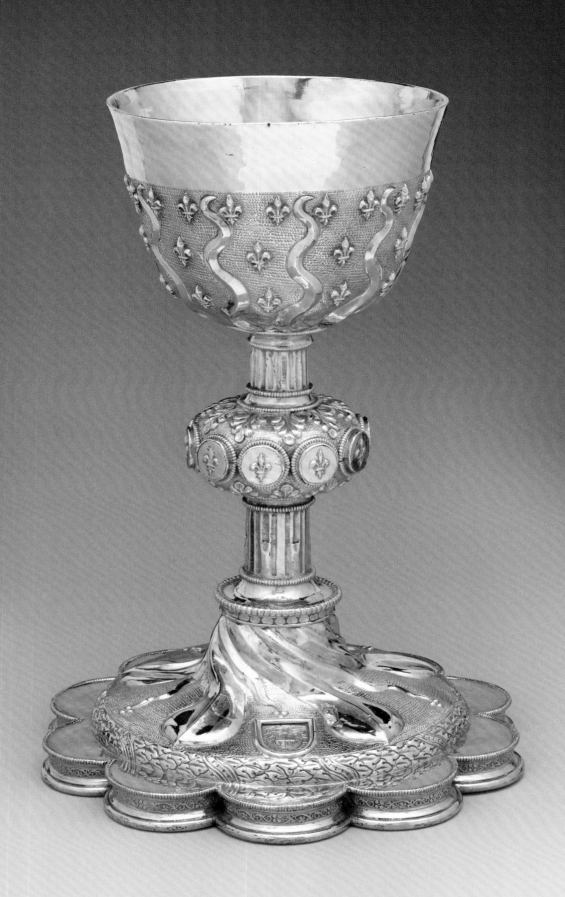

Book Cover

Dutch (possibly Amsterdam), ca. 1610–20
Silver; black velvet lining, 3⁷⁄₁₆ × 2¾ in. (8.7 × 7 cm)
Rogers Fund, 1937 (37.125)

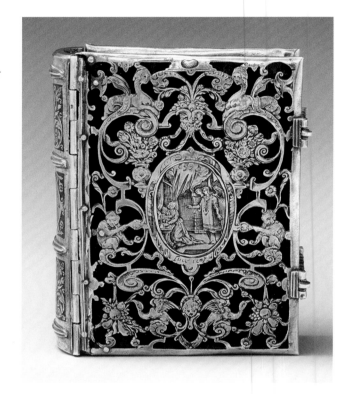

Protestantism's emphasis on Bible reading by the individual believer led to its being called the Religion of the Book. Founded in 1571, the Dutch Reformed Church encouraged religious education, and by 1700 a notable proportion of the adult population in the Netherlands (some fifty-seven percent) could read. The Reformation inspired new translations of the Bible, especially rhymed versions of the Psalms to be sung by the faithful during private or public worship. Few texts have been as influential in Europe as the hundred and fifty Psalms that are bound, along with other religious tracts, in this precious silver book cover.

Enclosing a contemporary Psalter accompanied by musical notes, the delicate openwork silver displays symmetrical decoration that includes sphinxes, monkeys, birds, caterpillars, coiling snakes, grotesque masks, and flower vases, all interconnected by slender scrollwork. In contrast to this purely secular decoration are the oval medallions placed in the centers of both sides of the binding. The Annunciation is flat-chased (engraved) on the front cover, with the Adoration of the Shepherds on the back. An inscription underneath each medallion indicates that these scenes, which may have been based on Bible illustrations, are derived from the Gospel of Saint Luke. The ribbed spine depicts a roundel with King David playing his harp, a direct allusion to the Psalms. Black velvet lines the pierced covers, while the background of the solid spine is darkened with black wax. This striking contrast of light ornament against a dark ground is not unlike the effect achieved in contemporary prints. Two hinged openwork clasps embellished with masks and scrolls keep the small portable book closed.

Despite various guild regulations stipulating that silver objects had to bear the hallmarks of a city, year, maker, and assayer (the latter tested the purity of the silver), this binding does not have any contemporary stamps. Given the fact that the binding had to fit the dimensions of this particular Psalter, it must have been specially commissioned, and such pieces were not always marked.

The high quality of the work suggests that the cover was created in one of the flourishing Dutch cities, quite possibly Amsterdam. The grotesque decoration, which can be dated stylistically to 1610–20, is closely related to published compositions by the Flemish printmakers

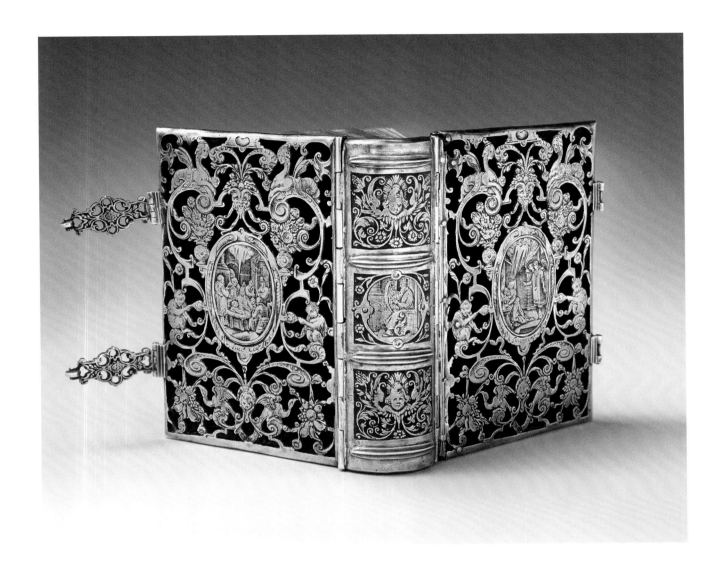

Theodor de Bry and Adriaen Collaert. The date and place of manufacture can be further substantiated by the text that the binding encloses. This work, entitled *De CL Psalmen Davids WT Den fransoyschen Dichte in Nederlant[s] Schon ouergheset door Petrum Dathenum* (*The Hundred and Fifty Psalms of David Beautifully Translated from French into Dutch by Petrus Dathenus*), was printed in Amsterdam, and although no publishing date is given, the Dutch theologian Dathenus worked in the city from about 1610 until his death in 1621.

Psalm books with *silver beslach* (silver mounts) are regularly listed in the inventories of well-to-do-burghers in the Dutch Republic. This early seventeenth-century example, preserved in its precious original binding, clearly illustrates the esteem in which Dutch Protestants held the Psalms of David, texts whose hymns of praise and lament were oft invoked in times of both thanksgiving and despair.

Reliquary Cross

Spanish, first quarter of the 17th century
Gold, rock crystal, enamel, and diamonds, (with ring) $3^{15}/_{16} \times 1^{13}/_{16} \times \frac{7}{16}$ in. (10 × 4.6 × 1 cm)
Gift of J. Pierpont Morgan, 1917 (17.190.1713)

Worn on the chest, this pectoral cross was much more than a precious jewel. Its shape was filled with religious significance, reminding the wearer of Christ's Crucifixion and its promise of salvation. The unidentified relics contained inside would have been venerated in their own right. Representing a direct connection to God, these physical remains of a saint or martyr, however small, were thought to effect healing because of the holiness embodied in them. In addition, the natural materials employed in the present cross were said to have apotropaic qualities: diamonds were long considered bearers of curative powers, while rock crystal, the transparent and purest variety of quartz, supposedly attracted benevolent spirits. Imbued with these protective properties, the pendant thus also served as an amulet, an object believed to make the wearer less vulnerable to disease and arguably to vice as well.

With the exploration of the "New World," an influx of gold, pearls, and precious stones arrived in Spain. Bullion from the Americas and diamonds from India were transformed by goldsmiths into lavish pieces of jewelry, often infused with religious meaning. Members of the Spanish nobility, both men and women, are portrayed wearing impressive cross-shaped pendants suspended from chains, ribbons, or rosaries (fig. 32). During the sixteenth and seventeenth centuries, such fashionable adornments were manifestations of the Counter-Reformation, when after centuries of Muslim rule the Roman Catholic faith was again staunchly defended by the sovereigns of Spain.

The minuscule relics here, preserved in six compartments on the front, are visible behind small pieces of rock crystal. These "windows" have been embellished with white-and-gold enamel frames set with table-cut diamonds, which display a flat surface instead of the pointed one more prevalent at the time. Although the development of new cutting techniques in the sixteenth and seventeenth centuries led to a preference for rose- and brilliant-cut diamonds, the jeweler may have chosen this older rectangular shape in order to match that of the rock crystal windows the gems surround.

A colorful decoration composed of masks, strapwork, flowers, and birds, executed in *basse taille* (literally, low-cut) enamel on a gold ground, embellishes the reverse side of the cross. With the aid of an engraving, or chasing, tool, the jeweler would first create a low-relief pattern in the precious metal and then cover it with a layer of translucent enamel. The sides of the pendant are covered in white enamel and display a composition of scrolling gold tendrils derived from the stylized plant and leaf decoration frequently found in Hispano-Moresque art.

The overall design of this piece is closely related to that of a cross in a drawing that Joan Lladó submitted in 1613 to become a master of the Barcelona guild of goldsmiths, suggesting an approximate date for the pendant. Given its multiple roles as a devotional object, reliquary, amulet, and object for personal adornment, this jewel was likely to have been worn daily.

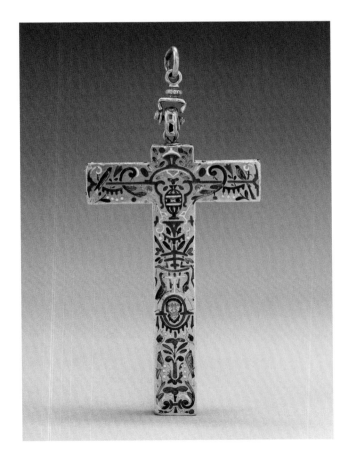

Fig. 32. Peter Paul Rubens (Flemish, 1577–1640) and Jan Brueghel the Elder (Flemish, 1568–1625). *The Infanta Isabel Clara Eugenia* (detail). Flemish (Antwerp), ca. 1615. Oil on canvas, 44½ × 69³⁄₁₆ in. (113 × 175.8 cm). Museo del Prado, Madrid (P01684)

Hanukkah Lamp

German (Hamburg), late 17th century
Silver, 13½ × 10½ in. (34.3 × 26.7 cm)
Rogers Fund, 1913 (13.41.9)

Because of the relentless religious persecution of Jews throughout history, few pieces of Judaica from the Middle Ages, Renaissance, or Baroque have been preserved. Among the exceptions is this rare late seventeenth-century lamp that was intended for domestic use during the annual Hanukkah celebration.

Also known as the Festival of Lights, the eight-day observance of Hanukkah commemorates the rededication of the Temple in Jerusalem after the Jewish military victory over their Seleucid (Hellenistic) oppressors in the second century B.C. As recorded in the apocryphal First Book of Maccabees (4:26–59), the Temple was sanctified with offerings and the lighting of the menorah on the twenty-fifth day of the Hebrew month of Kislev (which usually falls in December). Although there was only one day's worth of holy oil, the light nevertheless burned for eight days to allow sufficient time for the ritual. To mark this miracle, the eight flames of the Hanukkah lamp must be lit individually, with one light kindled on the first day and another on each successive day until all are burning. An additional lamp called the *shamash* (servitor or servant) was used to kindle the wicks. In the present lamp, the two holes above the central medallion indicate where the *shamash* was once attached to the backplate (the part placed against the wall). Other than the specification that the eight lights be aligned yet separate, the decoration and shape of the lamp can take any form.

This silver Hanukkah lamp is embellished with a frame of flowers that includes several tulips. Originally imported from Turkey, tulips were extremely popular in Europe, eternalized in seventeenth-century still-life paintings but also frequently rendered in silver during the second half of the century. The blooms here were shaped in relief by repoussé, or embossing, hammering the metal

from the reverse side, thereby raising the surface of the silver without any loss of the material.

The oval backplate, with its rippled edge, is similar in design to a chased wall sconce, but rather than a candle arm, it incorporates a semicircular band of eight oil containers below. The flickering light of the oil lamps would have reflected off the convex silver surfaces, thereby enlivening and illuminating the decoration. The central reserve is chased with a cartouche framed with a stylized wreath of berried laurel leaves. It once contained a Hebrew inscription that is now largely effaced. The initials *JF* were added later, most likely when the lamp's ownership changed—evidence of its continued use.

Two hemispherical crowns, one at the top and the other surmounting the row of shell-shaped oil wells, derive their form from a ducal coronet. Consisting of strawberry leaves and a circlet chased with imaginary gemstones, such coronets are frequently found in heraldry. Crowns also regularly embellish Hanukkah lamps and other Judaica, where, as here, they symbolize the power of the Almighty rather than representing a secular ruler.

Since Jews were generally not allowed to join the guilds of goldsmiths and silversmiths, most of their silver ceremonial objects were made by Christian masters. It is possible, however, that the absence of a master's mark here indicates that a craftsman working outside the guild system was responsible for this example.

Frequently presented as wedding gifts, Hanukkah lamps were traditionally hung in the window or on the doorpost outside a house to draw attention to the miracle and commemorate the Festival of Lights. The fact that this particular ritual object employs a precious metal implies that it was most likely destined for indoor use, which ultimately may have allowed for its survival.

The Adoration of the Shepherds

Adam Friedrich von Löwenfinck (German, born Poland, 1714–1754)
German (Fulda), 1741–44
Tin-glazed earthenware, 7¼ × 5⅝ in. (18.4 × 14.3 cm)
Gift of R. Thornton Wilson, in memory of Florence Ellsworth Wilson, 1945 (45.61.3)

That the division between the "fine arts" and the "decorative arts" is not always crystal clear is well illustrated by this painted earthenware plaque. Created in Fulda, this religious work is signed at the lower right with *de.Löwenfincken.pinx* (Painted by Löwenfinck), just as a composition on canvas would be.

Born in 1714 in the Polish city of Biała (modern-day Bielsko-Biała), Adam Friedrich von Löwenfinck was apprenticed at the age of thirteen to the Meissen porcelain manufactory. Having completed his training as a porcelain painter but frustrated by a lack of recognition, Löwenfinck fled from Meissen in 1736, leaving behind a mountain of unpaid debts. The itinerant artist was employed as a painter at various faïence manufactories starting in Bayreuth and later, among other places, in Ansbach, Fulda, Höchst, and Haguenau, directing a factory at the last location from 1750 until his early death in 1754. His work shows him to have been a talented artist, although the frequent moves hint at a certain restlessness and willfulness of character.

This piece was made at the "porcelain" factory in Fulda, which had been established under the patronage of Prince-Abbot Amand von Buseck. Despite its name, this enterprise was not successful in making true porcelain but instead produced a high-quality earthenware. Serving from 1741 until 1744 as enameler and painter to the Fulda court, Löwenfinck brought his expertise and technical innovation to the operation by introducing the use of the muffle kiln, which made it possible to expand the color palette.

Faïence had long been produced by a traditional series of steps. A piece was first shaped, either on the wheel, by hand, or by mold, and then fired unglazed. It was next dipped in a white tin glaze that, when dry, was painted over with pigments consisting of powdered minerals or

glasslike substances and coated again with a transparent glaze. As the piece was fired at a high temperature, known as the *grand feu* (about 1000°C), the heat would melt and fuse the pigments and glazes together, but only a limited range of colors could withstand such high temperatures.

However, the use of the muffle kiln, which was constructed in such a way that the products of combustion were prevented from entering the firing chamber, substantially changed both the process and its possibilities. The unglazed clay body was fired initially and then, after having been glazed, was fired a second time. The final firing occurred once the piece was decorated with powdered glass tinted with mineral oxides to which a large amount of lead or other flux was added to give the colors a low melting point and increase their fusibility. Painting over the glaze enabled greater precision, and the lower firing temperature, or *petit feu* (up to 850°C), allowed for a richer palette, which came to be known as muffle or enamel colors.

Löwenfinck is primarily noted for his bright floral and chinoiserie decorations and his distinctive style that relied on line and contour, but in this religious composition he departed from his typical subject matter and technique. One of only a few plaques by the artist known to exist, the work depicts a biblical subject recounted by Saint Luke the Evangelist (2:16). Although the exact source has not yet been established, it is very likely that Löwenfinck based his *Adoration of the Shepherds* on an Italian composition that may have been familiar to him through an

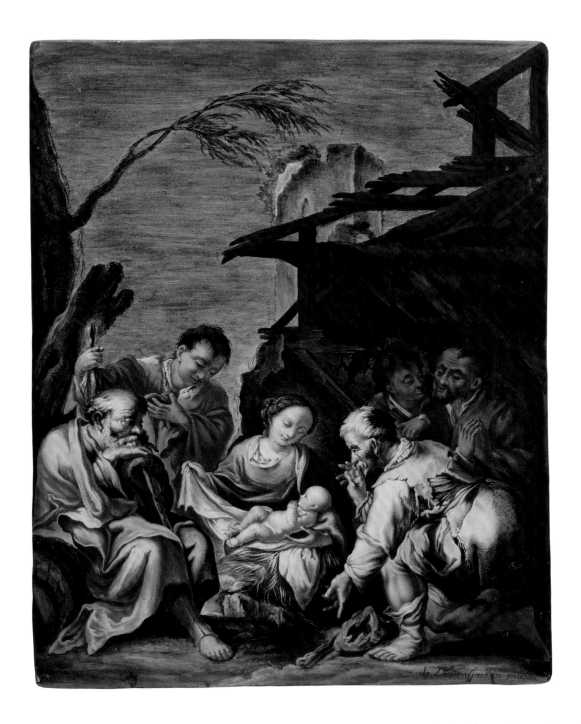

engraving. The masterful play of light and shadow, the overarching timbers of the ruined stable, the three-dimensionality of the figures, the beautiful folds in the garments, the expressive hand gestures, the saturated muffle colors, all show him to be an extremely skilled painter.

Only a handful of ceramics bear Löwenfinck's signature, and its presence on this plaque may well reflect his pride in what he accomplished here. The small scale and beveled edges suggest that the work was meant to be framed and placed on the wall as an object of private devotion. One wonders if it was intended for the artist's personal use. Löwenfinck, while born a Protestant, had converted by 1744 to Catholicism, a religion that readily encouraged and even sanctified such devotional objects.

Objects for Display
and Entertainment

Chess and Backgammon Board

Spanish (Castile), 1519–29
Gilded copper; walnut, partly dark stained; ivory, partly stained green; mother-of-pearl; serpentine and *rosso antico* marble, (open) 9¹⁄₂ × 18⁵⁄₈ × 1¹⁄₈ in. (24.1 × 47.3 × 2.9 cm); (closed) 9¹⁄₂ × 9¹⁄₄ × 2³⁄₁₆ in. (24.1 × 23.5 × 5.6 cm)
Pfeiffer Fund, 1963 (63.38)

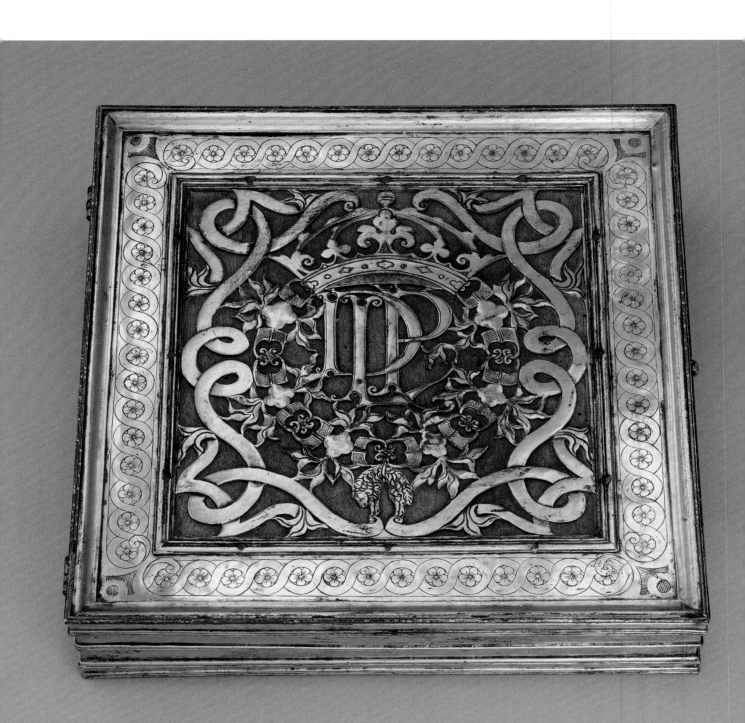

Imagine playing a round of backgammon on this intricately fashioned game board that offers the challenge of competition along with aesthetic enjoyment of its exquisite ornamentation and materials. Both chess and backgammon are thought to have originated in India and probably reached Europe by way of Persia and the Arab world. As these diversions evolved, they gradually transformed into the fashionable pastimes still enjoyed by professionals and amateurs alike. A manuscript of 1283 commissioned by King Alfonso X of Castile, *Libro del ajedrez, dados y tablas* (*Book of Chess, Dice and Board Games*), indicates that the intellectually demanding game of chess and various games of chance played with dice were by then well known at the Spanish ruler's court. Indeed, it was deemed an important aspect of education for both elite boys and girls to be skilled in such amusements.

Chess was foremost a matter of strategy and skill, a war game played between two opposing "armies," one of which must conquer the other's king in order to win. The man who commissioned the present gaming set, Diego López de Pacheco, second duke of Escalona, would have been familiar with this idea. An influential Castilian noble and Spanish grandee, the duke was also a military man. His interlaced initials, *DLP*, executed in gilded copper against a walnut ground, are displayed on the cover of this board.

Surmounting the monogram is a crown that reflects the ducal title Diego López de Pacheco inherited from his father in 1474. This crown is framed on three sides by a collar that alludes to the duke's investiture by Charles V, Holy Roman Emperor, as a knight of the Order of the Golden Fleece in 1519. The links of its chain are formed by the double letter *B* for Bourgogne (Burgundy), referring to the prestigious chivalric order that had been established in 1430 by Philip the Good, duc de Bourgogne. Suspended from the collar is the badge of the order, in the shape of a sheepskin, symbolizing the Greek mythological hero Jason and his successful quest to retrieve the Golden Fleece. The insignia of the order offers a terminus post quem, or a date after which the gaming set must have been made: in or after 1519 but before 1529, the year of the owner's death.

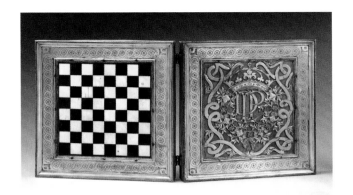

The interlaced, undulating patterns framing the ducal crown, initials, and collar have been adopted from Islamic art, which was extant in Spain, a country that was divided into Christian and Muslim principalities until its unification in 1492. The blending of Islamic influence and classical decoration—here expressed in the guilloche motif (a repetitive pattern resembling interlaced ribbons) featured on the raised borders—was typical for early sixteenth-century Spain.

The reverse side of the folded board has a playing surface divided into sixty-four squares, eight rows of eight, of alternating squares of dark-stained walnut and ivory, identical to the design of a modern-day chessboard. The raised edges prevent the chessmen from falling off. Held together by a small metal hook and eye, the two sides fold open to reveal a colorful interior with a backgammon board composed of contrasting mother-of-pearl and green-stained ivory. A border of green serpentine and *rosso antico* marble surrounds the double playing surface.

This gaming set was likely executed in Castile, one of the main centers of early Renaissance metalwork in Spain. The richness of the materials, artistic refinement, and skilled craftsmanship clearly expressed in its decoration bear witness to Diego López de Pacheco's social status. The original game pieces, which have not been preserved, would undoubtedly have contributed to the object's overall splendor, but hopefully did not distract the players' attention from the game at hand.

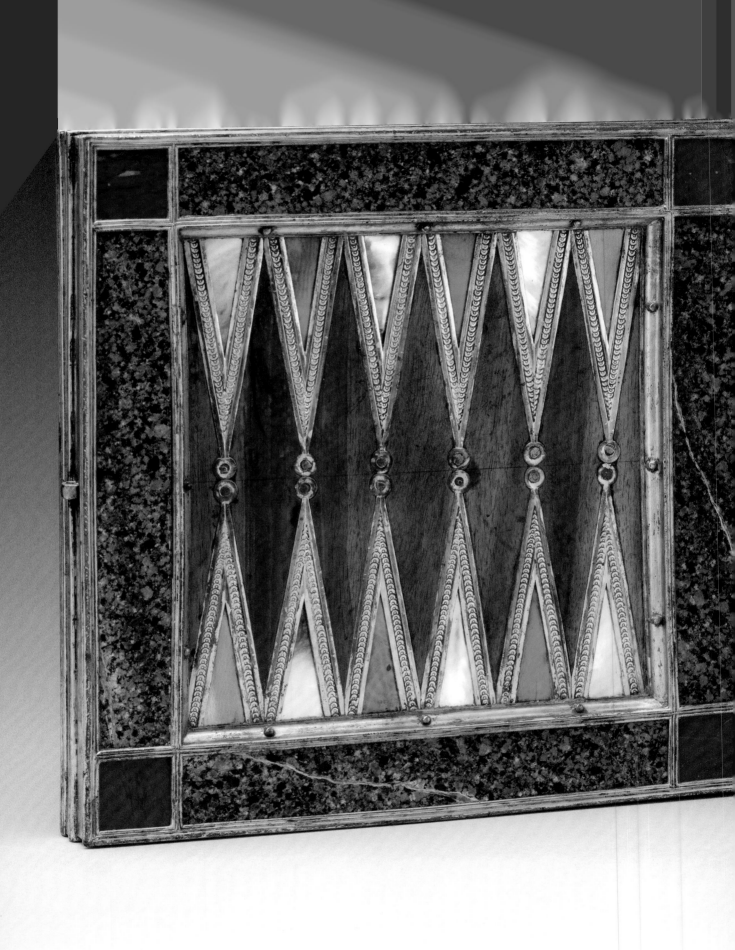

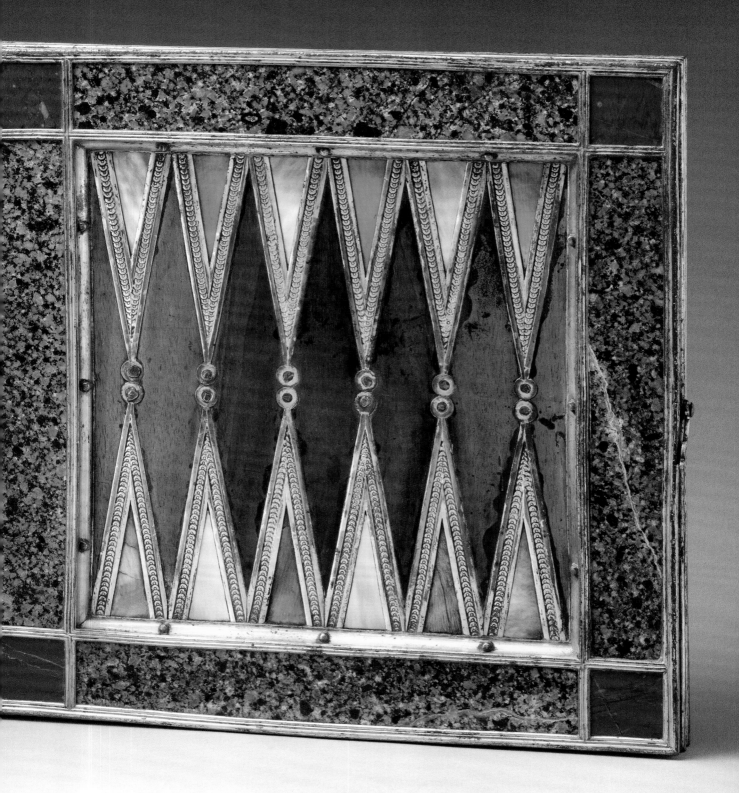

Ewer with Scenes from the Legend of Marcus Curtius

Adam van Vianen (Dutch, 1568/69–1627)
Dutch (Utrecht), 1619
Silver, 9 1/16 × 5 × 4 3/4 in. (23 × 12.7 × 12.1 cm)
Purchase, Lila Acheson Wallace and Howard S. and Nancy Marks Gifts; Gift of Irwin Untermyer
and funds from various donors, by exchange; From the Marion E. and Leonard A. Cohn Collection,
Bequest of Marion E. Cohn, by exchange; Bequest of Bernard M. Baruch and Gift of Mrs. Robert M. Hillas,
by exchange; Bequest of John L. Cadwalader and Gifts of Lewis Einstein and William H. Weintraub,
by exchange; From the Collection of Mrs. Lathrop Colgate Harper, Bequest of Mabel Herbert Harper and
Bequest of Alexandrine Sinsheimer, by exchange, 2018 (2018.194a, b)

Very few objects command our attention and manage to captivate, surprise, and delight as this extraordinary ewer does. While it stands just nine inches tall, the piece is immensely tactile and makes an unforgettable impression. With its ambiguity of form and sculptural exuberance, it is an exemplary manifestation of the fantastic, bizarre ornament fashionable in the Netherlands in the first half of the seventeenth century. Known at the time as *snakernijen* (drolleries), the organic and lobed forms are oddly reminiscent of the inner ear, which led to the coining of the term "Auricular" for them during the late nineteenth century.

Emerging as a two-dimensional decorative style in late sixteenth-century ornamental prints, the Auricular vocabulary found its greatest expression in early seventeenth-century Dutch gold- and silversmith work, especially in the oeuvre of several members of the Van Vianen family. Adam van Vianen and his younger brother Paulus were highly talented artists with unrivaled technical prowess and artistic virtuosity. Paulus left the Dutch Republic and worked abroad, most notably at the court of Holy Roman Emperor Rudolph II in Prague, whereas Adam stayed in his native Utrecht, where he served as an assayer to the silversmiths' guild. Both men incorporated Auricular ornament in their work, initially restricting the lobed forms to decorative borders and cartouches but gradually granting them prominence. By

1614 the Auricular style dominated the entire surface of Adam's objects, which displayed the unprecedented fluidity beautifully demonstrated by this ewer.

The object's overall shape is loosely based on earlier vase designs of the 1560s by Hans Vredeman de Vries, a Dutch Renaissance architect known for his decorative prints, and Enea Vico, an Italian engraver specializing in grotesque ornament. The vessel has been raised from a single sheet of silver and has a hollow handle modeled in the shape of a sea monster. A dolphin's head on which a large insect has alighted forms the separate lid. The metal alloy used for the piece has an extremely high silver content; indeed, it consists of almost pure silver. The malleability of pure silver allowed Van Vianen to manipulate the material with great sensitivity and originality, a skill thus praised by the Anglo-Dutch author Balthazar Gerbier: "The endless wonders of his genius are too great for my modest quill to describe." Van Vianen's work exemplified the belief, expressed in the treatise *Natural History* by the ancient Roman author Pliny the Elder, that an artist's mastery should surpass the quality of his materials.

The piece teems with life as light sparkles off the reflective surface, animating it and enhancing its plasticity. What is meant perhaps to resemble a thickening flow of lava morphs into human masks, fish, slugs, and dragons. This impression of a cooling, hardening flux of molten silver may well be steeped in the contemporaneous

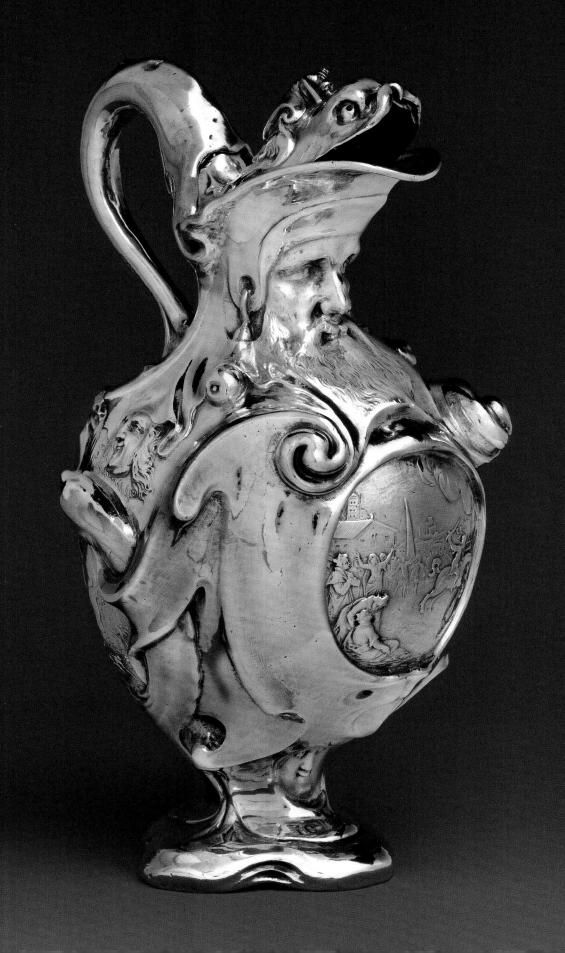

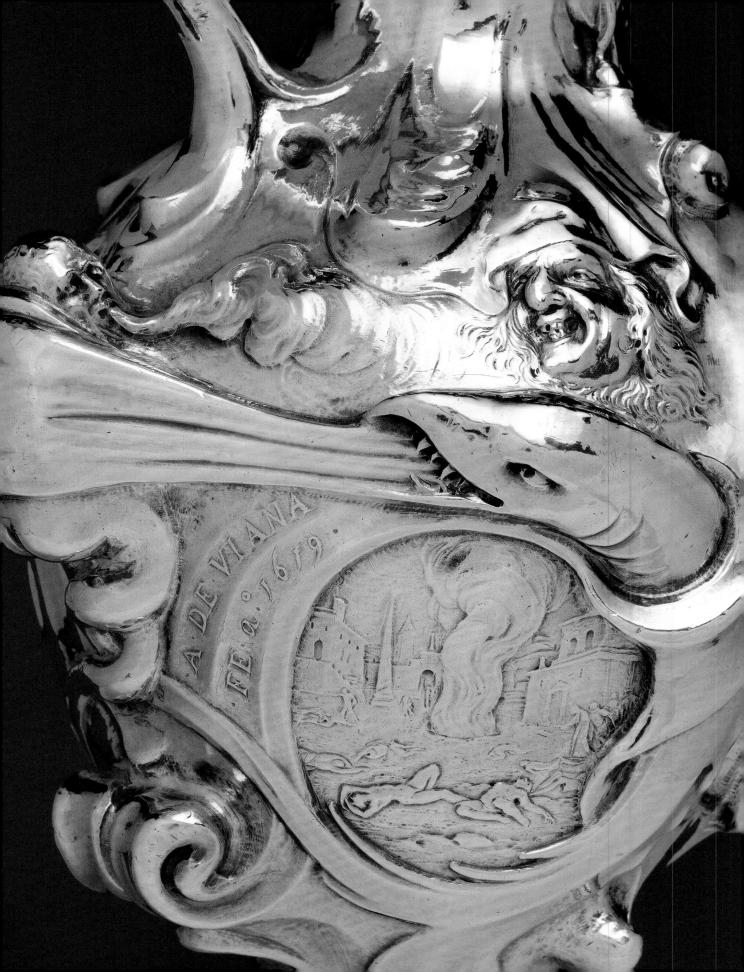

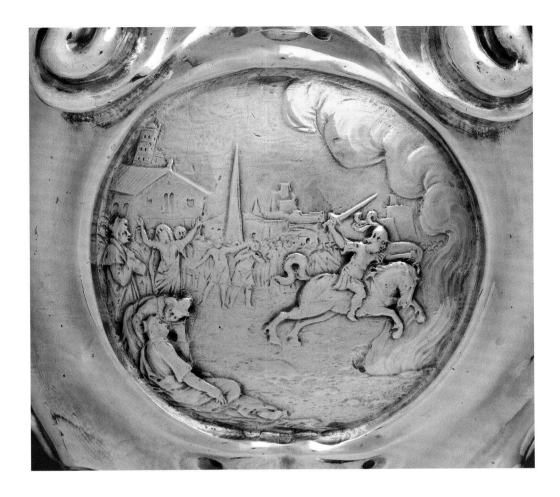

alchemical concept that base metals undergo a process of purification in the earth, slowly transmuting into precious metals. In order to hasten this process (and thereby exhibit their magical powers and dominion over nature), alchemists tried to reproduce it artificially. In a similar way, Van Vianen controlled and transformed the seemingly viscous silver into an organic force.

Lying nestled among the fleshy folds of silver are three medallions chased in low relief with scenes from the legend of the Self-Sacrifice of Marcus Curtius. The first of these roundels shows an earthquake ripping a huge pit in the Roman Forum, from which poisonous fumes emanate. Diviners declared that the abyss would close only by offering up a hero possessing the fundamental qualities of Roman greatness: bravery and military virtue. Depicted

on the front of the vessel is the one who made that sacrifice: Marcus Curtius, a young soldier who, scorning death for the benefit of the Roman Republic, leapt into the fiery chasm astride his horse. The subject of the last medallion is the oblation made out of gratitude by the Roman citizenry. Although usually seen as a representation of civic courage, Curtius's heroic act may in this case symbolize the Dutch struggle for independence from the Spanish Habsburgs during the Eighty Years' War (1568–1648).

Unlike most silver objects, which typically bear hallmarks as well as makers' marks, this vessel has, most unusually, a prominent signature and date supplied by the artist. This was surely an indication that Adam van Vianen proudly—and justly—considered himself a creative sculptor in precious metal rather than an artisanal silversmith.

Standing Cup

Possibly by the workshop of Lorenz Zick (German, 1594–1666)
or his son Stephan Zick (German, 1639–1715)
German (Nuremberg), 17th century
Ivory, 14 × 5 × 4¼ in. (35.6 × 12.7 × 10.8 cm)
Gift of Robert Gordon, 1910 (10.212.2a, b)

Visiting the grand ducal collections at the Palazzo Vecchio in Florence in 1644, the British diarist John Evelyn noted "rare turneries in ivory, as are not to be described for their curiosity." Evelyn must have been referring to eye-catching objects such as this particular cup, a product of ivory turning that displays exceptional technical skill and great virtuosity. An early example of machine-produced art, this cup was created on a lathe from the raw tusk of an African elephant. These ivory marvels would qualify as the ultimate pieces in the *Kunstkammer* (literally, art room), a kind of treasury filled with art and various curiosities found at many European courts. Spanning the categories of *naturalia* (rare or unusual specimens from nature) and *artificialia* (objects created by human beings), artworks made from elephant tusks manifested the dominance of man over nature and were much sought after for display in the *Kunstkammer*.

These collections, forerunners of modern museums, functioned as encyclopedias of the visible world that served to unlock the secrets of nature. They also bestowed power and magnificence on their owners, who might themselves have turned ivory at the lathe, an aristocratic pastime fashionable from the late sixteenth century until the end of the eighteenth (fig. 33). To perfect their skills, certain rulers attracted outstanding turners to their courts such as the several generations of the Zick family of *Kunstdrechslers* (art turners) from Nuremberg. Peter Zick, for instance, taught Emperor Rudolf II the art of turning in Prague, while his son Lorenz was turning master to Emperor Ferdinand III in Vienna.

Elephant tusks have solid ends but are hollow in the middle, and the thinner walls of this section were used for cups and tankards. Dentine, consisting of calcified tissue, which is strong and elastic as well as relatively easy to polish, forms the main component of ivory. These qualities,

Fig. 33. Attributed to Daniele Crespi (Italian, 1598–1630). *Portrait of Manfredo Settala*. Italian (Milan), ca. 1620. Oil on canvas, 17⅜ × 13 in. (44 × 33 cm). Pinacoteca Ambrosiana, Milan (492)

combined with its durability and attractive creamy-white color, made the rare and exotic material very desirable for decorative objects and carvings. Unfortunately, the resulting ivory trade came at a profound cost and led to the inexcusable slaughter and rapid decline of African elephants, a problem to this day.

Although not signed—few of such turned pieces are—this standing cup may have been created in the workshop of Lorenz Zick or his son Stephan. With its gravity-defying shape conforming to the curvature of the tusk, the piece is even more stunning than most. The turning motion of the lathe has been artfully employed to manipulate the ivory in different directions and produce a series of distinct moldings and flutings. Particularly difficult to achieve were the undercutting of the organic material and its hollowing out to a delicate thinness, as seen in the openwork foot, cover, and finial. Seemingly in perpetual movement, the cup has an almost dizzying, if not surrealistic, presence.

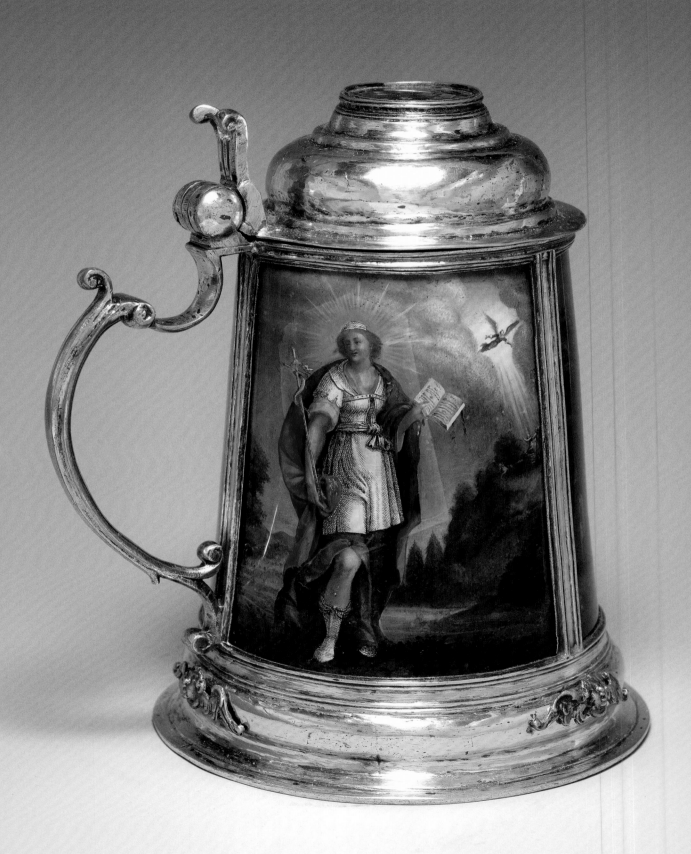

35

Tankard

Swiss (Zürich), 1649
Gilded silver; painted and gilded glass; engraved gold leaf, tinted varnish, tinfoil;
mirror glass, (with handle) 7⅛ × 6⅝ × 5½ in. (18.1 × 16.8 × 14 cm)
Gift of Irwin Untermyer, 1968 (68.141.178)

Long considered a healthy and nutritious beverage, beer was consumed in great quantities during the seventeenth century, one reason being that potable water was scarce. The thirst-quenching brew was generally served in pewter or stoneware mugs that were passed around for communal drinking. More precious drinking cups, made of silver or fitted with silver mounts, were used to toast one's health at special occasions such as weddings, anniversaries, and childbirth or to honor civic achievements.

An object worthy of display, this particular tankard is a true testimony to a close collaboration between a goldsmith and a glass painter. The gilded-silver mount frames the colorful reverse-glass decoration, transforming it into a vessel with a hinged lid, thumbpiece, serpentine handle, and circular foot; three simple struts keep the cylindrical glass in place. Although the silver is unmarked, the painted decoration, containing the date 1649 in two places, strongly suggests that the work originated in Zürich. This city had a long-standing tradition of goldsmith work, while its craftsmen excelled in the art of glass painting. Furthermore, the glass medallions mounted in the lid and underneath the tankard identify the original owners, who were citizens of Zürich, and indicate that this drinking vessel was specially commissioned and may have been a gift.

The double coat of arms featured on the lid belonged to Hans Heinrich Rahn and his wife, Ursula Escher. As a member of an important patrician family, Rahn had a successful administrative career, serving as mayor of Zürich from 1655 until his death in 1669. Married in 1612, the couple was blessed with many offspring: along with their names, those of their nine children are listed on the bottom of the tankard. The personalized medallions are

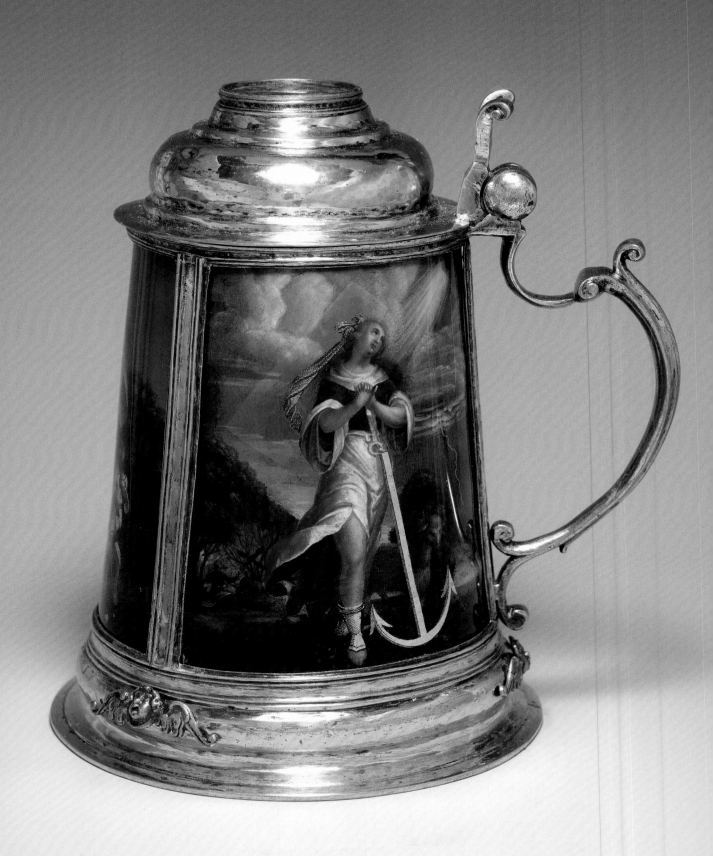

painted on the reverse of a single piece of glass. The slightly tapering body, however, has a double layer of glass since it is composed of two encased cylinders, the outer one painted on the inside and the inner on the exterior, creating "back-to-back" decoration protected between the glass walls.

Using opaque colors and gold leaf, the painter added detail and depth to the composition by crosshatching lines into the gold leaf, which allowed the tinted layer of varnish under the gold to shine through. Female personifications of Faith, Hope, and Charity are shown in a landscape background on the tankard's exterior. Each of these so-called Theological Virtues can be identified through her specific attribute: a cross and Bible for Faith, an anchor for Hope, and children for Charity. Tiny biblical scenes, demonstrating the hand of a skilled artist, serve as further illustrations of each virtue: for Faith, Abraham and the

Sacrifice of Isaac (Genesis 22:1–19); for Hope, Elijah being fed by a flock of ravens (1 Kings 17:1–6); and for Charity, the parable of the Good Samaritan (Luke 10:29-37).

The interior of the vessel is embellished with a depiction of Hercules at the Crossroads, as recounted by the ancient Greek philosopher Xenophon. In this story, the mythological hero was given the difficult choice between Vice and Virtue—a life of pleasure (personified by a voluptuous woman tempting him with a gold drinking bowl) or a less appealing one of hardship and honor (represented by an industrious, rather prim-looking female figure). Often based on engravings, such allegorical representations were popular during the sixteenth and seventeenth centuries, when they served as moralistic reminders to lead a virtuous life and perhaps, in this case, as a warning against excessive drinking. Both laudable goals.

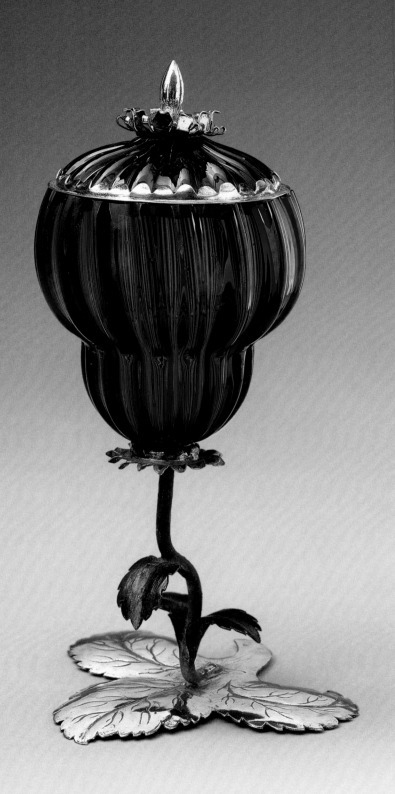

Standing Cup with Cover

Mounts by Matthäus Baur II (German, ca. 1653–1728, master ca. 1681)
Glass: probably South German; Mounts: German (Augsburg), 1690–94
Gold-ruby glass; gilded-silver mounts, partly lacquered, 6⅝ × 3⅜ × 3½ in. (16.8 × 8.6 × 8.9 cm)
Munsey Fund, 1927 (27.185.309a, b)

The primary goal of alchemists was to find the philosopher's stone, which was believed not only to grant immortality but also to transmute base materials into gold. Fortuitously, their experiments often led to other wonderful discoveries. The physician and chemist Johann Joachim Belcher, who practiced this protoscience, stated in 1678 that even if the alchemists "have found no gold, occasionally good medicaments and other curious arts came to light."

Among these so-called curious arts was the creation of brilliant gold-ruby glass, which this ribbed goblet of an inverted-pear shape magnificently exemplifies. The vogue for this type of red glass may well have been based on a twofold association: with rubies, thought to ward off illness and evil, and with gold, which was believed to have purifying qualities. Objects made of these materials were among the most prized *Kunstkammer* possessions (see no. 34).

Working in Potsdam at the court of Frederick William, elector of Brandenburg, Johann Kunckel managed to produce deep, translucent red glass vessels that possessed the qualities of ruby gemstones, a color long elusive to glassmakers. The son of a glassblower, Kunckel was well versed in alchemical writings. He experimented with older formulas, such as those in Antonio Neri's manual *L'arte vetraria* (*The Art of Glass-Making*) of 1612, and improved on these in his publication *Ars Vitraria Experimentalis* (*The Art of Experimental Glass-Making*) of 1679. Rather than using copper or manganese, as was done in the past, his formula required the addition of tin and gold particles to the glass batch. Dissolved in a corrosive mixture of nitrohydrochloric acid, known as *aqua regia* (literally, royal water), the precipitate of tin and gold particles served as a colorant and, once reheated, "magically" transformed the fired glass into a beautiful deep red. Despite attempts to keep Kunckel's achievement a secret, the formula was soon copied in Bohemia, Saxony, and South Germany, where the production of gold-ruby glass, largely supported by German princes, enjoyed a short-lived fashion.

A certain South German glasshouse, the precise location of which remains unknown, has been credited with the creation of various gold-ruby glass objects between about 1690 and 1710. These vessels have relatively simple shapes, with little or no surface decoration, and were mold-blown, that is, the hot glass was blown into a clay, wood, or metal mold. This cup was blown in one piece and cut afterward to create the removable lid. Often made without feet, handles, or covers, the vessels attributed to this workshop were mounted in gilded silver by silversmiths in Augsburg and Nuremberg. Augsburg especially had a long tradition of goldsmith work, and its craftsmen excelled in the creation of luxury products that combined precious metal with other costly materials.

Matthäus Baur II and his brother Tobias, members of a talented family of Augsburg silversmiths, were regularly commissioned to make gilded-silver mounts. Resembling a precious fruit on a curvilinear stem, the present cup rests on a trifoliate, leaf-shaped foot that bears the master's stamp underneath. The silver is partly lacquered brown and green to heighten the naturalism of the sprig and its foliage. A gilded-silver wreath marks the transition between the stem and the cup, while the lid is mounted with an inset brim, indented collar, and metal finial.

Unfortunately, nothing is known about the provenance of this vessel. However, a similar goblet in the form of a pomegranate, also mounted by Matthäus Baur II, presented in 1695 as a Christmas gift by the Danish king Christian V to his wife, Queen Charlotte Amalie (The Royal Danish Collections, Rosenborg Castle, Copenhagen), underscores the immense prestige this gold-ruby glass once commanded.

Wine Glass

Probably South Netherlandish or German, late 17th century
Colorless glass and transparent turquoise blue, opaque red, yellow, and white glass, H. 11¹/₁₆ in. (28.1 cm)
Robert Lehman Collection, 1975 (1975.1.1206)

Around the middle of the fifteenth century, a lightweight, transparent, and colorless glass was invented by Venetian glassblowers, who had dominated European glass production since the Middle Ages. This glass was called *cristallo* because in its clarity it resembled rock crystal. Its optical purity was achieved with marine plant ash rich in sodium carbonate or soda and potassium as well as crushed quartz pebbles from the Ticino River in northern Italy. Linked to alchemical experimentation (see nos. 33 and 36), *cristallo* glass was thought to have a magical property, similar to that associated with rock crystal, that made it shatter or change color when coming into contact with a drop of poison. Particularly fashionable were the *cristallo* drinking vessels with complex undulating stems called *vetri a serpenti* in Italian (dragon or serpent glasses). These pieces were blown into molds and worked freehand to attain a curvaceous shape that was further emphasized by blue glass details, as seen in this example.

The work of Venetian craftsmen was held in high esteem both in Italy and abroad. After their glassblowing furnaces had been banned from central Venice as a fire hazard in 1291, the artisans were relocated to the island of Murano. Despite risking stiff penalties from the local authorities, who did not allow them to travel and divulge the closely guarded secret of making *cristallo* glass, they were recruited throughout Europe to improve the production process in existing glasshouses. As a result, glass in the Venetian manner, so-called *façon de Venise*, was manufactured in the Low Countries, present-day Germany, and elsewhere, often making it difficult to ascertain where a particular example was made. When depicted in

Fig. 34. Circle of Georg Hinz (German, 1630–1700). *Still Life with a Façon de Venise Serpent-Stemmed Wine Glass, a Silver Vessel, a Block of Sugar, and Lemons on a Pewter Plate, All on a Draped Table*. German (Hamburg?), second half of the 17th century. Oil on canvas, 21⁵/₁₆ × 25¹³/₁₆ in. (54.2 × 65.6 cm). Whereabouts unknown

seventeenth-century still-life paintings, Venetian-style glass represented wealth and luxury; because of its fragility, it also symbolized the transitory nature of life (fig. 34).

In a striking demonstration of the glassmaker's technical skills, red, white, and yellow spiraling glass threads are incorporated into the intricately coiling stem of this particular goblet, which is further embellished with blue pincered wings. It is unknown whether this delicately beautiful artifact ever had a cover or whether it was used for drinking or merely for display.

Sweetmeat Dish

Claudius Innocentius Du Paquier period (1718–44)
Austrian (Vienna), ca. 1730
Hard-paste porcelain, 3⅜ × 9¹¹/₁₆ × 4⅜ in. (8.6 × 24.6 × 11.1 cm)
Gift of R. Thornton Wilson, in memory of Florence Ellsworth Wilson, 1950 (50.211.5)

Once described as a *bourdaloue* (a small chamber pot used by women), this unusual ovoid-shaped bowl has long since been elevated to a serving dish for the sweetmeats, such as candied fruit, offered at the end of a meal. In the eighteenth century, special porcelain services were commissioned for the dessert course, the most delightful and perhaps most anticipated one of a grand court dinner.

According to the *service à la française* tradition, first developed during the reign of the French king Louis XIV (1643–1715) and widely adopted at the German-speaking courts, all the savory courses were placed on the table at the same time. In a similar manner, the various fruits and confections were offered simultaneously. The variety of the serving dishes, laid out in a symmetrical fashion, greatly added to the splendor of the dessert table, which

was further frequently embellished with a centerpiece and sculptures made of sugar or porcelain (see no. 39).

This charming object was made in Vienna at the porcelain manufactory founded by the entrepreneur Claudius Innocentius Du Paquier (died 1751), which was the second European manufactory after Meissen to make hard-paste porcelain. Established in 1718 by special charter of Charles VI, Holy Roman Emperor and ruler of the Austrian Habsburg realm, the manufactory was deeply in debt by 1744 and was ceded to Maria Theresa, archduchess of Austria and queen of Hungary. In order to make porcelain, Du Paquier required knowledge of the necessary ingredients for the paste, glazes, and enamel colors as well as kiln technology, information that had long been shrouded in mystery. To achieve his ends and

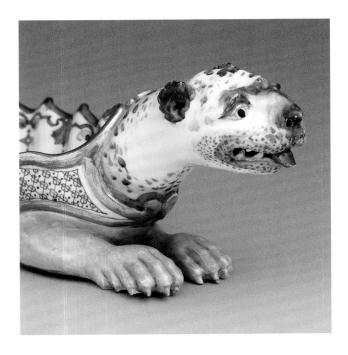

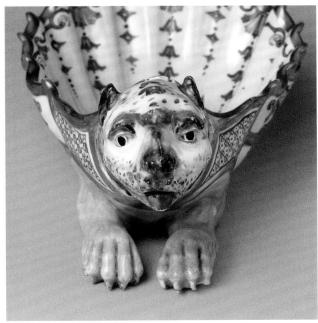

despite the fact that a worker's defection was considered a punishable crime, Du Paquier engaged in industrial espionage by recruiting several workers from Meissen with the needed expertise.

By the 1720s, after a shaky start and constant financial difficulties, the Viennese manufactory had succeeded in creating alluring and highly original pieces. These easily identifiable works are distinguished by their whimsical forms and beautifully painted decoration in predominant tones of purple and iron red, both seen here. The Du Paquier wares drew upon a wide range of sources. Although the inspiration for the overall shape of this vessel and its identical companion in Vienna (Museum für Angewandte Kunst, Vienna, Ke 7225) is not known, a scalloped rim and a fluted body (here generously accentuated with gold) were regularly used for silver objects and Asian porcelain. The sloping sides of the dish are embellished with painted trelliswork (known at the time as "mosaic" decoration), strapwork, and anthemion and bellflower motifs, all typical of Du Paquier porcelain. Naturalistic, so-called European flowers (as opposed to "Indian" blooms derived from Asian porcelain) and fruits are depicted in the well, which would become visible

once all the sweets were eaten. An unexpected detail, found on the underside, is a large blue acanthus leaf painted directly on the biscuit (unglazed) porcelain.

More surprising is the animal head that serves as a handle and can be identified by its brownish spots or rosettes as the large predatory cat generally known as a panther. Quite noteworthy are the animal's heavy brows, red-rimmed eyes, partly opened maw with visible teeth, and playfully stuck-out tongue; its front paws are generously provided with seven toes. Few people in Vienna would actually have seen such an animal, although it is possible that one may have been kept in the famous menagerie of Prince Eugene of Savoy, a renowned military commander of the Holy Roman Empire. A legendary creature, the panther was frequently included in medieval bestiaries, where it was known for its sweet breath. As a symbol of Bacchus, the animal was regularly depicted with the wine god, and it has been suggested that its presence here might refer to the sweet wines or liquors served with the dessert course. Whatever its source may be, it is easy to imagine this endearing panther dish stacked up with delicious confections to tempt sweet-toothed guests.

The Kiss

Modeled by Johann Joachim Kändler (German, 1706–1775)
After an engraving by Laurent Cars (French, 1699–1771)
After a composition by François Boucher (French, 1703–1770)
German (Meissen), ca. 1745
Hard-paste porcelain, 8 × 10⅛ × 6 in. (20.3 × 25.7 × 15.2 cm)
Gift of Irwin Untermyer, 1964 (64.101.58)

Small-scale porcelain figures such as this enamored couple clearly show how the realms of sculpture and decorative arts occasionally intermingle. The first porcelain figurines to arrive in Europe, through seventeenth-century maritime trade, were imported from Dehua, China, and were mostly depictions of deities executed in the all-white porcelain known as *blanc de Chine*. As the secret of producing hard-paste porcelain by using kaolin and feldspar was unknown in Europe at the time, these figures were initially copied in earthenware. The first successful experiments were conducted in 1708 at Meissen, near Dresden. Two years later, the Meissen porcelain manufactory was founded and supported by Augustus the Strong, king of Poland and elector of Saxony, who had accumulated an impressive collection of Asian porcelain.

While the Meissen workshops created some figural sculptures early on, the production of such pieces really expanded only in 1731, when the brilliant sculptor Johann Joachim Kändler joined the manufactory as chief modeler. Kändler was principally responsible for Meissen's highly original models featuring smaller human figures and groups. Mostly based on engravings, these represented a variety of different subjects and included pastoral, theatrical, and allegorical figures.

Cast from molds in multiple individual pieces, the parts were joined together with liquefied clay before the first firing. These engaging figurines often conveyed satirical comments on contemporary life and, as cabinet pieces, were displayed on brackets, mantelpieces, tables,

and chests of drawers. By the 1740s they began to replace the more traditional, but fragile, sugar-paste decorations on the dessert table.

This figurine derives from one of thirty-three compositions executed by the French painter François Boucher for a new edition of Molière's collected plays. Published in 1734, more than sixty years after Molière's death, this volume reflects the continued interest in the author's work. *Dom Garcie de Navarre, ou Le prince jaloux* (*Don Garcia of Navarre, or The Jealous Prince*) was originally written and performed in 1661 for Molière's patron, Philippe I, duc d'Orléans, with the playwright himself starring in the role of the prince. Although the production was neither a critical nor a financial success, Laurent Cars's engraving after Boucher's illustration in the 1734 edition had a lasting impact (fig. 35). Serving as the inspiration for this Meissen group, it also demonstrates how the modeler skillfully adapted a two-dimensional source into three-dimensional figures.

Since this figurine was meant to be seen in the round, it has interesting viewpoints from all sides, including those showing the placement of the couple's delicate hands and the gentleman's lifted right heel. With slightly tilted head and a black beauty spot marking her chin, the female figure wears a so-called *robe à la française*, or sack dress, which was fashionable in the mid-eighteenth century. The tight, funnel-shaped bodice is left undecorated, while the full petticoat, worn over a wide pannier, or hoop, is adorned with colorful bouquets of flowers. The free-flowing back pleats that extend from

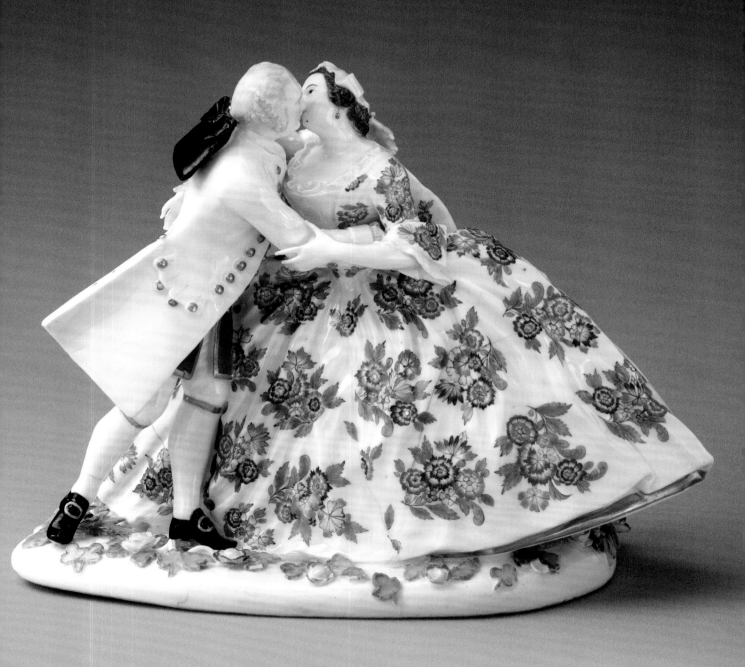

the shoulder to the hem are not visible in the engraving but indicate that Kändler was familiar with contemporary fashion. The cavalier wears a white suit composed of a matching coat and breeches embellished with large gold buttons over a gold-trimmed blue waistcoat; his ponytail is contained in a black wig bag that would have protected his collar and coat from his powdered coiffure.

Given the failure of Molière's comedy, which was performed only about a dozen times between 1661 and 1663, eighteenth-century dinner guests were not likely to have recognized these figures as Don Garcia, the jealous prince, and his beloved Elvira. Rather more auspiciously, as fashionable courtiers they may have identified with the couple but also envied the pair's display of tender intimacy.

Fig. 35. Laurent Cars (French, 1699–1771), after François Boucher (French, 1703–1770). *Dom Garcie de Navarre, ou Le prince jaloux* (*Don Garcia of Navarre, or The Jealous Prince*), from *Gravures de Boucher pour les oeuvres de Molière* (*Engravings by Boucher for Molière's Oeuvre*). French (Paris), 1734. Etching and engraving, 15¹⁵/₁₆ × 10¼ in. (40.5 × 26 cm). Harris Brisbane Dick Fund, 1942 (42.24[19])

Flowers

French (probably Vincennes), mid-18th century
Soft-paste porcelain, (largest) 1¼ × 2¹⁵⁄₁₆ × 2¾ in. (3.2 × 7.5 × 7 cm),
(smallest) 1 × 1½ × 1½ in. (2.5 × 3.8 × 3.8 cm)
Bequest of Mrs. Charles Wrightsman, 2019 (2019.283.56–58, 60–61)

Individual ceramic flowers were among the first and most successful accomplishments of the porcelain manufactory established in 1740 in the town of Vincennes, east of Paris. The workshops were initially housed in a former royal residence, the Château de Vincennes, but were moved to Sèvres in 1756, when the name of the factory was changed to reflect its new location. From the beginning, King Louis XV (r. 1715–74) provided financial support for the enterprise, and by 1759 he was its sole owner.

Between 1745 and 1755, Madame Gravant (née Marie Henriette Mille) directed the studio at Vincennes, where a group of female employees modeled by hand floral blossoms that were either left white or painted in naturalistic colors. The verisimilitude of the works suggests that they were based on direct observation of fresh flowers or those made of silk. The blooms may also have been copied from botanical prints, a genre that female artists such as Madeleine Françoise Basseporte, who served from 1741 until 1780 as the Royal Painter for the King's Garden, were allowed to practice at the time.

The secret of making true (hard-paste) porcelain, discovered at Meissen in the early eighteenth century (see no. 39), was unknown at Vincennes when these flowers were made. Although the clay mixture used for the porcelain produced there yielded a similar translucent white body, the lack of kaolin in the formula made the body less strong, rendering it in a soft-paste porcelain that could be fired at lower temperatures. The female artisans who contributed in significant ways to the porcelain production at Vincennes received little recognition and were paid two-thirds less than their male counterparts. Since the delicate blossoms are not signed, the names of their creators remain largely unknown, despite the fact that their artistry brought financial rewards and acclaim to the Vincennes manufactory.

Ranging from anemones to pinks, from ranunculus to poppies, some five hundred different types of flowers were exquisitely crafted in multiple sizes and produced on a large scale. The botanically accurate selection included local varieties but also the tropical examples that were introduced to Europe as the result of international trade

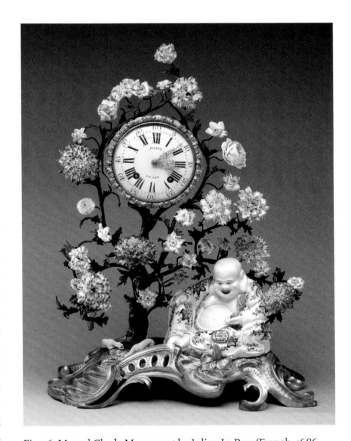

Fig. 36. Mantel Clock. Movement by Julien Le Roy (French, 1686–1759). Case: Chantilly soft-paste porcelain mounted on gilded bronze; Flowers: soft-paste with some hard-paste porcelain replacements; Dial: white enameled metal. French (Paris and Chantilly), 1745–49. H. 21½ in. (54.6 cm). The Jack and Belle Linsky Collection, 1982 (1982.60.68)

and colonization. While the smallest flowers served as knobs on the lids of coffeepots, teapots, and sugar bowls, the larger ones were applied to vases and potpourri vessels or fitted with green-lacquered brass stems and foliage. This latter practice, which allowed for the creation of bouquets placed in porcelain vases or baskets, was orchestrated by the so-called *marchands merciers*, the luxury dealers in Paris, who also added blooms to such furnishings as gilded-bronze wall lights, candelabra, and clocks (fig. 36).

The short lifespan of natural flowers, available only during part of the year, no doubt added to the general appeal of these lasting replicas, which were frequently offered as gifts. Sending porcelain examples to the first duke of Newcastle in 1751, Louis XV's mistress Madame de Pompadour, a devotee of Vincennes blooms as well as a patron of the factory, wittily referred to them as "flowers from her garden." The widespread demand for such artificial blossoms during the mid-eighteenth century was not without consequence: once other porcelain workshops began to copy the Vincennes flowers, both their price and their quality diminished.

Sources

*Asterisks indicate sources for direct quotations in text. Unless otherwise noted, all translations are the author's.

INTRODUCTION

*Address of the Officers of the Metropolitan Museum of Art, to the People of New York (New York: Francis & Loutrel, 1871), p. 10. https://libmma.contentdm.oclc.org/digital/collection /p15324coll10/id/2243.

Louis Courajod, Livre-journal de Lazare Duvaux, marchand-bijoutier ordinaire du roy, 1748–1758 (Paris: F. de Nobele, 1965).

Isabelle Frank, ed., The Theory of Decorative Art: An Anthology of European & American Writings, 1750–1940 (New York: The Bard Graduate Center for Studies in the Decorative Arts; New Haven: Yale University Press, 2000).

Anna Jackson and Amin Jaffer, eds., Encounters: The Meeting of Asia and Europe, 1500–1800, exh. cat. (London: The Victoria and Albert Museum, 2004).

Jonathan Meyer, Great Exhibitions: London–New York–Paris–Philadelphia 1851–1900 (Woodbridge, Suff.: Antique Collectors' Club, 2006).

Clare Crowston, "Women, Gender, and Guilds in Early Modern Europe: An Overview of Recent Research," International Review of Social History 53, Supplement 16, The Return of the Guilds (2008), pp. 19–44.

Daniëlle Kisluk-Grosheide, Deborah L. Krohn, and Ulrich Leben, eds., Salvaging the Past: Georges Hoentschel and French Decorative Arts from The Metropolitan Museum of Art, exh. cat. (New York: The Bard Graduate Center and The Metropolitan Museum of Art, 2013).

Peter Marshall, ed., The Oxford Illustrated History of the Reformation (Oxford: Oxford University Press, 2015).

Margret Dorothea Minkels, Alexander von Minutoli: Der Gründer des 1. Kunstgewerbemuseums der Welt (1844) (Norderstedt: BoD–Books on Demand, [2018]).

Andrea Bayer, ed., with Laura D. Corey, Making the Met, 1870–2020, exh. cat. (New York: The Metropolitan Museum of Art, 2020).

NO. 1

Anna Maria Giusti, Pietre Dure: Hardstone in Furniture and Decorations, trans. Jenny Condie and Mark Roberts (London: Philip Wilson, 1992), p. 30, fig. 15.

Alvar González-Palacios, Important French and Continental Furniture and Tapestries: Including the Contents of a South Kensington Residence, London, sale cat. (Sotheby's London, July 3, 2007), pp. 20–21, fig. 4.

Wolfram Koeppe and Anna Maria Giusti, Art of the Royal Court: Treasures in Pietre Dure from the Palaces of Europe, exh. cat. (New York: The Metropolitan Museum of Art, 2008), pp. 132–34, no. 15 (entry by Wolfram Koeppe).

NO. 2

Yannick Chastang, Paintings in Wood: French Marquetry Furniture (London: The Wallace Collection, 2001).

Marijn Manuels, "Technology and Attribution: Defining the Oeuvre of a Dutch Cabinetmaker," in Met Objectives: Treatment and Research Notes 2 (Spring 2001) (New York: Sherman Fairchild Center for Objects Conservation, The Metropolitan Museum of Art, 2001), pp. 1–3, no. 2.

Daniëlle O. Kisluk-Grosheide, Wolfram Koeppe, and William Rieder, European Furniture in The Metropolitan Museum of Art: Highlights of the Collection (New York: The Metropolitan Museum of Art, 2006), pp. 76–78, no. 27 (entry by Daniëlle O. Kisluk-Grosheide).

NO. 3

Hans Huth, Lacquer of the West: The History of a Craft and an Industry, 1550–1950 (Chicago: University of Chicago Press, 1971).

Oliver Impey and Christiaan Jörg, Japanese Export Lacquer: 1580–1850 (Amsterdam: Hotei, 2005).

NO. 4

Daniëlle Kisluk-Grosheide, "Gilt Bronze and Mounted Porcelain," in Daniëlle Kisluk-Grosheide and Jeffrey Munger, The Wrightsman Galleries for French Decorative Arts: The Metropolitan Museum of Art (New York: The Metropolitan Museum of Art, 2010), pp. 122–23.

NO. 5

*Correspondance de Madame, duchesse d'Orléans, trans. Ernest Jaeglé (Paris: A. Quantain, 1880), vol. 2, p. 204. https://gallica .bnf.fr/ark:/12148/bpt6k2137392.

*Giancarlo Ferraris, Pietro Piffetti e gli ebanisti a Torino 1670–1838 (Turin: Umberto Allemandi, 1992), p. 217, no. 3.

"Recent Acquisitions, A Selection: 2020–2022," *The Metropolitan Museum of Art Bulletin* 80, no. 2 (Fall 2022), p. 35 (entry by Wolfram Koeppe).

NO. 6

*William Hogarth, *The Analysis of Beauty*, ed. Charles Davis (London: John Reeves, 1753), p. 38. https://archiv.ub.uni-heidelberg.de/artdok/1217/1/Davis_Fontes52.pdf.

*Geoffrey Beard and Christopher Gilbert, eds., "Vile, William," in *Dictionary of English Furniture Makers, 1660–1840*, The Furniture History Society (Leeds: W. S. Maney and Son, 1986), pp. 926, 928.

Jane Roberts, ed., *George III & Queen Charlotte: Patronage, Collecting and Court Taste*, exh. cat. (London: Royal Collection, 2004), p. 265, no. 270.

Jennifer L. Anderson, *Mahogany: The Costs of Luxury in Early America* (Cambridge, Mass.: Harvard University Press, 2012).

NO. 7

*Louis Petit de Bachaumont, *Mémoires secrets pour servir à l'histoire de la République des Lettres en France depuis MDCCLXII jusqu'à nos jours; ou, Journal d'un observateur*, vol. 26 (London: John Adamson, 1786), p. 78. https://gallica.bnf.fr/ark:/12148/bpt6k6319261c/f82.item.texteImage.

Adrienne L. Childs, "Serving Exoticism: The Black Female in French Exotic Imagery, 1733–1785" (master's thesis, University of Maryland, College Park, 1999).

Samuel L. Chatman, "'There Are No Slaves in France': A Re-Examination of Slave Laws in Eighteenth-Century France," *The Journal of Negro History* 85, no. 3 (Summer 2000), pp. 144–53.

Clare Vincent and Jan Hendrik Leopold, with Elizabeth Sullivan, *European Clocks and Watches in The Metropolitan Museum of Art* (New York: The Metropolitan Museum of Art, 2015), pp. 218–21, no. 46.

NO. 8

Véronique Moreau, ed., *Chanteloup: Un moment de grâce autour du duc de Choiseul*, exh. cat. (Tours: Musée des Beaux-Arts de Tours; Paris: Somogy, 2007), pp. 294–95, no. 120 (entry by Thibaut Wolvesperges).

NO. 9

Susan L. Caroselli, *The Painted Enamels of Limoges: A Catalogue of the Collection of the Los Angeles County Museum of Art* (Los Angeles: Los Angeles County Museum of Art, 1993).

Clare Vincent, "Painted Enamels," in Wolfram Koeppe et al., *The Robert Lehman Collection*, vol. 15, *Decorative Arts* (New York: The Metropolitan Museum of Art, 2012), pp. 30–57.

Ian Wardropper, with Julia Day, *Limoges Enamels at the Frick Collection* (New York: The Frick Collection; London: In association with D. Giles, 2015).

NO. 10

Volker Jutzi and Peter Ringger, "Die Wellenleiste und ihre maschinelle Herstellung," *Maltechnik Restauro* 92 (April 1986), pp. 34–62.

Wolfram Koeppe and Anna Maria Giusti, *Art of the Royal Court: Treasures in Pietre Dure from the Palaces of Europe*, exh. cat. (New York: The Metropolitan Museum of Art, 2008), pp. 196–97, no. 53 (entry by Wolfram Koeppe).

NO. 11

Margaret Swain, "Cabinets, Mirror Frames and Bookbindings," in Margaret Swain, *Embroidered Stuart Pictures* (Princes Risborough, Bucks.: Shire, 1990), pp. 12–13.

Andrew Morrall and Melinda Watt, eds., *English Embroidery from The Metropolitan Museum of Art, 1580–1700: 'Twixt Art and Nature*, exh. cat. (New York: The Bard Graduate Center for Studies in the Decorative Arts, Design, and Culture and The Metropolitan Museum of Art; New Haven: Yale University Press, 2008), pp. 251–53, no. 70 (entry by Aleesha Nissen).

NO. 12

Viola Effmert et al., *Bernstein: Kostbarkeiten europäischer Kunstkammern* (Munich: Kunstkammer Georg Laue, 2006), p. 63, figs. 48, 49, pp. 176–81, no. 44.

"Recent Acquisitions, A Selection: 2006–2007," *The Metropolitan Museum of Art Bulletin* 65, no. 2 (Fall 2007), p. 26 (entry by Wolfram Koeppe).

Diane Morgan, "Amber: Sun, Seas, and Trees," in Diane Morgan, *Gemlore: Ancient Secrets and Modern Myths from the Stone Age to the Rock Age* (Westport, Conn.: Greenwood Press, 2008), pp. 13–22.

NO. 13

The Diary of John Evelyn, ed. William Bray (Washington, D.C., and London: M. Walter Dunne, 1901), vol. 1, pp. 224–25. https://www.gutenberg.org/files/41218/41218-h/41218-h.htm.

Meredith Chilton, with an essay by Domenico Pietropaolo, *Harlequin Unmasked: The Commedia dell' Arte and Porcelain Sculpture* (Toronto: George R. Gardiner Museum of Ceramic Art; New Haven: Yale University Press, 2001).

Lison de Caunes and Catherine Baumgartner, *La marqueterie de paille* (Dourdan: Editions Vial, 2004).

Danièlle O. Kisluk-Grosheide, "Inside the Box and Out: European Cabinets, Caskets, and Cases," *The Magazine Antiques* 178, no. 2 (March/April 2011), pp. 126, 131, fig. 11.

NO. 14

Antoine Chenevière, *Russian Furniture: The Golden Age 1780–1840* (London: Weidenfeld & Nicolson, 1988).

Burkhardt Göres, "Zur Biographie und zum Schaffen von Heinrich Gambs in Sankt Petersburg," in Rosemarie Stratmann-Döhler and Wolfgang Wiese, *Ein Jahrhundert Möbel für den Fürstenhof: Karlsruhe, Mannheim, Sankt Petersburg 1750 bis 1850*, exh. cat. (Sigmaringen: Thorbecke, 1994), pp. 63–71.

Wolfram Koeppe, *Extravagant Inventions: The Princely Furniture of the Roentgens*, exh. cat. (New York: The Metropolitan Museum of Art, 2012).

NO. 15

Giorgio Baldisseri et al., *Le maioliche cinquecentesche di Castelli: Una grande stagione artistica ritrovata* ([L'Aquila?]: CARSA, 1989).

Evelyn S. Welch, *Shopping in the Renaissance: Consumer Cultures in Italy 1400–1600* (New Haven and London: Yale University Press, 2005), p. 156.

James Shaw and Evelyn Welch, *Making and Marketing Medicine in Renaissance Florence* (Amsterdam: Rodopi, 2011), pp. 53–78.

Timothy Wilson, with an essay by Luke Syson, *Maiolica: Italian Renaissance Ceramics in The Metropolitan Museum of Art* (New York: The Metropolitan Museum of Art, 2016).

NO. 16

Kristin Duysters, *Theepotten steengoed: Roodstenen theepotten uit Yixing en Europa*, exh. cat. (Arnhem: Historisch Museum Het Burgerweeshuis, 1998).

Jan Daniël van Dam, "Les grès rouges de Delft, le commerce du thé," in Christine Lahaussois, ed., *Delft-Faïence* (Paris: Réunion des Musées Nationaux; Brussels: Mercator, 2008), pp. 112–15.

Robert D. Aronson and Suzanne M. R. Lambooy, *Dutch Delftware; Including "Facing East: Oriental Sources for Dutch Delftware Chinoiserie Figures"* [...] (Amsterdam: Aronson Antiquairs of Amsterdam, 2010), pp. 88–90, no. 47.

NO. 17

*Adam Olearius, *The Voyages and Travells of the Ambassadors Sent by Frederick, Duke of Holstein, to the Great Duke of Muscovy and the King of Persia* [...], trans. John Davies (London: Printed for John Starkey and Thomas Basset, 1669), vol. 3, p. 62. https://quod.lib.umich.edu/e/eebo/A53322.0001.001/1:9?rgn=div1;view=fulltext.

John Vrieze, ed., *Catharina, de keizerin en de kunsten: Uit de schatkamers van de Hermitage* (*Catherine, the Empress and the Arts: From the Treasuries of the Hermitage*), exh. cat. (Zwolle: Waanders, 1996), p. 234.

Wolfram Koeppe, "Chinese Shells, French Prints, and Russian Goldsmithing: A Curious Group of Eighteenth-Century Russian Table Snuffboxes," *The Metropolitan Museum Journal* 32 (1997), pp. 207–14.

Anne Odom, *Russian Silver in America: Surviving the Melting Pot* (Washington, D.C.: Hillwood Museum and Gardens Foundation; London: D. Giles, 2011), pp. 98, 102–3.

NO. 18

Leonée Ormond, *Writing* (London: H.M.S.O., 1981).

Clare Le Corbeiller, "A Tale of Two Cities," *Cleveland Studies in the History of Art* 8 (2003), pp. 146–55.

NO. 19

David Buten, with Jane Perkins Claney and contributions by Patricia Pelehach, *18th-Century Wedgwood: A Guide for Collectors and Connoisseurs* (New York: Methuen, 1980).

Marc Dumas, *Les faïences d'Apt & de Castellet* (Aix-en-Provence: Edisud, 1990).

NO. 20

"Recent Acquisitions, A Selection: 1991–1992," *The Metropolitan Museum of Art Bulletin* 50, no. 2 (Fall 1992), p. 37 (entry by Clare Le Corbeiller).

Lise Funder, *Danish Silver, 1600–2000* ([Copenhagen]: The Danish Museum of Decorative Art, 2002), p. 125, no. 176.

NO. 21

Clare Vincent and Jan Hendrik Leopold, with Elizabeth Sullivan, *European Clocks and Watches in The Metropolitan Museum of Art* (New York: The Metropolitan Museum of Art, 2015).

Clare Vincent and J[an] H[endrik] Leopold, "Seventeenth-Century European Watches," *Heilbrunn Timeline of Art History*, accessed November 1, 2022. https://www.metmuseum.org/toah/hd/watc/hd_watc.htm.

NO. 22

Renate Smollich, *Der Bisamapfel in Kunst und Wissenschaft* (Stuttgart: Deutscher Apotheker, 1983).

Günther Schiedlausky, "Vom Bisamapfel zur Vinaigrette: Zur Geschichte der Duftgefäße," *Kunst und Antiquitäten* 4 (1985), pp. 28–39.

Elizabeth Rodini, "Functional Jewels," *Art Institute of Chicago Museum Studies* 25, no. 2 (2000), Renaissance Jewelry in the Alsdorf Collection, pp. 76–78.

NO. 23

Diane Morgan, "Agate: Goodness and Grounding," in Diane Morgan, *Gemlore: Ancient Secrets and Modern Myths from the Stone Age to the Rock Age* (Westport, Conn.: Greenwood Press, 2008), pp. 1–12.

Daniëlle O. Kisluk-Grosheide, "Inside the Box and Out: European Cabinets, Caskets, and Cases," *The Magazine Antiques* 178, no. 2 (March/April 2011), pp. 124–31, fig. 5.

Aileen Ribeiro, *Facing Beauty: Painted Women & Cosmetic Art* (New Haven: Yale University Press, 2011).

NO. 24

Judit H. Kolba, *Hungarian Silver: The Nicolas M. Salgo Collection* (London: Thomas Heneage, 1996), p. 107, no. 84.

"Recent Acquisitions, A Selection: 2010–2012," *The Metropolitan Museum of Art Bulletin* 70, no. 2 (Fall 2012), p. 29 (entry by Wolfram Koeppe).

NO. 25

*L'Abbé Antoine François Prévost, ed., *Le pour et contre: Ouvrage périodique d'un goût nouveau*, vol. 3, no. 38 (Paris: Didot, 1734), p. 174. https://books.google.com/books?id=qGQHAAAAQAAJ&printsec=frontcover&hl=fr&source=gbs_ge_summary_r&cad=o#v=onepage&q&f=false.

Clare Le Corbeiller, "James Cox: A Biographical Review," *The Burlington Magazine* 112, no. 807 (June 1970), pp. 351–58.

Marcia Pointon, "Dealer in Magic: James Cox's Jewelry Museum and the Economics of Luxurious Spectacle in Late-Eighteenth-Century London," in Neil De Marchi and Craufurd D. W. Goodwin, eds., *Economic Engagements with Art* (Durham, N.C.: Duke University Press, 1999), pp. 423–51.

*Roger Smith, "James Cox (c. 1723–1800): A Revised Biography," *The Burlington Magazine* 142, no. 1167 (June 2000), pp. 353–54, fig. 16.

Jane Roberts, ed., *Royal Treasures: A Golden Jubilee Celebration*, exh. cat. (London: Royal Collection, 2002), p. 328, no. 292.

Clare Vincent and J[ohn] H[endrik] Leopold, "James Cox (ca. 1723–1800): Goldsmith and Entrepreneur." *Heilbrunn Timeline of Art History*, accessed November 1, 2022. https://www.metmuseum.org/toah/hd/jcox/hd_jcox.htm.

NO. 26

Suzanne Boorsch, "Fireworks! Four Centuries of Pyrotechnics in Prints & Drawings," *The Metropolitan Museum of Art Bulletin* 58, no. 1 (Summer 2000), pp. 36–37.

Miriam Volmert and Danijela Bucher, eds., *European Fans in the 17th and 18th Centuries: Images, Accessories, and Instruments of Gesture* (Berlin and Boston: Walter de Gruyter, 2020).

NO. 27

"Recent Acquisitions, A Selection: 1996–1997," *The Metropolitan Museum of Art Bulletin* 55, no. 2 (Fall 1997), p. 32 (entry by Jessie McNab).

Ian Wardropper, "The Flowering of the French Renaissance," *The Metropolitan Museum of Art Bulletin* 62, no. 1 (Summer 2004), pp. 9–10.

NO. 28

Daniëlle Kisluk-Grosheide, "Dating a Book by Its Cover: An Early Seventeenth-Century Dutch Psalter," *The Metropolitan Museum Journal* 35 (2000), pp. 153–60.

NO. 29

Priscilla E. Muller, *Jewels in Spain 1500–1800* (New York: The Hispanic Society of America, 1972), p. 62, fig. 71.

George E. Harlow, ed., *The Nature of Diamonds*, exh. cat. (New York: American Museum of Natural History; Cambridge: Cambridge University Press, 1998).

NO. 30

Bernhard Heitmann et al., *Die Goldschmiede Hamburgs*, vol. 2 (Hamburg: Schliemann, 1985), p. 10, no. 53.

Susan L. Braunstein, *Five Centuries of Hanukkah Lamps from the Jewish Museum: A Catalogue Raisonné* (New York: The Jewish Museum; New Haven: Yale University Press, 2004).

NO. 31

Ulrich Pietsch, *Phantastische Welten: Malerei auf Meissener Porzellan und deutschen Fayencen von Adam Friedrich von Löwenfinck 1714–1754*, exh. cat. (Dresden: Staatliche Kunstsammlungen; Stuttgart: Arnoldsche Art Publishers, 2014), pp. 98, 290–91, no. 197.

NO. 32

Colleen Schafroth, *The Art of Chess* (New York: Abrams, 2002).

Olivia Remie Constable, "Chess and Courtly Culture in Medieval Castile: The *Libro de ajedrez* of Alfonso X, el Sabio," *Speculum* 82, no. 2 (April 2007), pp. 301–47.

I. L. Finkel, ed., *Ancient Board Games in Perspective: Papers from the 1990 British Museum Colloquium, with Additional Contributions* (London: The British Museum Press, 2007).

NO. 33

Pliny the Elder, *Natural History*, trans. H. Rackham, vol. 9 (Cambridge, Mass.: Harvard University Press, 1952), book 34, chap. 3, p. 129. http://www.perseus.tufts.edu/hopper/text?doc=Perseus%3Atext%3A1999.02.0137%3Abook%3D34.

*Balthazar Gerbier, *Eer ende Claght-Dicht* [Poem of Honor and Lament] (The Hague: Aert Meuris, 1620), p. 10. https://balthazargerbier.files.wordpress.com/2012/02/eer-ende-claght-dicht-by-balthazar-gerbier.pdf.

Ger Luijten et al., eds., *Dawn of the Golden Age: Northern Netherlandish Art, 1580–1620*, exh. cat. (Amsterdam: Rijksmuseum; Zwolle: Waanders, 1993), pp. 64, 321, 454–55, no. 114, fig. 114.

Louise E. van den Bergh-Hoogterp and B. Dubbe, *De verzamelingen van het Centraal Museum Utrecht* (Utrecht: Centraal Museum Utrecht, 1997), vol. 4, *Edele en onedele metalen*, pp. 61–64, 170–71, no. 25.

Reinier Baarsen, *Kwab: Ornament as Art in the Age of Rembrandt*, exh. cat. (Amsterdam: Rijksmuseum, 2018), pp. 57–59, figs. 64, 65, p. 257, no. 7.

"Recent Acquisitions, A Selection: 2018–20, Part I, Antiquity to the Late Eighteenth Century," *The Metropolitan Museum of Art Bulletin* 78, no. 3 (Winter 2021), p. 26 (entry by Daniëlle Kisluk-Grosheide).

NO. 34

The Diary of John Evelyn, ed. William Bray (Washington, D.C., and London: M. Walter Dunne, 1901), vol. 1, p. 92. https:// www.gutenberg.org/files/41218/41218-h/41218-h.htm.

Noam Andrews, "The Ivory Turn: Of Solids, Curves, and Nests," in Wolfram Koeppe, ed., *Making Marvels: Science and Splendor at the Courts of Europe*, exh. cat. (New York: The Metropolitan Museum of Art, 2019), pp. 121–28.

Johanna Hecht, "Ivory and Boxwood Carvings, 1450–1800," *Heilbrunn Timeline of Art History*, accessed November 1, 2022. https://www.metmuseum.org/toah/hd/boxw/hd _boxw.htm.

NO. 35

The Metropolitan Museum of Art, *English and Other Silver in the Irwin Untermyer Collection*, text by Yvonne Hackenbroch, rev. ed. (New York: The Metropolitan Museum of Art, 1969), pp. 104–5, no. 205.

Hanspeter Lanz and Lorenz Seelig, eds., *Farbige Kostbarkeiten aus Glas: Kabinettstücke der Zürcher Hinterglasmalerei 1600–1650*, exh. cat. (Munich: Bayerisches Nationalmuseum; Zürich: Schweizerisches Landesmuseum, 1999), pp. 141–48, no. 8.

Philippa Glanville and Sophie Lee, eds., *The Art of Drinking* (London: Victoria and Albert Publications, 2007).

NO. 36

Johann Joachim Becher, Psychosophia oder Seelen-Weißheit, 3rd ed. (Lauenburg: Albrecht Pfeiffer, 1707), p. 141. https://books .google.com/books?id=SWNWAAAAcAAJ&printsec =frontcover&source=gbs_ge_summary_r&cad=0#v =onepage&q&f=false.

Dedo von Kerssenbrock-Krosigk, *Glass of the Alchemists: Lead Crystal–Gold Ruby, 1650–1750*, exh. cat. (Corning, N.Y.: The Corning Museum of Glass, 2008), pp. 124–37, 266–67, no. 93.

Sven Dupré, "Making Materials: The Arts of Fire," in Sven Dupré, Dedo von Kerssenbrock-Krosigk, and Beat Wismer, eds., *Art and Alchemy: The Mystery of Transformation*, trans. Susanna Michael, exh. cat. (Düsseldorf: Stiftung Museum Kunstpalast; Munich: Hirmer, 2014), pp. 84–97.

NO. 37

Dwight P. Lanmon, with David B. Whitehouse, *The Robert Lehman Collection*, vol. 11, *Glass* (New York: The Metropolitan Museum of Art, 1993), pp. 201–5, no. 74.

Reino Liefkes, "Façon de Venise Glass in the Netherlands," in Jutta-Annette Page, *Beyond Venice: Glass in Venetian Style, 1500–1750*, exh. cat. (Corning, N.Y.: The Corning Museum of Glass, 2004), pp. 226–49.

Suzanne Higgott, *Catalogue of Glass and Limoges Painted Enamels* (London: Trustees of the Wallace Collection, 2011).

NO. 38

C. Louise Avery, *Masterpieces of European Porcelain: A Catalogue of a Special Exhibition, March 18–May 15, 1949*, exh. cat. (New York: The Metropolitan Museum of Art, 1949), [p. 1], no. 2.

Meredith Chilton, ed., *Fired by Passion: Vienna Baroque Porcelain of Claudius Innocentius Du Paquier*, exh. cat., 3 vols. (Stuttgart: Arnoldsche Art Publishers, 2009), vol. 2, "The Theater of Dessert," pp. 848–902, vol. 3, p. 1306, no. 357, figs. 3:8, 10:27.

Jeffrey Munger, with an essay by Elizabeth Sullivan, *European Porcelain in The Metropolitan Museum of Art* (New York: The Metropolitan Museum of Art, 2018), pp. 101–9.

NO. 39

H. D. Howarth, "Dom Garcie de Navarre or Le Prince Jaloux?" *French Studies* 5, no. 2 (January 1951), pp. 140–48.

The Metropolitan Museum of Art, *Meissen and Other Continental Porcelain, Faience and Enamel in the Irwin Untermyer Collection*, text by Yvonne Hackenbroch (Cambridge, Mass.: Harvard University Press, 1956), p. 39, fig. 36, pl. 27.

Manfred Brauneck, Angela Gräfin von Wallwitz, and Alfred Ziffer, *Celebrating Kaendler 1706–1775: Meissen Porcelain Sculpture*, sale cat. (Munich: Angela Gräfin von Wallwitz, 2006).

NO. 40

*Madame de Pompadour, letter to the duc de Mirepoix, October 12, 1751. British Library, London, Add MS 32685, fol. 61. Newcastle Papers, Autographs 1714–1761. With gratitude to Alden Gordon.

Tamara Préaud and Antoine d'Albis, "Bouquets de Sèvres," *Connaissance des arts* 479 (January 1992), pp. 68–77.

Tamara Préaud, "The Origins and History of Porcelain Flowers," *The French Porcelain Society Journal* 1 (2003), pp. 47–55.

Alison McQueen, "Making Their Marks: The Significant Roles and Challenges for Women in the First Century of Sèvres Porcelain," *American Ceramic Circle Journal* 21 (Summer 2021), pp. 33–51.

Further Reading

For information about objects in The Met collection of European decorative arts, an invaluable resource is the Museum's website, https://www.metmuseum.org/art/collection/search?. Thematic discussions of European decorative arts can be found on the website's *Heilbrunn Timeline of Art History,* https://www.metmuseum.org/toah/.

Anderson, Jennifer L. *Mahogany: The Costs of Luxury in Early America.* Cambridge, Mass.: Harvard University Press, 2012.

Chastang, Yannick. *Paintings in Wood: French Marquetry Furniture.* London: The Wallace Collection, 2001.

Coutts, Howard. *The Art of Ceramics: European Ceramic Design, 1500–1830.* New York: The Bard Graduate Center for Studies in the Decorative Arts; New Haven: Yale University Press, 2001.

Dupré, Sven, Dedo von Kerssenbrock-Krosigk, and Beat Wismer, eds. *Art and Alchemy: The Mystery of Transformation.* Translated by Susanna Michael. Exh. cat. Düsseldorf: Stiftung Museum Kunstpalast; Munich: Hirmer, 2014.

Frank, Isabelle, ed. *The Theory of Decorative Art: An Anthology of European & American Writings, 1750–1940.* New York: The Bard Graduate Center for Studies in the Decorative Arts; New Haven: Yale University Press, 2000.

Grimaldi, David A. *Amber: Window to the Past.* New York: Abrams, in association with the American Museum of Natural History, 1996.

Gruber, Alain, ed. *The History of Decorative Arts: Classicism and the Baroque in Europe.* Translated by John Goodman. New York: Abbeville, 1992.

———. *The History of Decorative Arts: The Renaissance and Mannerism in Europe.* Translated by John Goodman. New York: Abbeville, 1994.

Huth, Hans. *Lacquer of the West: The History of a Craft and an Industry, 1550–1950.* Chicago: University of Chicago Press, 1971.

Jackson, Anna, and Amin Jaffer, eds. *Encounters: The Meeting of Asia and Europe, 1500–1800.* Exh. cat. London: The Victoria and Albert Museum, 2004.

Kerssenbrock-Krosigk, Dedo von. *Glass of the Alchemists: Lead Crystal-Gold Ruby, 1650–1750.* Exh. cat. Corning, N.Y.: The Corning Museum of Glass, 2008.

Kisluk-Grosheide, Daniëlle, Deborah L. Krohn, and Ulrich Leben, eds. *Salvaging the Past: Georges Hoentschel and French Decorative Arts from The Metropolitan Museum of Art.* Exh. cat. New York: The Bard Graduate Center and The Metropolitan Museum of Art, 2013.

Kisluk-Grosheide, Daniëlle, and Jeffrey Munger. *The Wrightsman Galleries for French Decorative Arts: The Metropolitan Museum of Art.* New York: The Metropolitan Museum of Art, 2010.

Kisluk-Grosheide, Daniëlle O., Wolfram Koeppe, and William Rieder. *European Furniture in The Metropolitan Museum of Art: Highlights of the Collection.* New York: The Metropolitan Museum of Art, 2006.

Koeppe, Wolfram. *Extravagant Inventions: The Princely Furniture of the Roentgens.* Exh. cat. New York: The Metropolitan Museum of Art, 2012.

———, ed. *Making Marvels: Science and Splendor at the Courts of Europe.* Exh. cat. New York: The Metropolitan Museum of Art, 2019.

———, and Anna Maria Giusti. *Art of the Royal Court: Treasures in Pietre Dure from the Palaces of Europe.* Exh. cat. New York: The Metropolitan Museum of Art, 2008.

Morgan, Diane. *Gemlore: Ancient Secrets and Modern Myths from the Stone Age to the Rock Age.* Westport, Conn.: Greenwood Press, 2008.

Morrall, Andrew, and Melinda Watt, eds. *English Embroidery from The Metropolitan Museum of Art, 1580–1700: 'Twixt Art and Nature.* Exh. cat. New York: The Bard Graduate Center for Studies in the Decorative Arts, Design, and Culture, and The Metropolitan Museum of Art; New Haven: Yale University Press, 2008.

Munger, Jeffrey, with an essay by Elizabeth Sullivan. *European Porcelain in The Metropolitan Museum of Art.* New York: The Metropolitan Museum of Art, 2018.

Murdoch, Tessa, and Heike Zech, eds. *Going for Gold: Craftsmanship and Collecting of Gold Boxes.* Chicago: Sussex Academic Press, 2013.

Truman, Charles, ed. *Sotheby's Concise Encyclopedia of Silver.* London: Conran Octopus, 1993.

Vincent, Clare, and Jan Hendrik Leopold, with Elizabeth Sullivan. *European Clocks and Watches in The Metropolitan Museum of Art.* New York: The Metropolitan Museum of Art, 2015.

Volmert, Miriam, and Danijela Bucher, eds. *European Fans in the 17th and 18th Centuries: Images, Accessories, and Instruments of Gesture.* Berlin and Boston: Walter de Gruyter, 2020.

Wardropper, Ian, with Julia Day. *Limoges Enamels at the Frick Collection.* New York: The Frick Collection; London: In association with D. Giles, [2015].

Wees, Beth Carver. *English, Irish, & Scottish Silver at the Sterling and Francine Clark Art Institute.* New York: Hudson Hills, 1997.

Wilson, Timothy, with an essay by Luke Syson. *Maiolica: Italian Renaissance Ceramics in The Metropolitan Museum of Art.* New York: The Metropolitan Museum of Art, 2016.

Index